The Teabowl

East & West

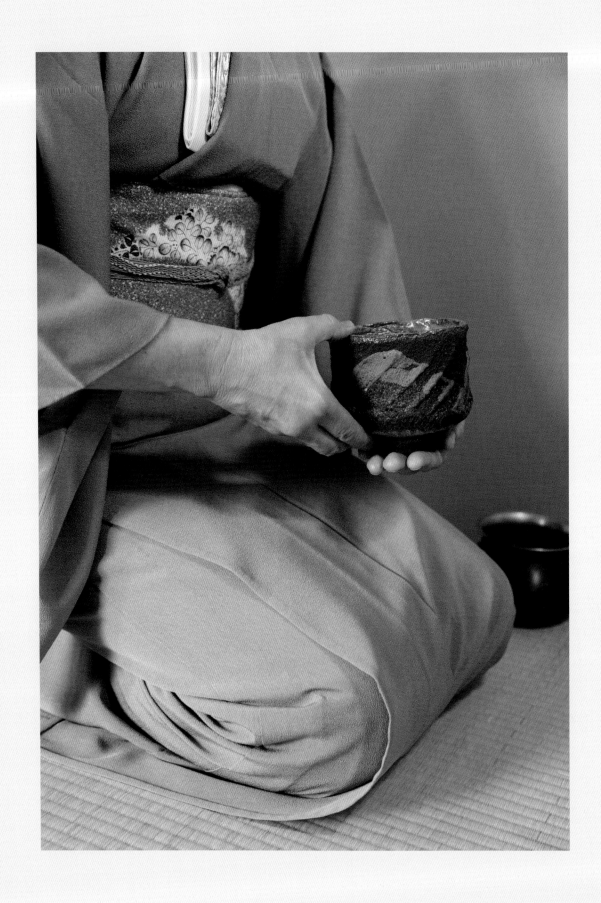

The Teabowl

East & West

Bonnie Kemske

HERBERT PRESS
LONDON · OXFORD · NEW YORK · NEW DELHI · SYDNEY

In memory of Michael Sōei Birch (1936–1997), Urasenke Tea master,
an inspirational teacher and a friend sorely missed.

HERBERT PRESS
Bloomsbury Publishing Plc
50 Bedford Square, London, WC1B 3DP, UK

BLOOMSBURY, HERBERT PRESS and the Herbert Press logo are trademarks of
Bloomsbury Publishing Plc

First published in Great Britain 2017

A catalogue record for this book is available from the British Library

Library of Congress Cataloguing-in-Publication data has been applied for

ISBN: HB: 978-1-4725-8560-8

4 6 8 10 9 7 5 3

Designed and typeset in Minion Pro by Susan McIntyre

Printed and bound in India by Replika Press

To find out more about our authors and books visit www.bloomsbury.com and sign up for our newsletters

Cover design: Louise Dugdale

Cover image: Teabowl with kintsugi repair, with seal of Nonomura Ninsei (1598–1666). 18th century repair.
From Koshosai Collection. Photo by Ian Olsson.

Title page image: Marcio Mattos, *Blue Wave*, 2014. Paperclay stoneware,
12 × 12 cm approx. PHOTO BY IAN OLSSON.

Contents

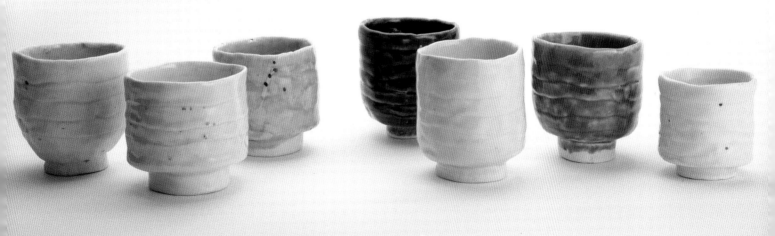

List of illustrations

- Jim Gottuso, *Etched Porcelain Bowl*, 2015. Grolleg porcelain, terra sigillata slip and glaze.
- Sylvian Meschia, *Bol*, 2013–14. Earthenware and local clays with white engobe, successive layers of oxide-coloured engobes, dilute transparent glaze.
- Sakai Mika, *Fletching* (yabane) *Pattern Tea Bowl*, 2014. *Nerikomi* (coloured clays) with clear glaze.
- Susan Nemeth, *Bowl with Blue Squares*, 2008. Press-moulded porcelain with layers of coloured clays and slips inlaid.
- Randy Johnston, *Tea bowl*, 2011. *Anagama* fired with natural ash and crackle Shino glazes over iron.
- Ellen Schön, *Eddy*, 2012. Wheel-thrown coloured clays, fired in electric oxidation.
- Maggie Zerafa, *Landscape Teabowl*, 2015. Reduction-fired stoneware.
- Stacey Stanhope Dundon, *Untitled*, 2013. Salt-fired stoneware with wax resist.
- Jeff Mincham, *Dry Lake*, 2014. Ceramic and timber from ancient mangrove wood retrieved from drought-stricken lake.
- Angela Mellor, *Tea bowls*, 2015. Slip-cast bone china with paper slip inclusions.
- Emmanuel Cooper, *Tea bowls*, 2010. Hand-built porcelain.
- Elaine Coleman and Tom Coleman, *Two Frog Tea Bowl*, 2014. Coleman porcelain with apple green celadon glaze.
- Steven Branfman, installation photo with *Kaddish Chawan 235/365, May 19, Jared's Birthday* in foreground.
- Anna Lambert, *Flood Chawan: Evening Rooks*, 2015. Altered soft slabs of white earthenware and stoneware, painted with layered slips and underglazes.
- Alastair Whyte, *Hiroshima*, 2014. Porcelain with copper red glaze with human ash.
- Rob Fornell, *Pink Chawan*, 2012–2014. Wheel-thrown tubes, cut and torn, then reassembled, thick white glaze with pink colouration.
- Raewyn Harrison, *Mud Larking Tea Bowls*, 2015. Thrown porcelain with rims of dripping casting slip, glazed with photo transfers from Elizabethan Agas map.
- Philip Eglin, untitled teabowl, 2014. Handmade earthenware with glaze and transfers of drawn images and open stock enamels.
- Ron Meyers, *T-Bowl with Hog*, 2014. Earthenware with slips, engobes and transparent glaze.
- Tanaka Takashi, *The Armor of Moonlight (Tea Bowl)*, 2014. Ceramic.
- Kevin A. Myers, *Tea Bowl 1000*, 2010. Thrown and altered porcelain on ceramic plinth.
- Carina Ciscato, *White Constructed Teabowl*, 2012. Porcelain with clear glaze.
- Ewen Henderson, *Tea Bowl*, 1990s. Stoneware.
- Charles Bound, untitled *chawan*, shown in 2014. Wood-fired stoneware.
- Kawabata Kentaro, *Shuwari Chawan*, 2012. Porcelain.
- Colin Pearson, *Vessel on Raised Foot*, c.1985. Porcelain.
- Andrew Deem, *Haptic Bowls on Cladding*, 2013. Porcelain, celadon, terracotta.
- Monika Patuszyńska, from the series *TransForms*, 2011. Wood-fired porcelain, slip cast from modified plaster moulds.
- Kuwata Takuro, *Bowl*, 2015. Porcelain.
- From the exhibition *Masashi Suzuki at Bedford House Dublin Castle*, 2014. *Chawan* by Suzuki Masashi.
- Tom Sachs, *Large Chawan Cabinet*, 2014. English porcelain, temple white glaze, NASA Red engobe (reduction fired), pine, latex, glass beads and museum glass.
- Glenn Grishkoff, from the performance *Marking My Life*, in collaboration with Jane Brucker and Mark LaPointe, 24 September 2014.
- Hamada Shōji, untitled *chawan* with fitted and signed wooden box, shown in 2014. Stoneware with brushed iron oxide decoration and Shino glaze.
- Jack Doherty, *Small tea bowl on the blue cupboard*, 2012. Soda-fired porcelain.

Preface

In 2013, as part of the Embassy of Japan's *Insight into Beauty* series, I curated an exhibition in London of contemporary teabowls made in Britain. Through this I discovered that those who make teabowls and those who collect them often know about the characteristic styles, clays and glazes of these enigmatic bowls and how they are made, but many have only a vague understanding of how teabowls are used, or the history and philosophy that underlies them.

Some time later I was asked by Alison Stace, when she was at Bloomsbury Publishing, to write this book. Alison understood the ubiquity of the teabowl in contemporary ceramics today and wanted to know how such a foreign ceramic form had become so important and prevalent in our ceramic culture. It is a question I had been pondering for some time, long before, even, the Embassy exhibition. This book has allowed me to look for an answer by following several threads of my personal and working life: a knowledge and love of ceramics; the study of *chanoyu* (Japanese tea ceremony); my interest in touch, tactility and ceramics as explored in my PhD; and the chance to share my passion for Japanese ceramics, *chanoyu* and the teabowl. I offer here the story of this intriguingly simple, yet profoundly meaningful ceramic form, not as a scholar of Japanese culture (indeed, the Japanese sources for this book have been restricted to translations), but from the perspective of someone steeped in the historical lore of both *chanoyu* and the teabowl, and in ceramics more widely.

In this book I talk about the teabowl within my own personal *chanoyu* experience, giving a sense of its physical and spiritual context. This means that I do not give details about the numerous effects achieved with Shino glazes; expound on whether all the bowls attributed to Chōjirō, the sixteenth-century potter, were actually made by him; give a critical history of teabowl design or an analysis of the teabowl through the lens of material culture studies; or even go into the fascinating (and sometimes fetishized) world of the teabowl foot. I unashamedly express my deep love of teabowls, traditional and contemporary, my admiration for how artists have explored the possibilities embedded in it, and how this iconic Japanese ceramic form has added to ceramic aesthetics in Japan and beyond.

During my research I found that teabowls of every description are being made on every continent of the inhabited world, within the rules and well outside them. To include all the teabowls I've come across and loved, this book would have run to many volumes. It has been a frustrating task to select which teabowls and makers to include, and although I have been able to at least give a mention to many notable artists, with

many others even that hasn't been possible. However, it is exciting to think that there are still thousands of beautiful and challenging teabowls waiting to be discovered.

I have chosen to use the single word 'teabowl' because I believe the object's heightened status allows for the forming of the new conjoined word. Although some potters have opted to use the Japanese word *chawan* to refer to traditional utilitarian teabowls, and 'teabowl' to refer to bowls not made for or useable in *chanoyu*, I have chosen to use the two words interchangeably as the border between them is sometimes blurred at best. I have done the same with 'Japanese tea ceremony' and *chanoyu*. Regarding Japanese names, I present them in the standard Japanese order, which is family name followed by given name. Following Japanese tradition, some well-known individuals are referred to by their given names alone.

There are many excellent books in print that provide histories of Japanese culture and Japanese tea ceremony, and many more ceramics books that include teabowls, both traditional and contemporary. In *The Teabowl* my aim is to bring these elements together in a way that will give a grounding in the knowledge and context of the teabowl, and to give me the opportunity to share the alluring sensory experience of handling a teabowl within the tea ceremony. I hope this introduction deepens the appreciation of the teabowl's complex and fascinating story, and encourages further research into this iconic form.

Acknowledgements

My sincere thanks go to Sōkei Kimura, Urasenke Tea master, London, and Michiko Sōmei Nojiri, Urasenke Tea master, Rome, for their support and for sharing their great knowledge. Heartfelt thanks also go to Peter Sōrin Cavaciuti, Urasenke teacher, Cambridge, who helped with this book at every stage, and to Michi Warren, who agreed so graciously to be photographed preparing tea.

My grateful appreciation goes to all the artists who supplied images and shared their perspectives and personal feelings about teabowls with me. I also cannot thank the galleries and gallery staff members enough who provided photographs for this book. These include André Kirbach from Gallery André Kirbach, Düsseldorf; Koichiro Isaka from Gallery St Ives, Tokyo; James Fordham, Rachel Ackland and Emily Waugh from Oxford Ceramics Gallery; Matthew Hall and Lauren MacRae from Erskine, Hall & Coe, London; Noriko Ozawa from Joan B. Mirviss Gallery, New York; Kathryn Manzella and Ai Kanazawa Cheung from the online shop Studio KotoKoto, San Diego; Marijke Varrall-Jones from Maak Contemporary Ceramics, London; Dennis Ambrogi from Snyderman-Works Galleries, Philadelphia; Kayode Ojo at Salon 94, New York; and Marissa Levien from Cavin-Morris Gallery, New York.

I also thank Peter Roberts-Taira and Hiroko Roberts-Taira at The Kaetsu Educational & Cultural Centre, Cambridge; Dr James Lin, Senior Assistant Keeper, Applied Arts, Fitzwilliam Museum, Cambridge; Dr Jenni Sorkin, University of California, Santa Barbara; and Elaine Henry, Editor of *Ceramics: Art & Perception*. I would like to thank Alison Stace, Abbie Sharman, Claire Constable and Rebecca Barden at Bloomsbury Publishing.

My unending thanks go to Vana Mather for her exacting critique of both content and style, and for being the best reader, proof-reader and project manager a writer could have; Christina Bolt, who valiantly managed to wrestle photographs and copyright permissions from all over the world into some kind of order; and finally, boundless thanks to my husband, Professor Tony Holland, who over the years has learned a lot about ceramics, tactile art and the Japanese tea ceremony, whether he has wanted to or not.

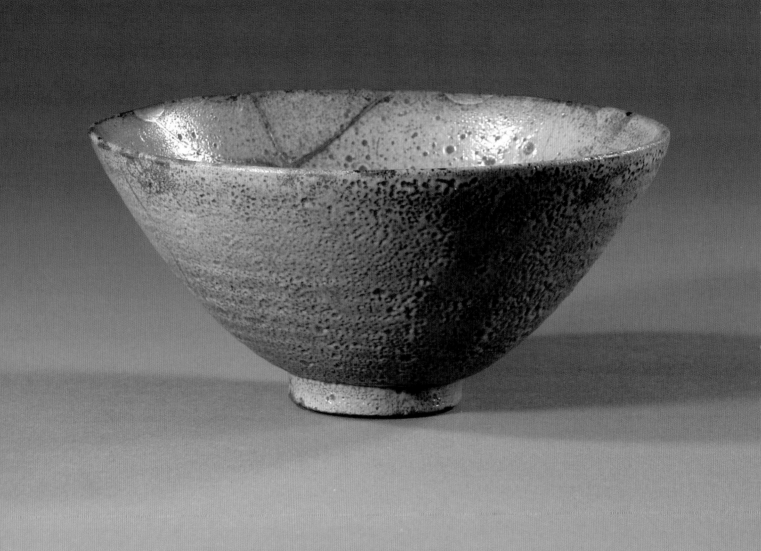

The iconic teabowl

As *chanoyu*, or tea ceremony, can be said to be one of the most Japanese of all Japanese arts, so the teabowl, or *chawan*, is often seen as the most Japanese of Japanese ceramics. Indicative of its veneration, eight of the fourteen ceramic objects designated by the Japanese government as Japanese National Treasures are teabowls. Sometimes squat, plain, or appearing roughly made, the Japanese teabowl is enigmatic. Grounded in its function, but communicating something well beyond its utility, this simple form carries an aesthetic loading that translates into myriad levels of understanding – and misunderstanding. As the teabowl made its way to Europe and the United States in the early twentieth century, potters there must have learned with astonishment about the level of respect given to Japanese potters, individual teabowls and the teabowl form itself. There is, simply, no equivalent in the West; no ceramic form engenders such deference in our culture. Contemporary teabowls not created for use in tea ceremony and seemingly devoid of *chanoyu* principles often still carry a touch of this reverence – a quiet strength, a sense of the monumental held in the hands, an aura of the form's profound legacy – even when in the bleak white space of the gallery setting or even when displayed on a dining room table (see figure 2).

(opposite) Figure 1: Hagi teabowl, Japan, 9 × 13.5 cm, early Edo period (first half 17th century). *Kintsugi* repairs in gold and silver, traces of abrasion from many years of use in *chanoyu*, the Japanese tea ceremony. PHOTO BY GALLERY ANDRÉ KIRBACH.

Figure 2: Three porcelain teabowls by Kevin Millward displayed on a 20th-century Amish patchwork table runner in the author's home. PHOTO BY IAN OLSSON.

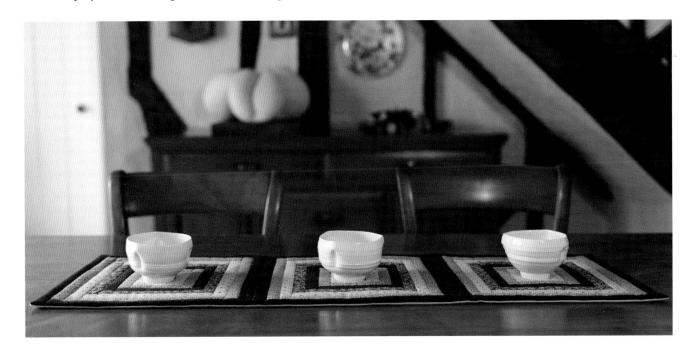

Although there are teabowls and tea ceremonies throughout Asia, and dramatic influences between the Asian cultures both in tea ceremonies and in ceramics, it is Japanese tea ceremony, *chanoyu*, that is the 'natural habitat' of the iconic *chawan*. Further, as Japan globalized in the latter part of the last century, along with exporting automobiles, information technology, and *anime* and *manga*, it also exported matcha, the powdered green tea for which the *chawan* was developed, and the teabowl began to find new homes around the world. Indeed, this has even led to teabowls being made for a more casual consumption of matcha.

Some people deeply admire the form; others see it as 'much ado about nothing'. The teabowl has been shaped by changes within its complex history, which is deeply entwined with the teabowl traditions of China and Korea, and its function, and understanding the importance of these contexts goes some way towards explaining the 'much ado'. Contemporary potters have drawn on this heavily encrusted history. Through a tendency to imbue what is perceived as 'exotic' or mysterious with higher status, they have sometimes endowed it with an even greater significance and value than it holds in Japanese tea ceremony, where the teabowl ranks in importance below the scroll hung in the alcove and the tea caddies. The teabowl's cultural weight (or burden) has drawn potters to it in their efforts to capture some of its status, but it has also provided an iconic form that has been used by some makers to challenge tradition, convention and established values.

A personal approach

In this book, my aim is to tell the story of the teabowl from the point of view of a ceramicist and a long-time but erratic student of the Urasenke school, one of the many schools of tea ceremony in Japan. My intention is to give a sense of the teabowl's use, history, lore and context, and to explore its meaning in Japan and beyond.

Like most potters, I can't recall a time when I didn't love ceramics – my great-grandmother's fine Limoges china with the tiny roses, the ornamental figure of a little cow won at an amusement park, the little cups with Mount Fuji on them bought by my mother in Okinawa, where I was born. Growing up in the United States, and influenced by my mother's creative family, where the men were sculptors and the women created beautiful handcrafts, I entered adulthood sure that I too would lead a creative life. But after a few years I became disenchanted: my training in ballet and contemporary dance had begun to feel empty; studies in drawing and sculpture didn't fill the hollow; and even ceramics, which I began to learn in my twenties, seemed unsatisfying, as studio ceramics in the United States at the time was dominated by the macho exhibitionism of Peter Voulkos and Paul Soldner, which I felt did not include me. It was then that I discovered *chanoyu*, Japanese tea ceremony – 'Tea'. I was drawn to the spiritual aspects of *chanoyu*; I felt that the Zen Buddhism in which it is

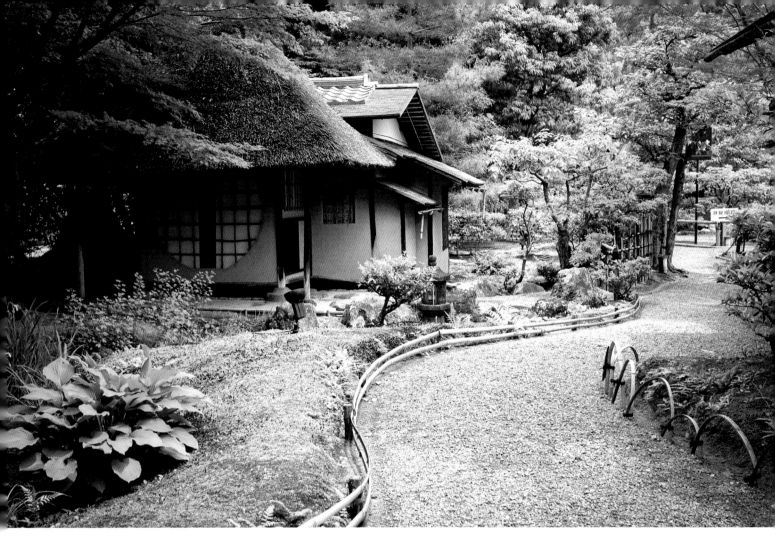

Figure 3: Ihoan teahouse at Kodaiji temple, Kyoto, Japan. GETTY IMAGES/ CREDIT: TOTORORO.

steeped went beyond the aesthetics I had learned, and touched me in ways that the arts I was studying had not. And in *chanoyu*, I found a place for my dance training – the involvement and awareness of the whole body, the prescribed movements, so beautiful and feeling so right – and my love of sculptural form. So I set out for Kyoto to learn more about the Urasenke *chanoyu* tradition (see figure 3).

It was in my first Urasenke Tea lesson, when I was taught how to hold the teabowl in the palms of both hands, secure and in total physical contact, that my interest in ceramics was revived. That teabowl, a mass-produced cream-coloured bowl with painted decoration representing the four seasons, was commonly used for students. It was simple, decorative and unchallenging; it held no mysteries. Yet holding that teabowl on that day was my first experience of how a ceramic form could be more than just useful or beautiful – it could be completely engaging.

Later in the UK, after handling many more teabowls that were less straightforward and carried more aesthetic complexity, I returned to art school with the intention of making *chanoyu* ceramics, which, more than two decades later, I have only recently begun to do. I avoided teaware then because I feared I would be making only inferior copies of the ceramics I was using and learning about in my Tea studies. But the essence of what I perceived in these wares came with me into my sculptural work. Mostly, it was a love of the tactile qualities of the teabowls that inveigled its way into my ceramic

aesthetic. I went on to produce highly textured abstracted and vessel forms based on the human body. In a PhD at the Royal College of Art, London, I went further, into the study of sensory perception and how ceramics can engage the body's sense of touch. Again, I found myself within the Tea aesthetic, trying through my sculptures, the 'Cast Hugs' that I make to fit the body, to recreate those moments in tea ceremony where everything leaves your mind except your awareness of the object you hold and the rightness of the feel of it – a sense of grounded sensuality.

So here I am, writing a book on teabowls. The project has taken me back to Kyoto memories of my first *chanoyu* lessons, when I was discovering and defining my own Tea aesthetic: the soft moss between the stones in the tea garden; the smell of the tearoom – incense, tea and ageing wood; the feel of tatami mats – smooth but textured; the warm teabowl, slightly rough, held securely in the hands (see figure 4). Like in my dance training, I learned how the ritualized movements of the tea ceremony could lead to a new aesthetic and full-body experience of art. Instead of *pas de bourrée*, I was sliding a foot across tatami; instead of the flow and lines of the adagio, I was learning the graceful centred posture needed to use tea utensils. The deep satisfaction I had felt from a well-executed dance step was there in Tea, but there was also a marked sense of the rightness of the moment, and the rightness of me in that moment. Over the years my Tea studies have been sporadic, but those studies have continued to influence everything I have done.

Why the teabowl?

In the early 1990s I heard Takeshi Yasuda, a Japanese potter living and working in Britain who influenced a generation of British potters, say that the iconic ceramic form for potters in Japan was the *chawan*, and that the iconic form for British potters was the jug. It seemed right to me. However, you are now likely to see more teabowls than jugs at a ceramics fair, even though most people who make or own teabowls know little about the details of the teabowl's use or origins. So why has this ceramic form become ubiquitous? What is it about the *chawan* that so appeals to potters and collectors? What has happened to the teabowl since it has travelled beyond Japan's shores? Has the *chawan* been lost in translation?

Even though the teabowl ranks below the tea caddy in *chanoyu*, it is the teabowl that carries hyperbole as no other ceramic form ever has. On one hand, a teabowl is just a bowl. On the other, it is said to have a transcendent power that can move the spirit. Robert Yellin, a leading spokesman for Japanese ceramics, summarizes it as, 'Simply, some of the hardest works of pottery to create'.[1] Elsewhere he says that an essential part of the creation of a 'true chawan' is the spirit of the potter. 'For without an infusion of the craftsman's deep understanding of himself, and of the mysteries of clay and fire, a tea bowl remains an empty shell.'[2]

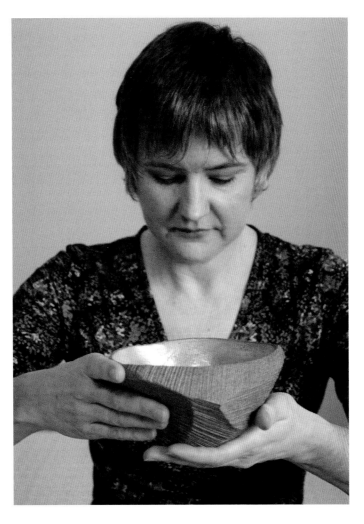

Figure 4: The author at a tea ceremony lesson using *Yuwan*, a bowl made by Hoshino Kayoko. PHOTO BY ADRIAN NEWMAN.

In 'The Cosmos in the Hand', an episode of the documentary series *Japan: Spirit and Form*, the making of a teabowl is referred to as 'the birth of a micro-universe'. The critic and author Katō Shūichi, the series host, reflects in the episode on the red Raku teabowl called *Twilight* (by Chōjirō, *c*.1600s):

> This tea bowl embraces all the characteristics of the psychological passage of human nature. We can feel with our senses that it's a summary of all the emotional ups and downs we experience with the passing of time. I'm growing old too, and approaching the twilight of my life, so for me too this is very meaningful. As I reflect back over my life, I somehow feel that everything, all the things I've experienced over the long years, is represented in this tea bowl. To me, this is a visible symbol of my own universe.[3]

Katō's words reflect the strong user-object relationship in traditional Japan, where precious objects are not permanently displayed as part of an assortment of items, but

rather are shown one at a time, changing with the seasons and the owner's life story. Shintoism, the indigenous religion, has its roots in a kind of animism where objects were often thought to be *kami*, or gods, or to hold the spirits of the gods, influencing how Japanese people interact with the things around them. In the Judeo-Christian cultures, religious and cultural history stress transcendence: man as separate and above the earth, made in the Creator's image, with the commandment to 'fill the earth and subdue it; have dominion over the fish of the sea, over the birds of the air, and over every living thing that moves on the earth' (Gen. 1.28). Even though in both cultures these fundamentalist views have largely died out, our contemporary understandings of ourselves as humans in the world remain powerfully influenced by the echoes of these beliefs.

Some have suggested that the cultural differences manifested in how individuals relate to objects may be partly explained in basic cognitive processes. In a study by Hannah Faye Chua et al. analysing eye movements when looking at photographs of objects set within complex backgrounds, those individuals the researchers classified as Americans tended to stare more fixedly and sooner at the central object than did those in the group classified as 'East Asians', who tended to allow their eyes to move around the photo more.[4] The researchers surmised that North Americans tend to analyse the central objects' attributes and categorize them, where the East Asians tend to spend more time contextualizing the images, and make judgements about them based on relationships and similarities.

Although this kind of small-subject-group research (52 participants) is controversial at best, it is tempting to see it as support for the view that the Japanese relationship with the teabowl may be different from other cultures. In European/American cultures, we tend to see the teabowl alone on its exhibition plinth, an individual object in its own right. But just as there are objects in this culture that are instantly contextualized, for instance, a Rolex watch or a bowler hat, so in Japan the teabowl can never be seen completely divorced from the context of the tea ceremony, with all its cultural and aesthetic loading, even for those who have only the vaguest idea of Tea. This may be one reason why many contemporary Japanese ceramicists will not make teabowls, whereas contemporary ceramicists outside of Japan from all genres will often 'give it a go'.

The teabowl context

Chanoyu, the tea ceremony, grew out of Japan itself, moulding to the Japanese people and the Japanese landscape. Even with all the influences from China, Korea and other countries and cultures, it could not have developed in any other place on earth. Yet, there are universal principles and aesthetics within *chanoyu* that are common to all cultures, and to humanity itself.

The forms of Tea we know today are largely based on the principles of the famous Tea master, Sen no Rikyū, from the sixteenth century, or at least on the lore passed down about him. This is *wabi* Tea, *wabi-cha*, where imperfection can be seen as beautiful, where social class distinctions are softened and challenged and where the importance of the 'here and now' is paramount. Using rustic utensils and materials, Rikyū established a Tea that is intimate and simple, where there is a reason for each choice of utensil and each movement and action, and a greater appreciation of our place in the natural world in which we live. Rikyū and the other Tea masters of the day changed the trajectory of Japanese Tea aesthetics from becoming more and more elaborate to a greater bodily engagement, where the value of objects is not situated only in skill and refinement, but in the relationship between the objects and the individual.

This remains the basis of contemporary *chanoyu*. The lacquered, bamboo, silk and ceramic objects used, the seasonal food and sweets, the quality of the water for the tea, the evocative scent of incense, the soft architectural rhythms of a tearoom or teahouse, the skilful flowing calligraphy of a scroll, the power of a simple flower arrangement, and the taste of tea itself are only some of the components of a Tea gathering, which also involves the discernment needed by the host to bring these elements together, called *toriawase*, and the well-ordered, spare and graceful movements of the host and guests (see figure 5).

Chanoyu is an art of participation, not an art of distanced observation, an art that engages the whole body: vision, through the beauty of the setting; touch, in the feel of the *chawan* in the hands and the tactile sense of the tatami underneath the legs; hearing, in the soft hiss of the water simmering in the kettle and the solidity of the sound of bamboo tapped against ceramic; smell, through the fragrant tea and incense; and taste, in the delicately sweet *okashi* biscuit, followed by the slight bitterness of the tea.

A Tea gathering is all these things and more. As Samuel Lurie and Beatrice Chang state in their book *Fired with Passion: Contemporary Japanese Ceramics*, 'It is not easy to understand the power of complex, simultaneous tactile, visual and taste sensations, primitive sensory stimuli complicated by intimate, perhaps novel, personal relationships within the special conditions of the tea room. All these factors somehow combine and interact to produce the spiritual and other higher experiences of the tea ceremony.'[5]

Tea is the thoughtful and considered creation of a unique event, shared between the host and the guests – an experience, a way of being – not a thing. A favourite Tea expression is *ichigo ichie*, meaning 'one time, one meeting'. Tea is an art created not just by the host, but by the host and guests together.

In English, the term 'tea ceremony' is a particularly problematic translation of *chanoyu*. Since the diminution of the role of religion in many of our lives, 'ceremony' often implies empty ritual, the performing of repetitious actions or words that fulfil

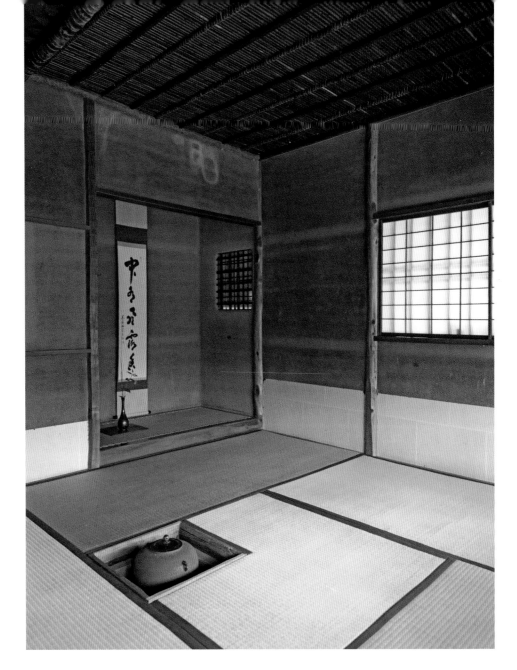

Figure 5: Traditional Japanese tea ceremony room, Daiho-in, Kyoto, Japan. GETTY IMAGES/CREDIT: DAMIEN DOUXCHAMPS.

no role beyond protocol, etiquette or politesse, or a kind of repressive 'grammar' of behaviour – and in truth, *chanoyu* can be all this. However, at its best, *chanoyu* is not the hollow form of a set of rules, but rather *chado*, the Way of Tea. Steeped in the principles of Zen Buddhism, Shinto, Taoism, Confucianism and other philosophical understandings, for those of us who desire it, the experience of *chanoyu* can be transformative, not just pleasant or moving. This is the setting in which we find the teabowl.

Contemporary interpretations outside of Japan

Many contemporary artists have sought ways to capture or recreate the ritual quality of *chanoyu*. Ceramicist Sandy Brown (UK) has used *chanoyu* to inspire her own particular perspective of the rites of tea. About *Ritual: The Still Point* (2005) (figure 6), an installation in which she invited guests to participate, Brown says:

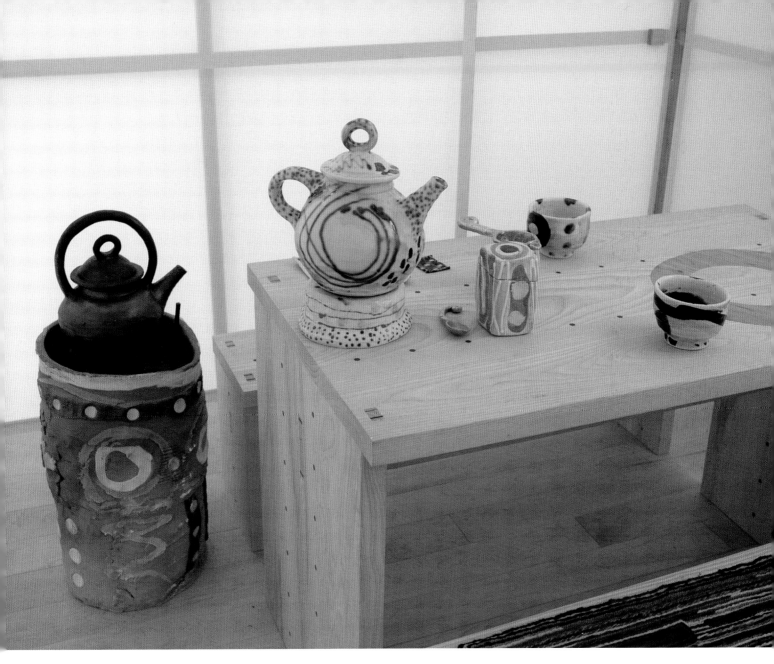

The Still Point tea ceremony expresses my belief that we are lacking Ritual in our culture, particularly ritual which involves contemporary works of art. Before the Reformation, that used to be the repository of the Church, but it was lost in the destruction of art and creativity of that time and we have not fully recovered. When I experienced the Tea Ceremony in Japan I saw how a spiritual ritual can incorporate art. It brings together art and life and integrates the two.[6]

Figure 6: Sandy Brown, *Ritual: The Still Point*, UK, 2005. Tea ceremony room and all utensils made or designed by the artist. PHOTO BY THE ARTIST.

Chanoyu and its heritage are being explored in architecture as well. New tearooms and teahouses are being constructed around the world. One group of architects in the Czech Republic, a1architects, has designed beautiful contemporary versions of the *chashitsu* (tea house), paying attention to the 'insignificant details [that] shape the uniqueness of our life'[7] (figure 7).

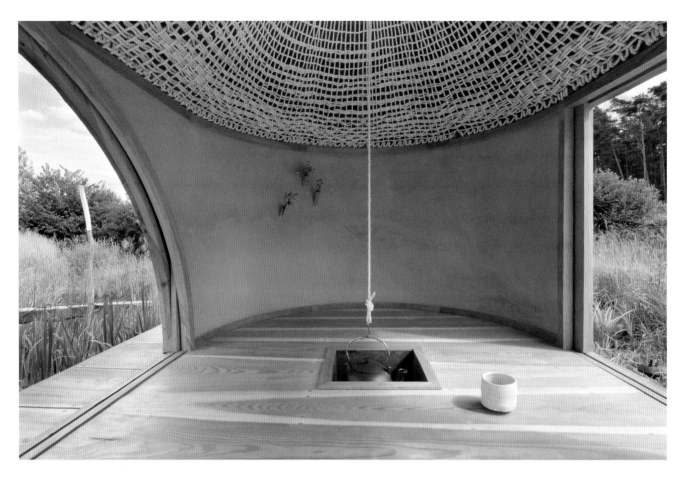

The teabowl, as well, has had the twenty-first-century treatment. Chris Gustin has taken the iconic teabowl form and reproduced it using 3-D printing (figure 9). The *chawan* form has even travelled beyond ceramics. Ed Bing Lee has made a large number of *chawan* using ribbons, raffia, hemp and other knotted fibres (figure 8). In *100 Days*, Tatiana Ginsberg made a paper teabowl each day, and every day she drank from it, allowing the liquid to stain the paper and reshape the form (figure 10). In an interesting link to *chanoyu*, the wet teabowls needed to be held in both hands to remain intact. The date and type of liquid drunk from the bowl are recorded on the bottom of each.

There is room for these explorations within teabowl iconography. The Tea aesthetic is strong, long-lived and fertile. *Chanoyu* can be both an everyday experience and a transcendent one. It can engage the intellect through its long history, discerning aesthetic and refined discipline. It can engage the spirit through the appeal of its four principles: *wa* (harmony), *kei* (respect), *sei* (purity), *jaku* (tranquillity). It can engage our drive for sociability through the communion of host and guests. And it engages all the senses of the body. And because of the teabowl's function and the intimacy of the form, the teabowl can be said to be the embodiment of *chanoyu*. It is the mundane made sublime.

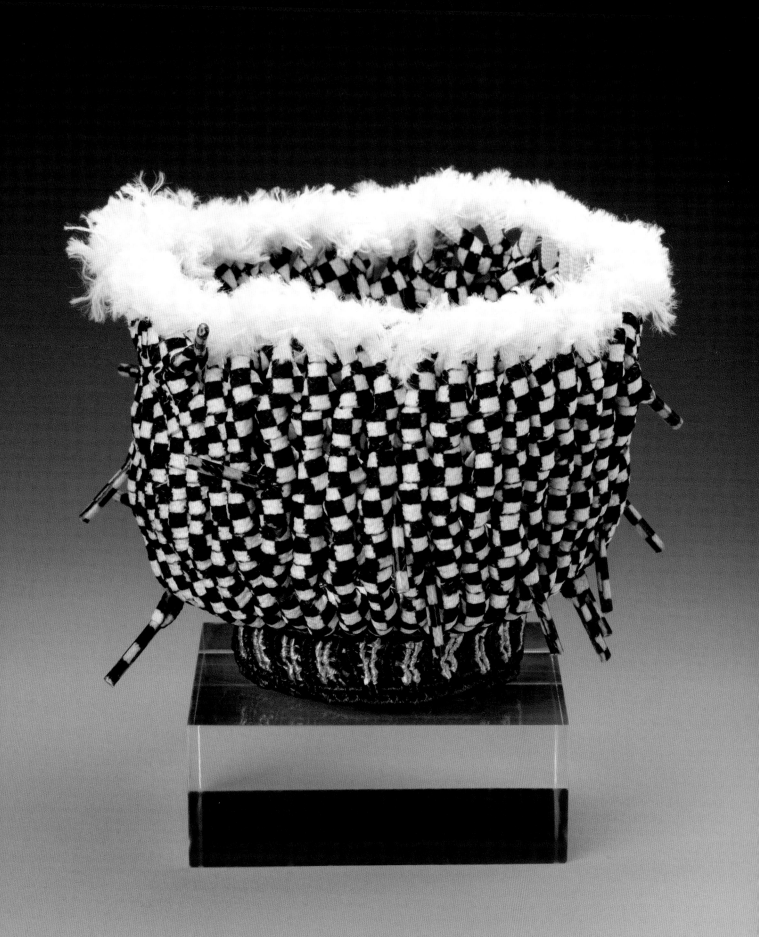

Figure 9: Chris Gustin, *Sound Wave Tea Bowl #1464*, 2014. 3-D rapid prototype printed at Tethon 3D, Omaha NE, stoneware, *anagama* wood fired. 12.7 × 10 cm. PHOTO BY DEAN POWELL PHOTOGRAPHY, LEXINGTON MA.

Figure 10: Tatiana Ginsberg, *September 25*, from the project *100 Days*, 2006. Handmade *kozo* paper, natural dyes, tea. PHOTO BY THE ARTIST.

Defining the teabowl

I could leave the definition of a teabowl as 'a bowl used in *chanoyu* to make tea'. Indeed, a Tea master may choose to use anything he or she wants as a teabowl, and in *chanoyu* we are taught how to handle bowls that are exceptions, such as those that are tall and thin, or wide and shallow, or very large. Much study has gone into the nuances of teabowl shapes and variations. In addition, the traditional teabowl has specific parts to be considered (see figure 11). However, in thinking how best to define the teabowl, I decided the starting point should be through its use, through a *temae*, the procedure used to make and serve tea. Experiencing how the *chawan* is used and handled in Tea practice, placing it in its 'natural habitat', gives a much better understanding of what a teabowl is – and isn't.

The abbreviated description that follows is of a *temae* called *furo hirademae* for *usucha*, or thin tea, as taught in the Urasenke school. The teabowl described is one appropriate for a beginner's use. Other schools have different styles and procedures. *Hirademae* is one of the first *temae* a student learns at Urasenke (see figure 12). Used in the warmer months of the year, *furo hirademae* is part of a full Tea gathering (*chaji*), which can last up to four hours.

At this point in the *chaji* the guest is seated in the tearoom. The host has brought in the fresh-water container, the lacquered tea caddy and the teabowl. Inside the teabowl

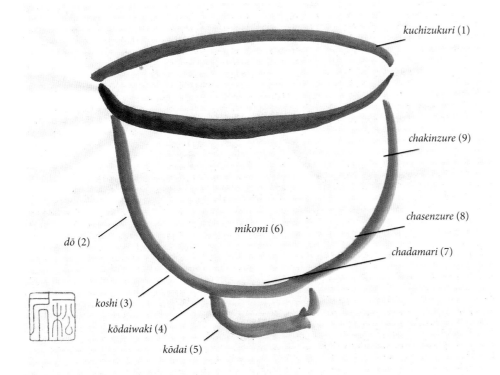

Figure 11: Parts of a *chawan*. Original brushwork by Peter Sōrin Cavaciuti.

1 *kuchizukuri* (rim).

Outside:

2 *dō* (body).

3 *koshi* (hip).

4 *kōdaiwaki* (base outside foot ring).

5 *kōdai* (foot).

Inside:

6 *mikomi* (view looking in).

7 *chadamari* (tea pool).

8 *chasenzure* (where the chasen whisks).

9 *chakinzure* (where the chakin wipes).

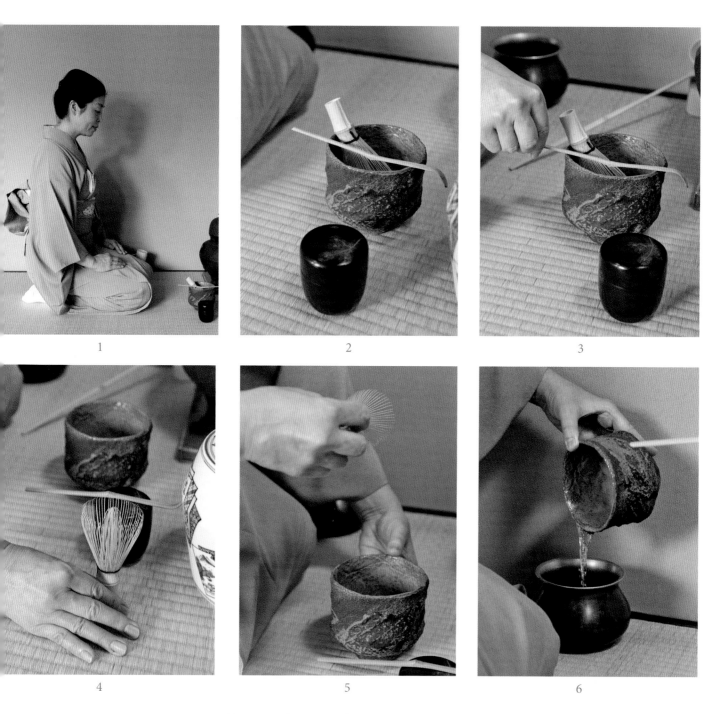

Figure 12: Making Tea. Tea host: Michi Warren. Teabowl: *Blue Wave* by Marcio Mattos. PHOTOS BY IAN OLSSON.

1 The host takes a centring breath.
2 Arrangement of teabowl and *natsume* (tea caddy) at the start.
3 Lifting the *chashaku* (tea scoop) from the teabowl.
4 Placing the *chasen* (whisk) onto the tatami.
5 Inspecting the *chasen*'s fine tines.
6 Emptying the water used to rinse the teabowl.

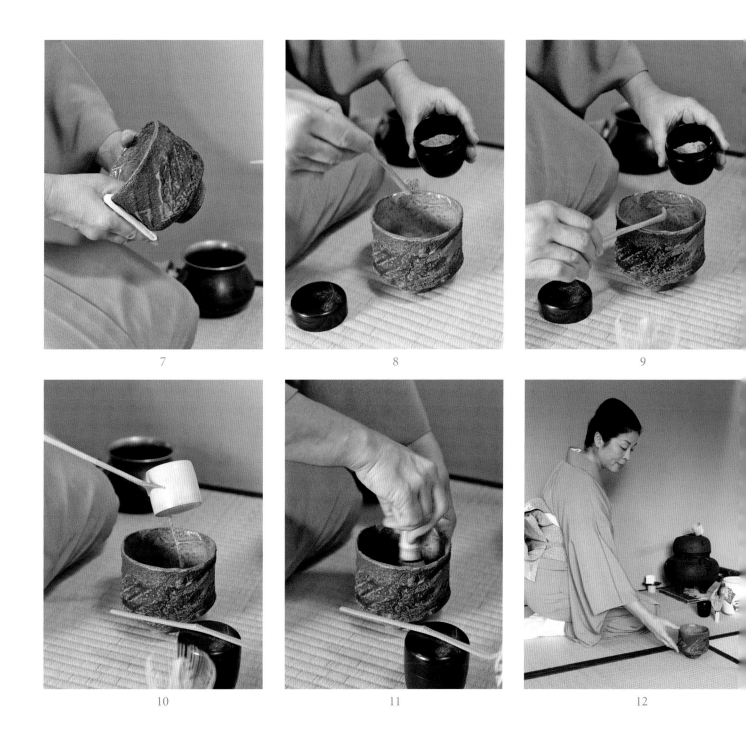

7 Wiping the teabowl with the *chakin* (linen cloth).
8 Scooping the tea from the *natsume* and putting it into the teabowl.
9 Tapping the *chashaku* (tea scoop) on the teabowl rim.
10 Pouring water onto the tea.
11 Whisking the tea.
12 Placing the teabowl out for the guest.

is a dampened linen cloth, folded and resting against the far inner side, with a bamboo tea whisk propped against it. A tea scoop rests across the rim.

The host then brings in the container for water that has been used in rinsing the utensils, which has a bamboo water ladle across it and a stand on which to place the ladle. She sits and places these in their predetermined positions to her left on the tatami. Having settled into her place, the host pauses and takes a breath, then releases it. This is a gathering moment, a moment for both host and guests to let go of everything except the making of the tea.

After opening the kettle lid, the host lifts the teabowl with her right hand by placing her fingers under the bowl and her thumb on the rim. She transfers it into her left, then repositions her right hand at its side and sets it down in front of herself. *The teabowl should be shaped so the fingers fit underneath the hip (often with a foot ring to provide this space), and should not be higher than can be held within the span of the hand.* She moves the tea caddy to a position in front of the teabowl.

The host wipes the tea caddy and tea scoop using a folded silk cloth and repositions it on the tatami. Then, using her right hand, the host moves the *chawan* closer to her body on the mat. She ladles hot water from the kettle and pours it into the *chawan*. She inspects the fine bamboo tines of the whisk by lifting the whisk out of the water and turning it, each time placing the handle back against the rim of the teabowl. The whisk often makes a slight sound as it is placed on the rim; *this sound is part of the*

Glossary for *chanoyu* and *chawan*

cha	tea		*futaoki*	stand for ladle and brazier lid
chadamari	inside the bottom of the teabowl where the		*haiken*	looking at the tea utensils
	remains of the tea pools		*hishaku*	bamboo water ladle
chado	the Way of Tea		*kaiseki*	light meal as part of Tea gathering
chaji	full-length Tea gathering		*kensui*	waste-water container
chakai	a less formal Tea gathering than chaji		*keshiki*	landscape glaze quality of a teabowl
chakin	linen cloth used to wipe teabowl		*koicha*	thick tea
chanoyu	literally 'water for tea', the art of the		*mizusashi*	fresh-water container
	tea ceremony		*mizuya*	preparation room
chasen	bamboo whisk		*natsume*	tea caddy, usually lacquered
chashaku	tea scoop		*ro*	sunken hearth for cooler months
chashitsu	tea house or tea room		*shomen*	front of a teabowl
chawan	teabowl		*temae*	procedure for serving tea
furo	portable brazier for warmer months		*usucha*	thin tea

teabowl aesthetic and is determined by the quality of the clay, the making, and how it has been fired. The whisk is then swished lightly through the water before the host inscribes a spiral and lifts it from the bowl.

The host then pours the water into the waste-water container, her fingers holding it under the foot ring or the very bottom of the teabowl. The linen cloth is placed into the teabowl, and the host unfolds and drapes it over its rim. She carefully wipes both the inner and outer sides of the bowl by holding the cloth over the rim and running it smoothly around the teabowl sides three and a half times before drawing it out. *If the teabowl is too rough or too irregularly shaped, this can be difficult.*

Two scoops of matcha (powdered green tea) are placed in the bottom of the bowl. After the last scoop the tea scoop is lightly and deliberately tapped against the rim of the teabowl. *This quiet but audible 'thunk', again determined by the quality of the clay and firing of the teabowl, is desirable and part of the aesthetic soundscape of Tea.* Half a ladleful of hot, but not boiling, water is poured onto the tea in the teabowl.

The tea is rapidly whisked until there is a slight froth on top, the left hand holding the bowl securely on the tatami. *The inside of the teabowl should not be so irregular or rough that the fine tines of the whisk break, leaving tiny pieces of bamboo in the tea, and it should be wide enough that the whisk doesn't hit the upper sides as it whisks. The teabowl's sides and bottom should join smoothly enough that the powdered tea doesn't get trapped.* A teabowl used in *ro* season (winter) may have steep high sides to keep in the heat, whereas a *furo* (summer) teabowl may be shallow and open. The fourth of the sixteenth-century Tea master Sen no Rikyū's rules is, 'Provide a sense of coolness in the summer and warmth in the winter.'

After thoroughly whisking the tea, the host replaces the whisk on the tatami. She then lifts the teabowl and turns the front towards the guest before placing it onto the tatami. The guest takes the teabowl back to his position in the tearoom and places it on the tatami in front of him. *The teabowl must be able to sit securely on tatami.*

After a formal thank you to the host, the guest lifts the teabowl, again with fingers underneath and thumb on the rim, then places it on his left palm, readjusting his right hand so his palm and fingers make full contact with the teabowl's right side with his thumb wrapped towards the front. He lifts it slightly and bows to the host, a silent acknowledgement. Then using his right hand, he turns the teabowl two quarter turns. This is to turn the front away so he can drink from the opposite side. *If the teabowl is too heavy, it will be uncomfortable for the guest to lift. If it is too light, it will feel insubstantial and may transmit the heat of the tea too quickly. Its weight should feel evenly distributed.*

The guest drinks the tea in three sips, keeping the teabowl angled and fairly close to the face between sips so the thickish tea can pool and flow. *The rim needs to be smooth enough to feel comfortable on the lips. A glazed rim is usually more comfortable than an unglazed one.* After the final sip the guest wipes the rim where he has been drinking with his finger and thumb.

The guest turns the teabowl back so the front is facing him, places it down and briefly bows. He then looks closely at the teabowl. This is called *haiken*. It is the time when the guest can truly appreciate all aspects of the teabowl. It may be the only time the guest ever sees this particular *chawan*. With his hands in the bow position on the mat, the guest considers the teabowl's overall shape (including the rim, especially if it is irregular), colour, style and decoration, and the corresponding quality called *keshiki*, or 'landscape', which is an appreciation of the subtle characteristics of the glaze. Distinctive qualities have names such as sesame seed (*goma*), a stone erupting (*ishihaze*), and scorch marks (*koge*). The guest will also look to see how the remaining tea or froth has pooled in the bottom, called the *chadamari*. Potters are mindful of the *chadamari*, sometimes creating a slight indentation in the bottom. This is a subtle, rather than an obvious feature. After a general look, the guest can lean forward and, keeping his elbows on his knees, lift the teabowl. He may turn it over to look at the bottom, which is an integral part of its aesthetic. The guest may see the potter's stamp,

A list of teabowl attributes derived from the tea ceremony

- A *chawan*, or teabowl, is a handleless bowl. The dimensions vary, but are most commonly about twelve or thirteen centimetres across and nine or ten centimetres in height.
- It should be shaped so the fingers can lift it from underneath, and be shallow enough that the thumb reaches the rim. This may mean the inclusion of a foot ring.
- It should stand securely on tatami without wobbling.
- It should be heavy enough to feel substantial, but light enough to not be cumbersome, usually about 300–500 grams, depending on the type of teabowl.
- The teabowl should fit snugly and pleasurably in the hands, with the left hand holding it underneath and the right hand wrapped around the side.
- The rim should feel pleasing and engaging to the lips.
- The clay and firing qualities should be such that the bamboo implements tapped on its rim produce a mellow and satisfying sound.
- The inside and outside of the teabowl should be smooth enough for a damp linen cloth to be run over the surfaces.
- The inside bottom should be smooth enough that it does not damage the fine bamboo tines of the whisk. The bottom can be subtly shaped to create a reservoir for any tea and froth remaining after the guest has drunk.
- The potter's mark can be inside the foot ring or on the underside of the bowl, often on the left, but ultimately it is up to the host to determine the front of the teabowl.

but even with no mark, a signature foot ring might tell the guest who the potter is. The potter's mark may be to the left and under the hip of the teabowl or it may be within the foot ring. If the bottom is unglazed, the exposed area may reveal the clay's origin and how the bowl was fired. If there is one, the guest will consider the quality of the edge of the glazing.

Placing the teabowl back onto the tatami, the guest bows briefly before returning it to the host. After the guest has indicated that he has had enough tea, the host finishes the *temae*, cleaning the teabowl and other utensils and carrying them out of the tearoom.

Figure 13: Sonia Lewis and Peter Sōrin Cavaciuti, *Fujihana*, bowl by Lewis, decoration by Cavaciuti, 2015. Western raku fired, 10.5 × 7 cm. PHOTO BY IAN OLSSON.

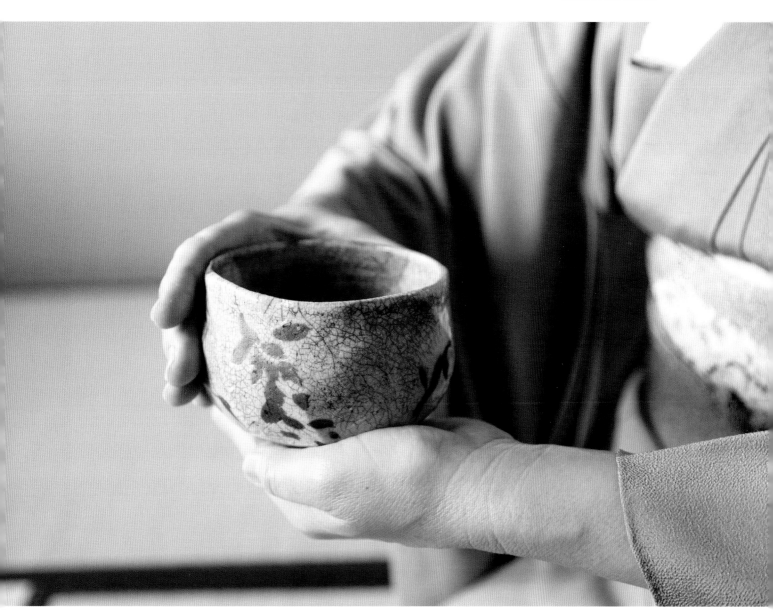

神農炎帝

Tea and the tea ceremony

Tea and tea drinking

The story of the teabowl is, of course, embedded in the story of tea itself. There are many teas, many ways to prepare it and many vessels and utensils used in those preparations. These differ from culture to culture and have undergone changes throughout history. The iconic Japanese teabowl is most closely linked to tea and tea preparation from the sixteenth century.

Roughly 10,000 years ago, when humans came together and began to form cities, waterborne diseases began to arise as water supplies became contaminated by sewage and waste. Water became a dangerous drink and alternative beverages developed around the world. In northern and eastern Europe and the Middle East people have been making beer as a substitute for water since ancient times, as the antiseptic attributes of alcohol and the acidity of beer kill many of the harmful bacteria found in contaminated water.[8] In the medieval era 'small beer', with its low alcohol content, was drunk throughout the day by all members of society, including women and children. In areas of southern Europe where grapes could be easily grown, wine, made with a fermentation process that also kills pathogens, became the prevailing drink.

Alcohol was also part of Asian cultures. However, it is thought that in Asia water was boiled before drinking, making it safer. The discovery that a pleasant drink could be made by adding the leaves of the tea plant *Camellia sinensis* (figure 15) to boiling water led to a long history of tea as medicine, a focus for aesthetics and other expressions of cultural taste, a marker of social status, a way of nurturing community and an element in ritual practices. Today tea has become second only to water as the most widely consumed beverage in the world. Tea's overshadowing of alcohol in some parts of Asia as a day-to-day drink may perhaps be partly due to a genetic ALDH2 deficiency, which affects about fifty per cent of the population in those areas. In this condition there is a lack or deficiency in the enzymes needed to break down the toxins in alcohol, causing unpleasant physical side effects when alcohol is consumed.

Although there are various claims for the discovery of tea, most agree that *Camellia sinensis* originated in the southern Himalayas. It is thought that the tea leaf was at first chewed, probably for taste and perhaps for its caffeine content, and it is still chewed in some parts of the world. Chinese origin myth holds that the first infused tea was discovered around 2700 BCE by Shennong (figure 14), the second Chinese emperor

(opposite) Figure 14: Chen Jiamo (woodcut by Gan Bozong), *Shen Nong*, legendary discoverer of tea, Tang period (618–907). THE WELLCOME LIBRARY, LONDON HTTP:// WELLCOMEIMAGES.ORG/ IMAGE NO. L0039313.

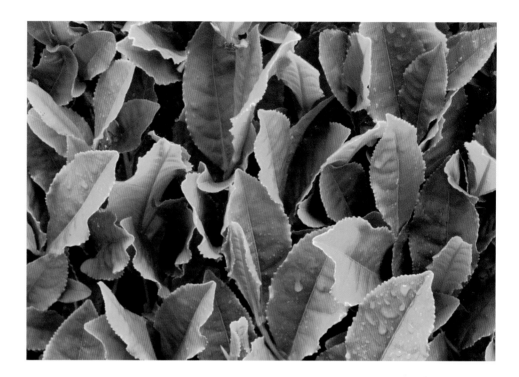

Figure 15: Tea plant *Camellia sinensis*. Close-up of green tea leaves growing on the Makinohara tea plantation in Shizuoka, Japan. GETTY IMAGES/CREDIT: PHOTO JAPAN/ROBERTHARDING.

and an herbalist, who seems to have been a fairly unobservant man since he drank a cup of boiled water without noticing that a stray tea leaf had blown into it.

For centuries following its discovery tea was used medicinally and as a ritual offering. From early on, monks drank it to help them stay awake during the long gruelling hours of meditation. A later myth links the monk Bodhidharma of the fifth or sixth century to tea being used as a stimulant. Being turned away from the Shaolin monastery, he went into a cave to meditate. After seven years of continuous meditation he fell asleep and was so angry with himself that he cut off his eyelids. As they fell to the ground they become tea plants. Bodhidharma (called Daruma in Japanese; figure 16) is also credited with bringing into China a form of Buddhism called Chan, which in its Japanese form, Zen, became an elemental influence in the development of *chanoyu*.

Tea drinking was well established in China by the Tang dynasty (618–907 CE), having spread with Chan Buddhism from southern to northern China. Lu Yü is the person most revered in the Tang dynasty for promoting tea drinking. His treatise, the *Chajing*, or *The Classic of Tea*, was compiled around 758–760 CE and contains instructions about the processing and preparation of tea. Lu Yü, who was a scholar, is said to have been an unattractive man who was garrulous despite a speech impediment. The *Chajing*, which is very specific in its guidance, clearly shows that he was single-minded and forthright in his opinions. A man of his times, Lu Yü believed that 'discrimination between good and bad tea is a matter for secret oral transmission.'[9] This approach to tea, and how the processing and preparing of tea

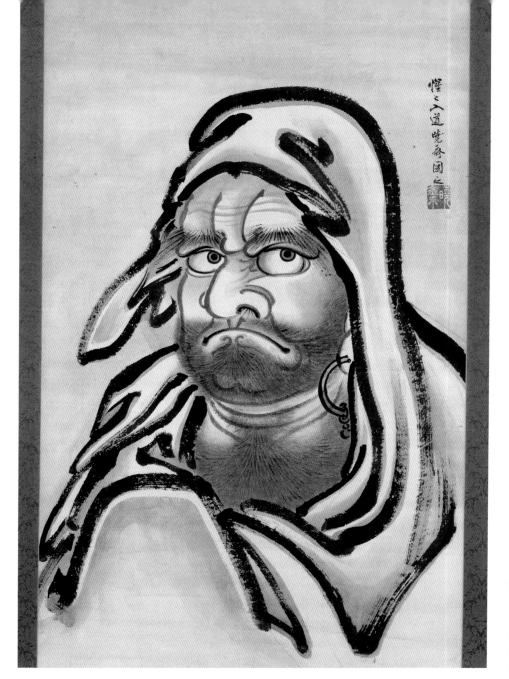

Figure 16: Kawanabe Kyōsai (1831–1889), *Daruma*. Ink on paper, 139.7 × 89 cm. IMAGE COURTESY OF THE INDIANAPOLIS MUSEUM OF ART, MR AND MRS RICHARD CRANE FUND, 2000.39, IMAMUSEUM.ORG.

should be taught, echoes down through the generations to today, where the teachings of the tea ceremony schools in Japan remain hierarchical; students must master one level of knowledge before being allowed to be taught the next. As easy as it would be to read into Lu Yü's *Chajing* an early form of the later spiritual art form of *chanoyu*, Sen Genshitsu (Sōshitsu XV), Grand Master of the Urasenke school from 1964 to 2002, sees Lu Yü's understanding of tea first and foremost as a medicine or stimulant. The rules he sets out, the poetic approach he uses, Sen implies, are part of the 'sacerdotal gravity' of priesthood.[10]

Lu Yü was so admired in China that he was called the 'god of tea',[11] with porcelain statues made of him and distributed among Tea practitioners (*chajin*). Later in Japan, Tea practitioners also revered Lu Yü, as his methodical approach to preparing tea resonated with Japanese tea culture.

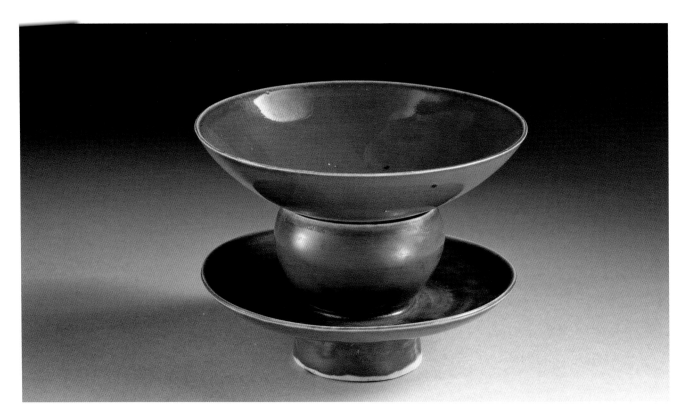

Figure 17: Chinese bowl with stand, China, 11th century. Stoneware, brown-glazed Ding ware. GIVEN BY MR AUBREY LE BLOND. ©VICTORIA AND ALBERT MUSEUM, LONDON.

Tea of the time was not as we know it today. Well into the Tang dynasty other flavourings such as garlic, rice, salt, orange peel and mint were boiled with tea to make a kind of gruel, or alternately, the flavourings were roasted, boiled with the tea, then strained and discarded and the scum skimmed off before the tea was served. These teas were prepared in one vessel, then ladled into others, so the teabowls used to drink the tea did not also have to be appropriate for its preparation. In the *Chajing* Lu Yü declares, 'Drinks like that are no more than the swill of gutters and ditches; still, alas, it is a common practice to make tea that way.'[12] Lu Yü appreciated tea's pure taste. He goes on to describe the stages from the growing and picking to the processing and preparation of several different types of tea, but the one most pertinent to the later development of the teabowl was a powdered tea, which was whisked. Lu Yü had strong opinions about the bowls used to serve tea as well (see figure 17). He felt that white was not a good colour for teabowls, and preferred Yuezhou greenish wares (celadons). There was no distinct ceremony as such at this time, but Lu Yü's meticulous instructions for tea no doubt felt familiar to the monks, who were already inclined towards ritual and discipline.

In the Song dynasty (960–1279) tea was so essential that it was listed in the travel memoir *Dongjing menghua lu* (usually translated as *The Eastern Capital: A Dream of Splendor*) as one of the 'seven necessities of daily life', along with firewood, rice, oil, salt, soy sauce and vinegar. A powdered tea similar to the tea later used in Japanese

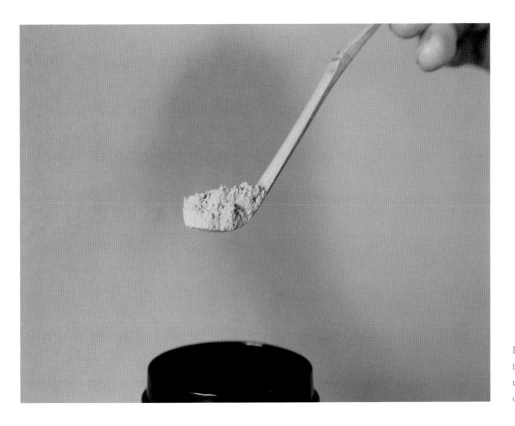

Figure 18: Matcha (green powdered tea) being drawn from a *natsume* using a *chashaku*. PHOTO BY IAN OLSSON.

tea ceremony, called matcha, became popular. The tea plants used for this are grown in shade, and the leaves come from the top of the earliest crop, where the new growth is the most tender and softest. The leaves are picked, laid out flat to dry, then de-veined and de-stemmed before being stoneground. The resulting tea is a vibrant green powder with the consistency of talc (figure 18). After sieving, the tea powder is whisked with hot water directly in the teabowl, resulting in a slightly bitter mixture. In this preparation, the entire tea leaf is consumed, rather than infused or steeped, as it is in the ubiquitous black teas that have been drunk in the West for several centuries, or the green teas drunk every day in many parts of Asia. Powdered tea fell out of favour in China after this period, and in the beginning of the Ming Dynasty (1368–1644) the Emperor Zhu Yuanzhang banned the production of tea bricks, including those made from powdered tea, allowing only loose tea leaves to be sold. This action contributed to the development of the Chinese teapot used for steeped tea.[13] We don't know if this ban was due to the emperor's personal preference or if his decision had political and economic reasons behind it – the Chinese court had a monopoly on tea trade. Powdered tea was not popular again in China until the present day, when matcha grown and processed in Japan became fashionable internationally.

An important factor in the spreading of a more formalized style of tea drinking was the monasteries. Tea was often grown in the mountains, and the Chinese monasteries had perfect growing conditions for it. In addition, tea was being promoted as a

substitute for alcohol, the consumption of which was banned within Buddhist faiths, although its prohibition was not always adhered to. In the Song dynasty the monasteries became major producers of tea as well as places for tea appreciation, which allowed interaction between monks and literati of the time.[14] Chan Buddhism, which arrived in China in the sixth century, emphasizes a direct and embodied spiritual experience, rather than an intellectual approach to enlightenment. This 'of the moment' approach to life would greatly influence tea ceremony. Monks from Japan had been travelling to China for some time, and in the Song dynasty they were exposed to Chan Buddhism. Taking their personal experience and knowledge of Chan back to Japan with them, along with tea and Lu Yü's *Chajing*, Chan Buddhism, as Zen Buddhism in Japan, laid the foundations for the development of *chanoyu*.

Tea in Japan

Tea is thought to have grown wild in Japan in early times, but was not widely used. Later, it was brought from China by monks as early as the Nara period (710–784 CE). Throughout the later Heian era (794–1185) tea was made using the principles and instructions laid down by Lu Yü in the *Chajing*, but the practice was not thought to have extended beyond the Japanese emperor's court and the monasteries. Early in the Kamakura era (1185–1333), a priest by the name of Myōan Eisai (also known as Yōsai), like many others, went to study Buddhism in China. Other monks were known to have brought back tea and teabowls from China, but when Eisai returned in 1191 he also brought back tea seeds to propagate in Japan. Eisai established a temple in Kyushu for Rinzai Zen Buddhism, and promoted both Zen and tea, serving tea at inns, even to social outcasts. One story is that Eisai met a shepherd in his travels to whom he offered tea, saying it would help him stay awake and calm his passions. The shepherd replied that he worked hard and needed his sleep, and since he had nothing else, passion was his only pleasure, so he refused the tea. Although it's a lovely story, this tale may be a fabrication that arose later, perhaps when tea was seen as a privilege of the upper and merchant classes.[15]

Eisai advocated tea's use in ways that were similar to Lu Yü's, and along with tea seeds he carried back to Japan the knowledge of the preparation of matcha, the powdered tea of the Song dynasty. Matcha is the type of tea used in *chanoyu* to this day. Although both matcha and *tencha*, which was the precursor of the steeped green tea now known as *sencha*, were known in Japan before Eisai's return in 1191, Eisai can be safely said to have successfully promoted the drinking of matcha in Japan.

At this time Japan was looking outward to China, emulating its cultural institutions as well as its religions and language. In 1211 Eisai wrote the first Japanese book on tea called *Treatise on Drinking Tea for Health*, or *Kissa yōjōki*.[16] Like Lu Yü, Eisai's approach to tea was practical, and he promoted tea for its medicinal value, but the

monks living a contemplative life seemed to find sincere pleasure in tea as well. The following poem, which was included in the *Keikokushū*, a collection of Chinese-style verse written by Japanese poets, demonstrates this:

> Temple in the mountain fastness,
> The High Priest will not return to the secular.
> Flourishing his staff sounding his priestly bells, he goes.
> With plain surplice he sits in peace.
> In the cold, snow still clings to the bamboo leaves;
> Spring herbs sprout in the ancient mountains.
> Talking together, we dip the beautiful green tea,
> While smoke and fire arise amid the evening snow.[17]

The drinking of tea spread from the monasteries to the aristocracy and then to the rising warrior class. Tea had a specific purpose in the monasteries, to aid meditation, but in the wider cultural realms of the upper classes, tea drinking developed into a form of lavish entertainment, devoid of the spiritual underpinning of the Zen monasteries. The academic Takahashi Tatsuo drew the conclusion that this was where the division arose between drinking matcha (in the monasteries), which became *chanoyu*, and drinking infused tea (among the aristocracy), which led to steeped tea, or *sencha*, becoming an everyday beverage.[18]

Roots of *chanoyu*

Dōgen, a monk of the Soto sect, travelled to China in 1223 after visiting Eisai at Kenninji. Dōgen's Zen approach stressed the discipline of *zazen* (meditation) to reach enlightenment. In his book *Eihei Shingi*, Dōgen refers to tea in ceremonial terms as a regular feature of life in a Zen monastery. He applies the same discipline that he emphasizes for *zazen* to the serving of tea. The following excerpt demonstrates this:

> First, the individual responsible for tea will strike the sounding board before the monks' quarters. When he does, the assembly will place their hands palms together, bow once in thanks, and take their seats. The one who is to prepare the tea will proceed to the center brazier and light incense. There should not be more than nine people assembled at this time. When the small sounding board inside the monks' quarters is struck, there will be a bow and the tea bowls, distributed. Thereupon, the server will move around the room preparing the tea. The assembly will then raise their bowls in presentation and drink the tea.[19]

This attention to detail closely mirrors the rules of *chanoyu*.

As tea drinking spread to the samurai and common classes, tea tournaments became popular. In China tea contests consisted of guests evaluating the preparation and qualities of various teas. In Japan such contests (*tōcha*), involved guessing the provenance of the different teas, which led to a competitive party atmosphere with great emphasis placed on lavishness and ostentation.

Development of *chanoyu*

Up until this time Japan had been absorbing many things from Chinese culture intact, including the serving of tea, but Japan in the Muromachi era (1336–1573) was a very different place from China; indeed, it was a very different place from Eisai's Japan. It was a turbulent and violent time, when strength and might were what determined success, not necessarily family or class affiliations. The samurai, or warrior class, gained power through their individual political and military skills. The powerful influence of the samurai leaders soon extended into cultural life, and many followed the ways of the nascent *chanoyu*. However, the tea style they practised was one that displayed their newfound wealth and prestige. 'The ideal, spiritual style of life in which one gazed dreamily into a bowl of tea to perceive dimly some poetic emotion was hardly a part of their existence.'[20] In addition, since the spread of its cultivation in Japan, tea was no longer such an exclusive, imported commodity, and with lowering prices, it lost much of its rarity value. Nōami (1397–1471), a painter, poet and critic, is credited with creating an early tea culture that embraced both the poetic and spiritual qualities of the monasteries and that of the more flamboyant style of the samurai.

In the fifteenth century the serving of tea had begun to be formalized into an art form with established, systematic rules and aesthetics, recognizable as *chanoyu* today. Formal classification of tea utensils also began at this time. An early priest who promoted the developing tea ceremony, Ikkyū Sōjun (1394–1481; figure 19), was by all accounts (many no doubt apocryphal) eccentric and iconoclastic. Although he was an influential figure in the development of *chanoyu*, his effervescent personality and cheeky approach to life sometimes seem to overshadow his contribution. Thought to be the illegitimate son of the emperor and a lady of the court, he was placed in a Rinzai Zen temple at a very young age. A delightfully impish fellow, on one occasion he mishandled his master's favourite teabowl and broke it. He hid the bowl away and when the master entered the tearoom he innocently asked, 'Why do people die?' The master explained that everything had to die, after which Ikkyū showed him the pieces of his favourite teabowl, saying, 'It was time for your bowl to die.'[21] Ikkyū was known to drink too much and indulge in excessive sexual activities frowned upon by the monastery; he felt they were all part of a Zen life. In one rather tame poem attributed to him, he writes, 'The autumn breeze of a single night of love is better than a hundred thousand years of sterile sitting meditation.'[22] In his tea practice Ikkyū stressed the

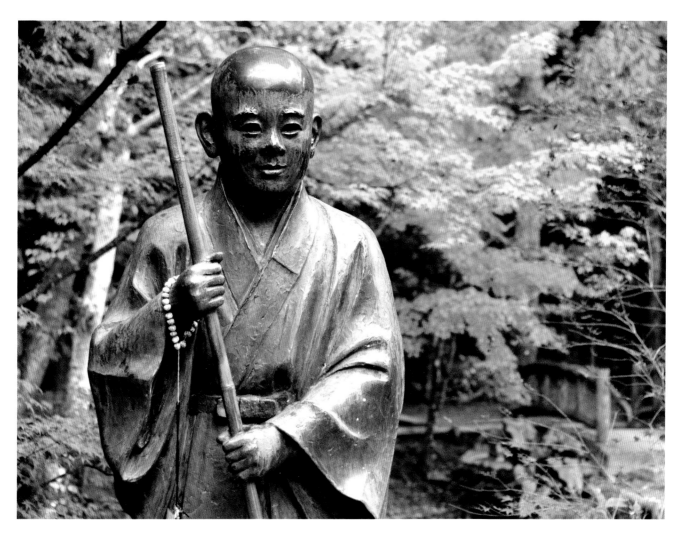

Figure 19: Statue of Buddhist monk Ikkyū Sōjun at Shuon-An Ikkyuji Temple, Kyoto, Japan. GETTY IMAGES/ CREDIT: THE ASAHI SHIMBUN.

communion of guests and host, placing more emphasis on the here and now than on a set of rules. Ikkyū also challenged the popular use of expensive tea utensils, sometimes using rustic everyday objects. Perhaps because he was so unconventional, at the time this did not affect the tea world as greatly as one might expect. However, other famous Tea masters, such as Sen no Rikyū, who is closely linked to tea ceremony as we know it today, continued the practice. Because of Rikyū's gravitas and the respect in which he was held, the practice of using rustic objects blossomed into what was to become *wabi-cha*, one of the most important principles of tea ceremony and tea ceremony ceramics.

Murata Jukō (also known as Shukō) (1423–1502) was an associate of Ikkyū. Jukō's tea style also embraced the simple and unpretentious, but Jukō was more serious in his approach to tea. When called upon by Shogun Yoshimasa Ashikaga to explain tea, Jukō said, 'Tea is not play; it is not technique; it is not entertainment.'[23] One cannot imagine the impetuous and irrepressible Ikkyū saying such a thing. Eschewing the grandness of earlier tea styles, Jukō created the four-and-a-half-mat tearoom, which remains the

standard tearoom size. Tatami are made to standard sizes depending on the region in which they are produced, and they are usually about one metre by two metres. Jukō was known for his *sōan-cha*, or thatched hut tea, which greatly contrasted the aggressive lavishness and formalism of the court. The thatched huts of those who practised *sōan-cha* offered a quiet and centring experience of tea. Jukō was the first prominent Tea master to promote *chanoyu* through the Zen precepts of modesty, respect, purity and tranquillity. One change he initiated was his insistence that the host, rather than an assistant, make the tea for his guests. *Chanoyu* was becoming a source of calm in this tumultuous time and providing a spiritual focus for people of all classes.

Next in the line of influential Tea masters of the Muromachi era was Takeno Jō-ō (1504–1555). Jō-ō was from the merchant class of Sakai, a prosperous trading centre near Osaka. He was a Zen priest and poet in the *renga* form, which was the precursor to *haiku*. Jō-ō is said to be the first Tea master to link tea and the all-important concept of *wabi*.[24] Jō-ō also dispensed with the *daisu*, or stand, used to display the utensils, placing the teabowls directly on the tatami mat. This meant that less refined teabowls could be used. Although archaeological evidence suggests that inexpensive Korean rice bowls and other 'found objects' had been used in *chanoyu* for a century before,[25] Jō-ō popularized their use.

Sen no Rikyū

It is Sen no Rikyū (1522–1591; figure 20) with whom we associate most closely the concept of *wabi*, *chanoyu* and the iconic teabowl. The changes that Rikyū brought into effect, the strength of his following and the establishment of the San Senke (three houses or schools of Sen: Omotesenke, Mushakōjisenke and Urasenke) by his descendants were undoubtedly ingredients in the mix that led to *chanoyu* becoming an art form that quintessentially embodies the Japanese spirit, even today.

Like Jō-ō, Rikyū was born in Sakai in the merchant class, and indeed he studied *chado* with Jō-ō. Rikyū also trained in Rinzai Zen Buddhism at Daitokuji temple in Kyoto. In personality it seems that Rikyū could not have been more different from his Tea forebear, Ikkyū, the eccentric priest, yet both were known to challenge the status quo, to innovate and to have developed an individual and independent approach to *chanoyu*.

Rikyū was one of the most important cultural figures of his age, and he was Tea master to two of the most powerful warlords, Oda Nobunaga and Toyotomi Hideyoshi, for whom he also served as a political aide. Rikyū was known as *Tenka-ichi Sosho* (World's Foremost Teacher) and was Hideyoshi's teacher. Their partnership contributed greatly to the acquisition of many fine *chanoyu* utensils, and Hideyoshi's support and patronage of Rikyū allowed Rikyū to develop his distinctive style of *wabi-cha*. Rikyū was, however, not a simple man to understand. It is evident that

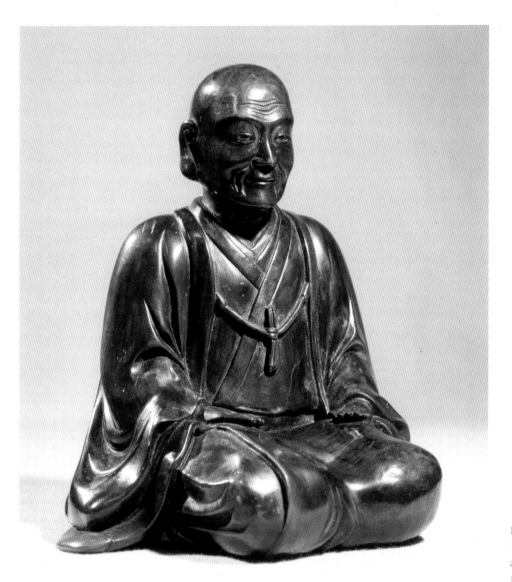

even with his natural proclivities towards the simple, the natural and the unadorned, Rikyū sometimes wholeheartedly supported Hideyoshi's flamboyance. For instance, Rikyū was integral to the planning and execution of the Great Kitano Tea Ceremony in 1587, which comprised hundreds of guests. At this massive event Hideyoshi displayed his own vast collection of fine tea utensils, and others were encouraged to do the same. Another instance of the conflicting ideals of Hideyoshi and Rikyū was in Hideyoshi's commissioning and use of a portable golden tea room (figure 21), where other than the linen cloth, bamboo whisk and wooden ladle, everything, including the walls, floors and tables, were made of gold or covered in gold leaf.[26] However, Hideyoshi obviously also respected and practised Rikyū's more austere form of *chanoyu* on many occasions.

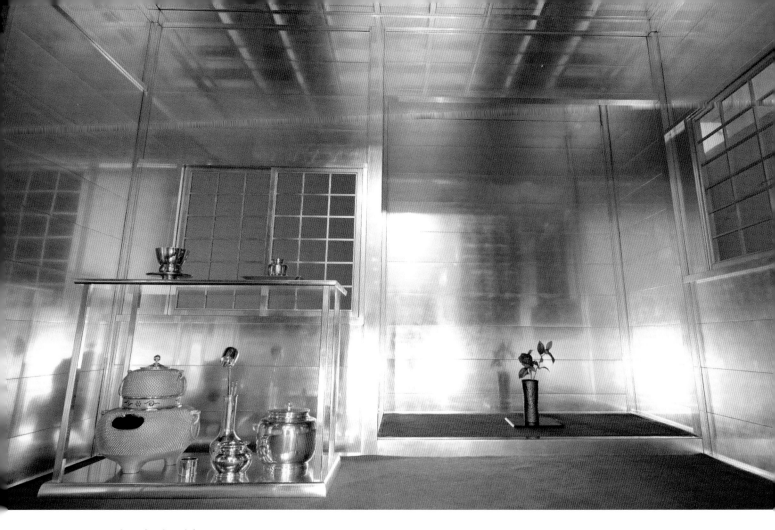

Figure 21: Replica of Hideyoshi's 1587 golden tea room, on display at the gold exhibition at a Tokyo department store on 31 January 2009. 270 × 255 × 250 cm. GETTY IMAGES/AFP/TOSHIFUMI KITAMURA.

Rikyū's and Hideyoshi's close relationship was not enough to save Rikyū when Hideyoshi turned against him. One account is that there was a statue of Rikyū placed on the upper level of the Sammon gate in Daitokuji. This meant that Hideyoshi and other nobles would have to walk beneath it when entering, and this so angered the great warlord that he ordered Rikyū's suicide by *seppuku*, a form of honourable capital punishment that involves a particularly gruesome form of obligatory suicide by sword. Another story is that Hideyoshi had glimpsed Rikyū's widowed daughter and asked him for her. Rikyū refused and incurred Hideyoshi's wrath.

Emergence of *wabi*

The contribution that Rikyū made to *chanoyu* was original, ground-breaking and ultimately, unsurpassed. Rikyū influenced all aspects of the Way of Tea, from its performance through to its utensils, but he is most known as the Tea master who developed and refined *wabi-cha*. The concept of *wabi* is ineffable, strikingly complex and at the same time tantalizingly straightforward. Since *wabi* is indefinable, there are many views of what it is. It is a concept specific to Japan that arose out of the teachings of Shinto, Taoism, Confucianism and Zen Buddhism, as well as from the many art forms that were flourishing in the Muromachi era. (*Wabi*, along with the related concept of *sabi*, extends beyond *chanoyu* to other Japanese arts.) Usually seen

in the West as an aesthetic quality, *wabi* should also be considered a philosophy, or at least a worldview, just as *chado*, the Way of Tea, is; both are thought of as ways of being in the world that influence and guide all aspects of life.

There is no more ambitious task than to try to explain the elusive concept of *wabi*. *Wabi* is not an objective set of rules, but requires an openness of mind and character in order to sense it: why is that pot – so cracked, so rough – beautiful? It is a personal and individual response, and those who practice *wabi* say that, based on the spirit, *wabi* is beyond words, sharing the Zen Buddhist understanding of enlightenment as achievable not through rational thought but by challenging and breaking down intellectualism. The practice of Tea shares many qualities with Zen practice, and *wabi* is *chanoyu*'s most Zen expression. It is also the concept that has most affected the creation of the teabowl as an iconic form outside Japan.

In *wabi-cha* (*wabi* tea) imperfection can be seen as beautiful, and an accidental incompleteness can be perceived as complete in itself. A modest teabowl that may originally have been made for everyday use might have a rustic quality, or it may be old and look a bit worn. There is no self-consciousness in it; you sense that the potter who made it did so without too much thought or analysis. It is of a simple, slightly asymmetric design and lacks ornamentation or ostentation. It fits in with the surrounding space, where there is nothing artificial; the natural materials in the tearoom serve as a link to the natural world, rather than displaying man's skills in conquering nature. The host shows deep consideration for the guests through the choice of utensils, called *toriawase*: the utensils will be seasonal; perhaps the tea scoop (*chashaku*) will have a poetic name that reflects the season; one utensil may allude to an interest of one of the guests as a way of honouring him or her. Flowers picked that morning have been simply arranged and displayed in the display alcove (*tokonoma*); they will not last beyond this day. The choice of these items, and the way in which the tea is served, creates an atmosphere of active calm, where you sense a profound stillness in the intimacy of the here and now. *Ichigo ichie*: one time, one meeting – a unique experience that is there, then gone. All this and more is *wabi*.

'*[Wabi]* is a beauty that is seen not with the eyes but with the heart.'[27]

Chanoyu principles

Being from the newly emerged merchant class, Rikyū aimed to eliminate class distinctions in the tearoom. Prior to Rikyū, guests of the nobility entered the tearoom through the *kininguchi*, which allowed them to walk upright into the tearoom. Rikyū provided only a *nijiriguchi*, a small entrance through which all guests entered by kneeling. Like Jukō before him, Rikyū advocated *sōan-cha*, or thatched hut tea. His promoting the use of found objects as tea utensils added another dimension to

chanoyu, and he was responsible for the design and commissioning of many craft items, including Raku ceramics, one of the most important forms of teabowls. He set the principles of harmony (*wa*), respect (*kei*), purity (*sei*) and tranquillity (*jaku*) as the basis of *chado*, yet stressed that

> Tea is nought but this:
> First you heat the water,
> Then you make the tea.
> Then you drink it properly.
> That is all you need to know.[28]

All of these aspects of *chanoyu* led to the determinative concept of *sōan-cha*.

Chado remained deeply embedded within Japanese cultural and political life after Rikyū's death. His successor as Tea master to Hideyoshi was Furuta Oribe (1544–1615), who served Hideyoshi as a *daimyō*, or military commander. Oribe had been Rikyū's student and even Rikyū saw him as his natural successor over his own son Dōan, whom he nevertheless acknowledged to be a gifted Tea master. This may have been because Oribe, like Rikyū, was a man of independent taste. At first Oribe carried on Rikyū's *wabi-cha*, but as the years passed, Oribe's tea became grander and even 'glamorous'.[29] Where Rikyū seems to have been almost universally admired, Oribe has brought out extremes in people, with some loving him and some hating him. However, regardless of how one feels about the man, Oribe's influence on contemporary *chanoyu* and teabowls cannot be over-estimated. For instance, for Rikyū *wabi* qualities were accidental, such as the 'natural' warp of an Ido teabowl, thought by Japanese connoisseurs of the time to have been made by Korean 'peasant' potters, whereas Oribe allowed *wabi* to be intentionally added in the creation of an object. The conflicting views of whether *wabi* can be created or must be accidental are still in debate, with much discussion among contemporary teabowl potters and Tea students.

Oribe loved exaggeration. Where Rikyū used a straight wooden post as the corner support for the display alcove (*tokonoma*), Oribe used one with a pronounced bow. Where Rikyū identified beauty in the irregularity that occurred in the ceramics made by the roof-tile maker Chōjirō, Oribe's *katsugata* (shoe-shaped teabowls; see figure 22) were intentionally warped and misshapen during their making.

Oribe often incorporated found objects into his *chanoyu*, and he also seemed to lack the reverence for objects that typifies *chanoyu*. For example, he snipped a piece of fine silk into small pieces to make cloths to use when serving tea, and cut a Korean bowl, now called *Jūmonji*, which he considered to be too large, into pieces that he made smaller and reassembled. This approach certainly has resonance in contemporary times, from Yoko Ono's performance pieces in which she used broken ceramic bits to Ai Wei Wei's iconic *Dropping a Han Dynasty Urn* (1995). An interesting contemporary take on the theme is

(opposite) Figure 22: Mino ware (Oribe style), serving dish, Japan, early 17th century. Stoneware with Oribe glaze and iron decoration under clear glaze; *kintsugi* repairs. 8.3 × 37 × 37 cm. FREER GALLERY OF ART, SMITHSONIAN INSTITUTION, WASHINGTON, D.C.: PURCHASE, F1973.6A-E.

seen in the shard collections and 'exploded' ceramics of Bouke de Vries (The Netherlands/ UK). And let's not forget the love affair contemporary craft has with upcycling.

In tea ceremony, and when considering the teabowl today, Oribe's influence can be said to be as great as that of Rikyū's, although it can also be said that Oribe's aesthetic could not have developed without Rikyū's monumental achievements. Rikyū had already begun to turn *chanoyu* away from the refinement of Chinese ceramics; Oribe took it further. Rikyū's aesthetic was austere and sombre; Oribe's could be said to be whimsical.

Oribe, like Rikyū, was ordered to commit suicide. One story is that while seeking out a piece of bamboo from the battlements to make a tea scoop, Oribe was shot in the finger by a sniper. He boasted to Tokugawa Ieyasu, the great shogun who displaced Hideyoshi's son, that he had been wounded in his service. Ieyasu commented, 'That Oribe is the sort of fellow who will die from a fish-bone stuck in his throat.'[30] Oribe was offended by this and later plotted to overthrow Ieyasu, who discovered the plan and ordered Oribe's suicide. Other accounts cite Oribe's Christian beliefs as a factor in his death sentence. The Portuguese brought Christianity to Japan in 1549, and as long as the Christians did not interfere with the political strength of the military rulers, they were tolerated. However, the conversion to Christianity of many high-ranking individuals and the arrival of more Portuguese, and later the English, threatened to destabilize Japan, and in 1597 twenty-six Christians were crucified. Even so, Christian proselytizing continued, leading to a ban in 1614.

A new era for Japan

The unification of the warring states of Japan, which began during Oribe's lifetime, was consolidated by Tokugawa Ieyasu. The Tokugawa era, sometimes referred to as *Tokugawa Pax*, was a time of peace and stability, albeit a peace imposed by the shogunate's ambition to isolate Japan from certain aspects of foreign influence. Rikyū's and Oribe's *chanoyu* had been the products of an exciting, if intemperate and stressful, time. Men rose through the ranks of society through their talents and strengths. The Tokugawa shoguns' powerful control meant the imposition of a more rigid social structure, and positions in *chanoyu* became largely dependent on noble connections.[31] Early in this time Oribe created a tearoom that separated the first and most honoured guest from the others, going against one of Rikyū's most treasured principles.

Kobori Enshū (1579–1647), like his teacher Oribe, was from the samurai class, and he retained class distinctions in the tearoom. His tea style is known as *buke-cha* or *daimyō-cha*, or tea for the warrior, because it both came out of and was supported by the samurai class, and because it embraced Confucian concepts. Enshū became the *chanoyu* teacher to the third Tokugawa shogun, Tokugawa Iemitsu, and was a leading figure in political as well as cultural spheres, where he was known not only as a Tea master but also for his architectural and garden designs.

In the new age of stability and relative luxury, Enshū did away with the extreme aesthetic engendered by Oribe, creating the quality known as *kireisabi*, or a beautiful worn grace. This quieter and more restrained style was more conventional than the radical tea styles of Rikyū and Oribe, and indeed, Enshū himself was a much less subversive figure than either of his predecessors, both of whom refused to adapt their aesthetics to the tastes of the new shoguns. Enshū influenced a rising neo-Heian movement that looked back to an earlier classical era of court culture.

Some have said that *chanoyu* declined in this time, although it is probably more accurate to say that *chanoyu* underwent a period of reorientation. *Chanoyu* continued to be a vehicle for the exercise of power, reverting to a more glamorous style, which blossomed in the prevailing peace. Of most importance to the future of *chanoyu* was the consolidation of the *iemoto* system. This meant that the position of Grand Master within the different schools in many crafts and arts passed directly to an appointed heir, ensuring that the families were heavily invested in the schools' futures. The Grand Masters (*iemoto*) in *chanoyu* also began to give formal approbation, a sort of 'seal of approval' that established ownership and provenance to specific tea utensils through the granting of names to the objects, or by signing the wooden boxes in which the utensils were kept. This is part of the reason why, even today, precious Japanese ceramics are stored in specially made boxes, sometimes in multiple boxes, on which are written information about the artists, the names of the pots and their owners. The Grand Masters and the *iemoto* system, which gave them a strong position within Japanese society, ensured that *chanoyu* became an important cultural factor in historical and contemporary Japan. Today there are more than twenty-four different schools of *chanoyu*.

Chanoyu in the modern era

In 1633 Japan began to isolate itself by instituting policies called *sakoku*, which limited contact to the Chinese, Koreans, those in the Ryukyu Islands (Okinawa), and the Dutch East India Company, who were willing to separate religion and trade. In addition, Japanese citizens were not allowed to travel abroad. Although this is often known as a 'closed door' policy, news and technical knowledge from abroad did still move in and out of Japan during this time. Along with scientific objects from Europe, such as clocks, globes and medical instruments, the Dutch also brought theoretical and technological knowledge.

After two hundred years of *sakoku*, in 1854 the arrival of American gunships forced a treaty onto the shogunate that allowed for American representation in Japan. The American treaty was quickly followed by trade agreements, and as early as 1860 Japan sent emissaries to the United States. Agreements with other countries quickly followed. As the Japanese were exposed to more and more influences from abroad, the power of the Tokugawa shogunate began to wane, and in 1868 the last shogun

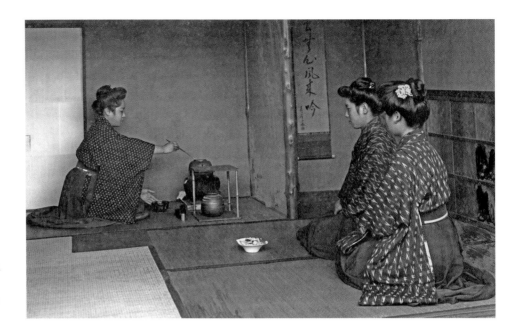

Figure 23: Japanese women in a tea ceremony lesson at a college for women, 1916. Tokyo, Japan. GETTY IMAGES/ULLSTEIN BILDS.

fell from power and the emperor was reinstated as the nominal ruler of Japan. This is called the Meiji Restoration and it marks the beginning of an explosion of frenetic Japanese modernization. Japan entered an outward-looking phase in its history, soaking up influences from around the world in areas such as the arts, the military, politics, education, economics and social structures.

Interest in many traditional Japanese arts quickly dwindled within Japan, and many Tea schools struggled to continue. However, *chado* is ultimately a creative endeavour, so it is not surprising to find that within two decades things began to improve. Gengensai, the eleventh-generation Grand Master of Urasenke, for example, successfully petitioned the Meiji government to recognize *chanoyu* as a special Japanese art form of cultural and spiritual significance. *Chanoyu*'s role as a specifically Japanese endeavour was boosted more as it gained adherents from the rising business elite.[32] Gengensai also developed *ryūrei*, a style of Tea where tables and stools are used. At the time Japanese people were beginning to wear Western dress and *ryūrei* accommodated this. In addition, *ryūrei* was more comfortable and welcoming to the many Europeans and Americans who visited Japan.

Tea had been a predominately male pursuit, but Shinseiin, Gengensai's daughter and the wife of the twelfth Grand Master Yumyosai Jikiso Sōshitsu (1852–1917), was successful in having *chanoyu* included in the curriculum of the new secondary schools for girls that had been set up as part of the modernization of the Meiji Era. Ennosai Tetchu Sōshitsu (1872–1924), the thirteenth Urasenke Grand Master, began to teach war widows following the Sino-Japanese War. (See figure 23.) This move towards teaching women and girls led to *chanoyu* being seen as a feminine art form, and as prerequisite training for marriage for a young woman, much like lessons in dance or

piano were seen in Europe and North America. *Chanoyu* training did grant young women grace and good manners, and taught them about Japanese cultural values and aesthetics. According to Kato Etsuko, women educators of the time were thought to have taught women *temae* (forms of making tea) without the underlying philosophy and mythic contexts, leading to what some saw as a 'superficiality'. However, she adds that it was the fact that women had learned the various *temae* during this era that *chanoyu* myth and *temae* were reunited in the post-World War II era.[33]

Interest in *chanoyu* grew outside Japan later in the twentieth century when Bernard Leach and Hamada Shōji set up the Leach Pottery in St Ives, Britain, and Zen Buddhism reached the shores of the United States. Mugensai Sekiso Sōshitsu XIV, known as Tantansai (1893–1964), the fourteenth Urasenke Grand Master, established the International Chado Cultural Foundation in 1946 and toured the United States and Europe to demonstrate the art of Tea. His son, Hansō Sōshitsu XV, known as Genshitsu (b. 1923) since stepping down as Grand Master, has continued to develop *chanoyu*'s overseas presence by setting up a Tea school for foreigners in Kyoto and promoting 'peacefulness through a bowl of tea' as a UNESCO Goodwill Ambassador (figure 24). Urasenke tea groups are now found around the world, some of the other *chanoyu* schools also having an international presence. This has extended *chanoyu*'s influence beyond Japan, and contributed to a form of *chanoyu* that is no longer seen as a way to make a young woman more marriageable, but rather as an art form of spiritual depth, grace and beauty.

Figure 24: Myanmar's democracy leader Aung San Suu Kyi receiving tea from former Grand Master Genshitsu Sen, Kyoto, Japan, 15 April 2013. PHOTO: GETTY IMAGES/STR/AFP.

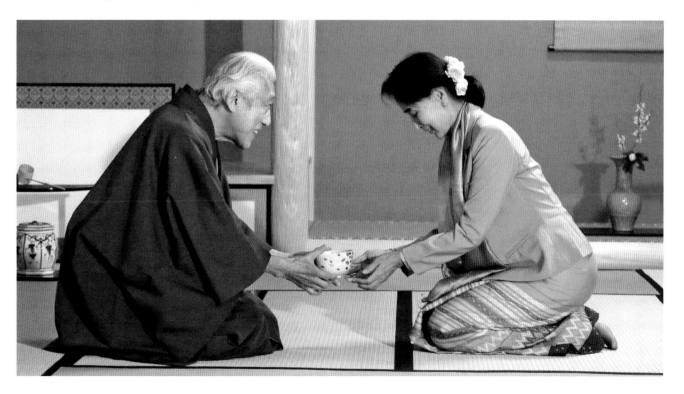

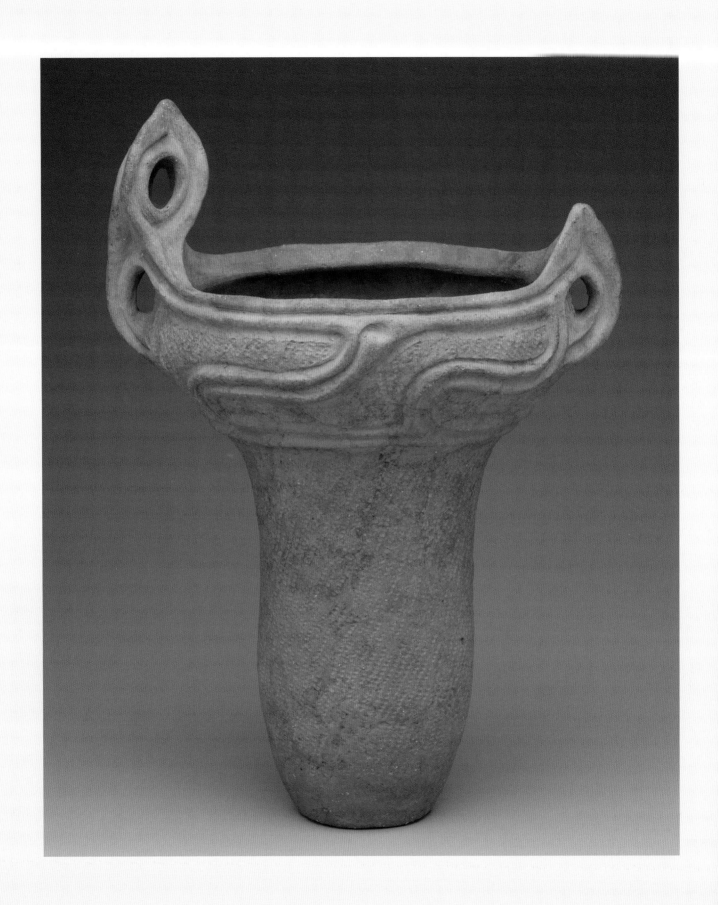

The teabowl's ceramic heritage

In the same way that the development of *chanoyu* is completely entwined with the discovery and spread of tea, the characteristics and aesthetics of the teabowl are entirely dependent on the evolution of *chanoyu*. However, it is not a clear-cut 'form follows function' equation. Serendipity and appropriation play a large part in the aesthetics of the teabowl, both historically and in our contemporary world.

Japan has a long ceramic history, and as with all histories, the different movements and eras often fold over each other, defying our inherent tendency to see this narrative as linear. In Japan this history also includes the introduction of knowledge and fashion from other cultures, and the migration and forced importation of potters themselves. Although Chinese tea and the teabowls in which to prepare and serve it were brought to Japan as early as the Nara period (710–784), we do not see tea spread significantly in Japan until the Kamakura era (1185–1333), when the Japanese monk Eisai, along with other monks, brought tea, tea utensils, Lu Yü's book the *Chajing*, and Zen Buddhism over from China. But Japan's rich ceramic history predates this era, and these earlier ceramic traditions greatly influenced Japanese ceramics, *chanoyu* and teabowl aesthetics as they developed from the Kamakura period onwards.

Early Japanese ceramics

Until recently, it was thought that the earliest utilitarian ceramic wares in the world were Jōmon (see figure 25), which are found throughout Japan and date back to 14,500 BCE. Recent scholarship and re-dating, however, have found that ceramic fragments discovered in a cave in Jiangxi Province in China date from 19,000 to 20,000 years ago.[34] Nonetheless, the Jōmon hunter-gatherers were creating ceramics at an extremely early date. They produced wares for over 10,000 years by coiling or slab-building, then open-pit firing to temperatures of about 750°C.[35] In these firings there was naturally occurring reduction, meaning the firing atmosphere was starved of oxygen and the fire 'took' oxygen from the clay, changing the colour of the clay body.

The word 'Jōmon' means cord markings, and many of the pots show extensive decoration created by impressing or rolling cords over the surfaces of the pots. However, over the centuries and through six distinguishable phases Jōmon wares encompassed many styles – from those simpler in design to the highly embellished, such as the classic 'flame pots', which have modelled ornamentation.

(opposite) Figure 25: Deep Bowl (*fukabachi*), Japan, Middle Jōmon period (*c.*2500–*c.*1500 BCE). Reddish-brown earthenware with impressed cord marks, 44.4 × 32.4 cm. PHOTO: YALE UNIVERSITY ART GALLERY.

Korean ceramic skills, technologies and aesthetics, gained through trade and several migrations (some through abduction) of Korean potters to Japan, were integral to the development of Japanese ceramics. In the Yayoi era (300 BCE–300 CE), people who may have been of Chinese descent came from the southern part of the Korean peninsula to settle in Japan. They brought the skills of rice cultivation, metallurgy and pottery, and established agrarian settlements. Yayoi pottery (see figure 26) is smoother of surface, thinner walled and often more graceful in form than the Jōmon before it. It is suggested that this was because the Koreans brought a simple turntable (the precursor of the potter's wheel), and with more permanent settlements, established the beginning of a professional and skilled potters' class. The pots were fired in an oxygen-rich, more cleanly burning atmosphere, producing a lighter coloured clay body than seen in the earlier Jōmon, and some Yayoi wares had a covering of slip containing red iron oxide and were burnished.

Dates for the Kofun era, named after the burial mounds from the time, vary from 300 to 552 CE, the date that Buddhism is thought to have been brought into Japan, or to 710 CE, the date the capital was moved to Kyoto. The coiled Haji ware vessels were undecorated, low-fired, mostly reddish pottery made primarily for domestic use. Late in the period a black, smoked version of Haji ware appeared. Production faded with the introduction of better kilns and glazing. Outside of Japan the Kofun era is largely known for its large, enigmatic *haniwa* figures (see figure 27), which were placed in circles around ancient burial mounds. The original forms were mostly plain cylinders, but later *haniwa* included human and animal figuration, as well as houses and other objects.

In the fifth century CE, Sue potters arrived from Korea, bringing with them a more advanced potter's wheel and knowledge of the *anagama* kiln. This uphill single-chambered kiln allowed a more efficient firing than earlier kilns, and led to the first stoneware ceramics being produced in Japan. It seems the Sue potters held true to their heritage, as often the ceramics produced in Japan at the time are indistinguishable from their Korean counterparts.[36] The ware was fired in reduction (oxygen starved) to temperatures of about 1000–1200°C, producing a grey, vitreous clay body with natural ash glazes, which were created as the fly ash from the burning wood settled onto the pots and formed a glaze. (See figure 28.)

The Nara period (710–784) is significant because Chinese Tang dynasty *sancai* glaze technology was introduced to Japan from China and Korea. *Sansai*, the Japanese term, were low-fired lead glazes that used iron and copper to produce brown and green, often covering the entire piece. The production of Nara *sansai* ware was relatively short-lived, although green glazes and attempts to copy Chinese wares continued into the next era.

(opposite) Figure 26: Jar, Japan, Yayoi period (*c*.300 BCE–*c*.300 CE). Earthenware with incised decoration, 25.4 × 22.9 cm.

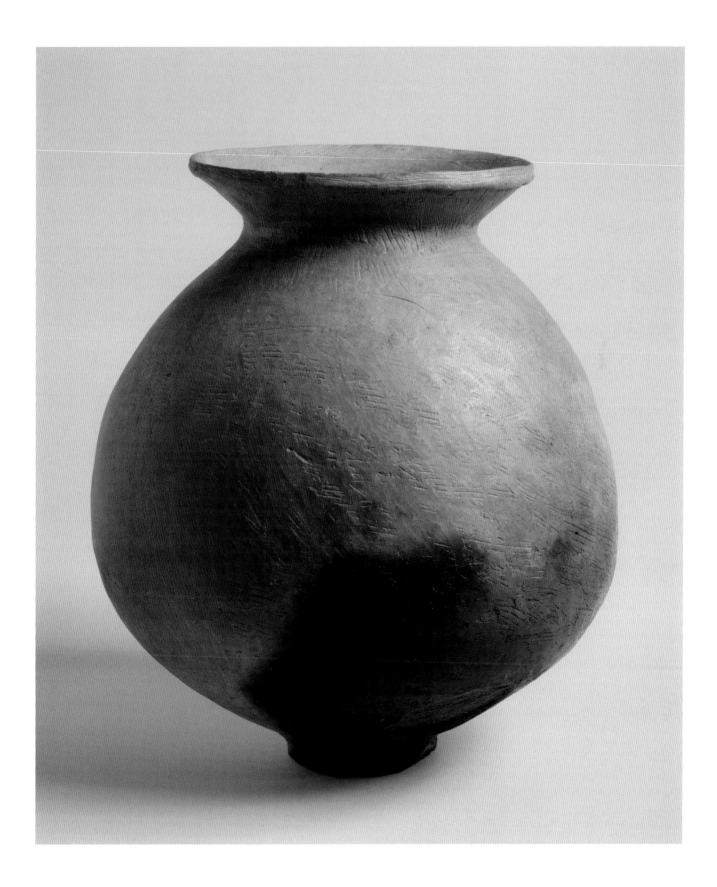

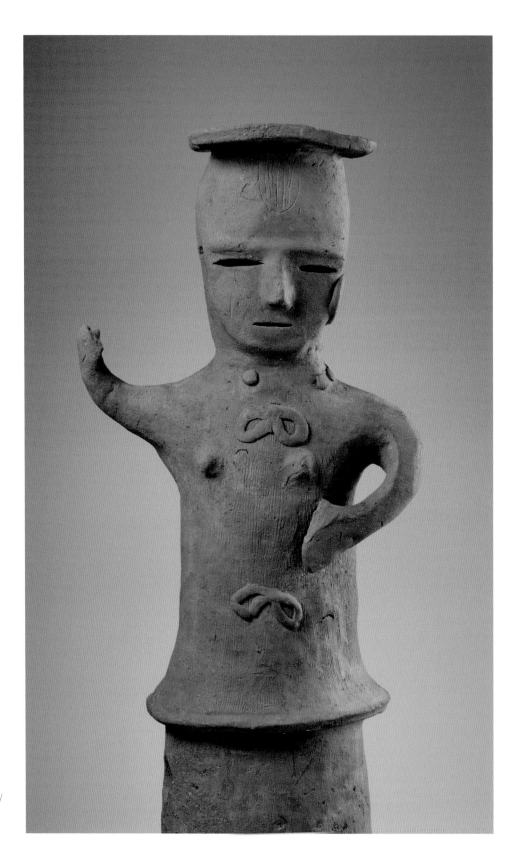

Figure 27: Standing Female, Haniwa, 6th–7th century. Reddish earthenware, 88.9 × 26.7 × 20.3 cm/ base 2.2 × 28.5 × 21.6 cm. PHOTO: YALE UNIVERSITY ART GALLERY.

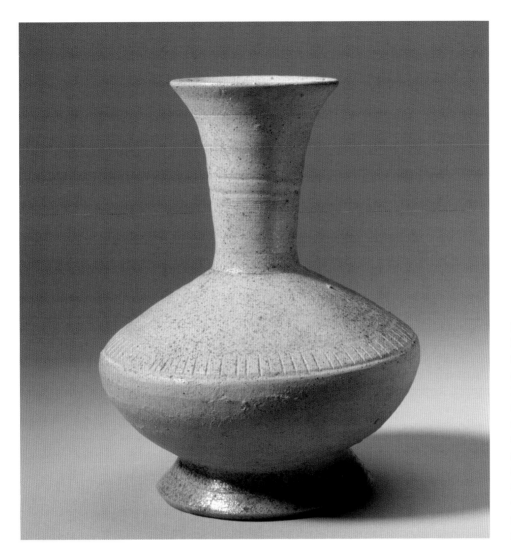

Figure 28: Long-necked bottle, Sue ware, Nara period (710–794). Stoneware with natural ash glaze and incised decoration, 21.6 × 17.1 cm. THE METROPOLITAN MUSEUM OF ART, WWW.METMUSEUM. ORG, THE HARRY G. C. PACKARD COLLECTION OF ASIAN ART, GIFT OF HARRY G. C. PACKARD, AND PURCHASE, FLETCHER, ROGERS, HARRIS BRISBANE DICK, AND LOUIS V. BELL FUNDS, JOSEPH PULITZER BEQUEST, AND THE ANNENBERG FUND INC. GIFT, 1975.

The Heian era

The Japanese entered the ninth century with a flourish. During the Heian era (794–1185), with the influence from China at its height, the emperor sent out regular emissaries to China and Korea. The missions returned with both knowledge and objects. However, during the latter part of the Tang dynasty (618–906) China entered a period of violent imperial successions, corruption, civil unrest and increased pressure from the military class. Japan, by this time, was developing a strong cultural identity of its own, and the close association with China began to wane. Many Chinese imports from earlier Japanese missions, such as a centralized bureaucracy, penal codes, standardized measurements for land and the use of the Chinese calendar, had already been incorporated into Japanese culture. Then in 845, Chinese Emperor Wuzong initiated persecution policies against religions that were not Chinese in origin

as a way of breaking the power that many monastic centres had accrued. Buddhism, which originated in India, was well established in Japan, and this persecution, and the continued decline of the Tang dynasty, furthered the Japanese move away from China. The last of the fifteen official Japanese missions sent to China during this era was in 838 CE.

This period can be seen as a time of turning inward in Japan. The period heralds the development of a Japanese script, derived from Chinese but distinctly Japanese, and the flowering of a lively Japanese vernacular literature, with masterpieces such as *The Pillow Book* by Sei Shōnagon and *The Tale of Genji* by Murasaki Shikibu, which is referred to as the world's first novel.

During the following era, known as the Kamakura period, Chinese celadon and tenmoku teabowls were still used extensively in *chanoyu*, but with improvements in kiln technology in Japan they began to be copied at Seto, Aichi Prefecture. These advances included the first intentionally glazed Japanese stoneware vessels. Other kilns copied these techniques and improvements, and by the end of the era many kiln centres were established or substantially extended. The most famous are the so-called Six Ancient Kilns: Tokoname, Bizen, Tamba, Shigaraki, Echizen and Seto. These centres, along with many others in Japan, mostly produced heavy stoneware jars for everyday domestic and agricultural use. Importantly, these wares later would be greatly admired by *chajin* (Tea practitioners), including leading Tea masters. The wares from each kiln have individual characteristics, which are dependent on the clays in the area, the firing and the objects produced, but early works were often made in similar forms and are sometimes hard to distinguish without specialized knowledge. They are all characterized by a sense of strength and a quiet presence.

Coming out of the Sue tradition, Bizen and Shigaraki are two of the Six Ancient Kilns that produced wares that are used in tea ceremony. The wares from these two kilns often had fly ash glazing. *Ko Bizen* ('Old' Bizen) wares tended to dark reds and browns, and were irregular in shape (see figure 29). These pieces, made as utilitarian storage containers,[37] appealed to later *chajin* for their unrestrained freedom of form and simplicity. Well-known Bizen characteristics today include *hidasuki-yaki* (see figure 30), where straw cords wrapped around the pots prior to firing produce red, graphic marks across the surfaces, and *goma* (sesame seed), where pine ash melting on the surface produces a gold/brown mottled glaze. A Bizen pot may have a dry surface, making it unappealing as a teabowl. More often, Bizen wares are used in *chanoyu* for vessels that hold water, such as flower vases and *mizusashi* (fresh-water containers), as it is said that Bizen is most beautiful when it is wet.

Shigaraki ware (see figure 31) is characterized by its warm deep orange clay body with feldspar eruptions through it. Like Bizen, the pots have a fly ash glaze. The potters in Tamba, another of the Six Ancient Kilns, are known to have worked with the Tea master Kobori Enshū in the seventeenth century to create objects for *chanoyu*. Tamba

(opposite) Figure 29: *Mizusashi*, Ko Bizen, Late Edo period (1615–1868), Japan. 17.9 × 17.7 cm.
PHOTO: YALE UNIVERSITY ART GALLERY.

Figure 30: Spouted bowl, Bizen, *c.*1700–*c.*1850. Stoneware with orange *hidasuki* markings (salt-water soaked rice straw wrapping). 10.8 × 19.7 cm. © VICTORIA AND ALBERT MUSEUM, LONDON.

(opposite) Figure 31: Jar, Shigaraki, 15th century, Muromachi period (1336–1573). Stoneware coil-built in sections with natural olive-green ash glaze, 54.5 cm. PHOTO: YALE UNIVERSITY ART GALLERY.

is also known for slip trailing, especially on sake bottles. Just as a bottle of soft drink today displays its name graphically, so slip trailing was used to identify different sake shops. Tokoname was the largest of the six kiln centres. Its location on Ise Bay ensured that its wares were distributed throughout Japan. In the 1800s it began to produce *chanoyu* wares.

Iga, not named one of the Six Ancient Kilns, dates back to the late sixteenth century. Iga is close to Shigaraki and shares some characteristics. It is known for its natural fly ash glaze, which vitrifies into rivulets or glassy drops. Iga ware is used in *chanoyu*, especially for flower vases.

Although the early wares produced in the other Six Ancient Kilns later influenced the development of the teabowl, Seto was the first place in Japan to actually produce *chawan*. These were copies of the Chinese blackwares, known in China as Jian, and in Japan as tenmoku.

The first teabowls in Japan

As discussed previously, Buddhist monks brought tea to Japan from China as early as the eighth or ninth century, but it was the monk Eisai who, on returning to Japan in 1191, promulgated tea's use in his book *Kissa yōjōki* (*Treatise on Drinking Tea for Health*). Eisai is also the founder of the Rinzai sect of Zen Buddhism, which is the form of Zen most closely linked to the arts.[38] It is the arrival of powdered tea during the Kamakura period (1185–1392), and a specified way of serving it, that marks the beginnings of *chanoyu*, and it is the first bowls brought over from China that were *chanoyu*'s first teabowls.

These bowls were suited to the new powdered tea: the ground tea was placed into an individual teabowl, then whisked with hot water. Jian wares (tenmoku), made in Fujian province, China, were the most popular among the tea drinkers, especially those who indulged in the fashionable tea tournaments, or tea contests, known as *tōchakai*. The dark-glazed Jian bowls (see figure 32) displayed the green tea and its lighter coloured froth well, both of which were criteria used in comparing different kinds of tea in the tea judging. Each Jian bowl was presented on a stand, usually made of natural or lacquered wood. Jian teabowls and their stands were brought back to

Figure 32: Jian ware teabowl, 13th century, Southern Song dynasty (1126–1279). Stoneware with hare's fur glaze. 6.3 × 12.7 cm. PHOTO: YALE UNIVERSITY ART GALLERY.

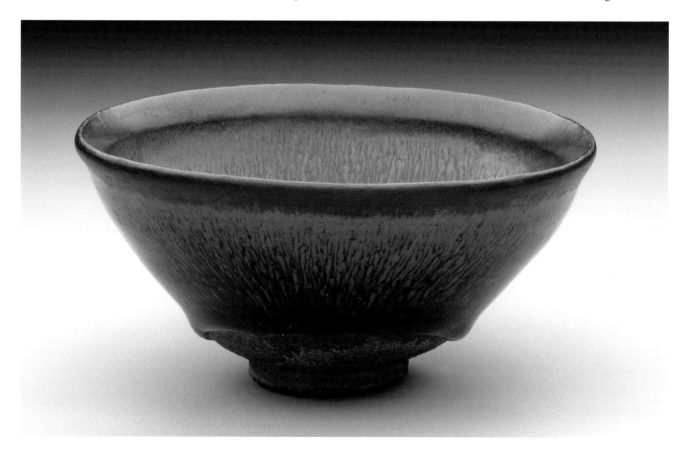

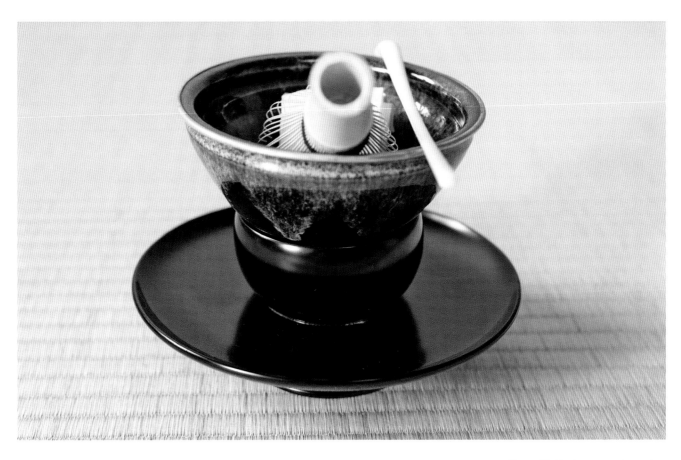

Figure 33: Contemporary tenmoku teabowl with *dai* (stand), *chasen* (whisk), *chakin* (linen cloth) and ivory *chashaku* (tea scoop). PHOTO BY IAN OLSSON.

Japan by the monks who had studied Chan (Zen) Buddhism in Tian-mu mountain (pronounced tenmoku in Japanese) in China.

Most tenmoku bowls (see figure 33) are small, reflecting the modest amount of tea that was prepared per serving. They are conical in shape with a narrow base. The symmetrical sides commonly flare out to a well-defined rim, which is sometimes slightly narrower than the widest part of the bowl and sometimes set apart by a small indentation just under the top edge.

There are over twenty variations of tenmoku, and as with all ceramics in *chanoyu*, they are set out in a hierarchy of value. Most have descriptive names, such as hare's fur, tortoiseshell, oil spot, persimmon and partridge feather. The glazes took significant skill to produce, both in their formulation and their firing. In traditional blackware tenmoku, a stoneware clay body containing iron was used, along with a thick high-clay, iron-laden glaze.[39] This either formed crystals, as in the oil spot glaze, or streaking, as in the hare's fur glaze, or a luscious deep brown/black. The glaze often pooled in the bottom, and often the slight change in the angle of the outside contour of the bowls encouraged the glaze to stop flowing, forming a soft ridge about two-thirds of the way down the sides. In Japanese tea ceremony today tenmoku bowls are still used, always with a stand, which is called *tenmokudai*. The stand lifts the bowl off the

tatami mat and features an integrated 'saucer' under the teabowl. Each *dai* is made for a specific bowl. Each needs to ensure that the unglazed area of the particular teabowl sits below where the teabowl rests on the *dai*. The type of *temae* (tea preparation) in which a tenmoku bowl and *dai* are used is still performed today when special honour is due to one of the guests. The tea is both made and served in the bowl. The beauty of these glazes is subtle and understated, perfect for the aesthetic growing within the Zen monasteries.

Celadon bowls were also popular among Tea masters in the early stages of *chanoyu*. Rand Castile raised the question of why: 'The celadon color is not suited to the rich color of green tea. The appearance of celadon, too, is rather cold or stand-offish. It is not an inviting, warm color. The glaze has a cold touch and the surface of a celadon bowl tends to make handling difficult.'[40] However, *chajin* of the time found reasons to use celadon. Chinese Song celadons were particularly prized, both in Japan and in Korea, and later celadon ceramics would be used in the tea ceremony for utensils other than teabowls, such as incense burners and vases. Castile's comment demonstrates that contemporary *chanoyu* aesthetics have changed over time, and perhaps also reflects the pick-and-choose appropriation of *chanoyu* aesthetics. Chinese blue and white Ming bowls were also imported and used.

Although Chinese ceramics continued to be prized and used in the tea ceremony (and still are), Japanese potters in Seto, where glazed ceramics were already being produced, began to copy the Chinese blackware teabowls as the demand increased. The local clay did not have the same iron content as that used in China, so the Chinese and Japanese tenmoku can often be distinguished by the colour of the unglazed foot ring.[41] From this point on in Japan's history, with the growing link between Tea masters and potters, Tea masters began to exert a powerful influence on the development of Japanese ceramics.

Ceramics lore has it that Katō Kagemasa (also known as Tōshirō) was the first to produce Chinese-style tenmoku in Seto in Japan in the thirteenth century. As with all the legends about ceramic developments in Japan, this story may be greatly influenced by later *chajin*, collectors and merchants, who had appreciable cultural and monetary investment in the story. According to the legend, Katō accompanied the monk Dōgen to China and studied ceramics and glazes there for six years. On his return to Japan he searched for a suitable clay to reproduce the Chinese celadons and tenmoku and settled in Seto. Putting this story aside, in the fourteenth century Seto did begin to produce significant numbers of glazed wares in these styles. Production techniques spread to nearby Mino. In later years Seto and Mino were associated with *setoguro* (black Seto, the first Seto type) and *kiseto* (yellow Seto, which includes the first underglaze decoration in Japan, *c.* late 1500s) and later, Shino and Oribe.

Fine Chinese, Korean and Seto teabowls continued to be used exclusively in *chanoyu* until the development of *wabi-cha* in the sixteenth century.

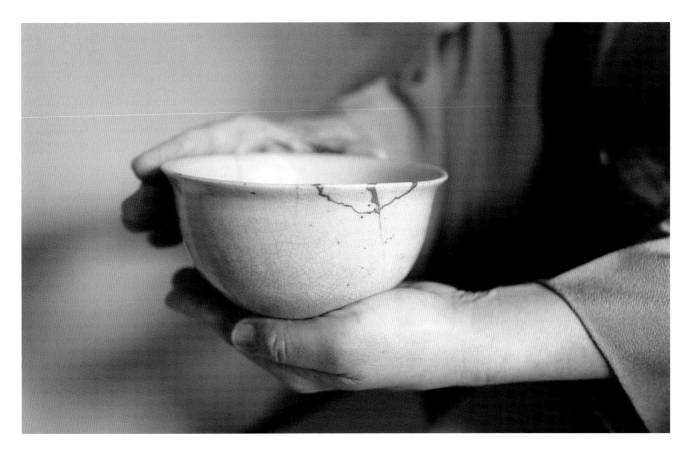

Kintsugi

Kintsugi, or gold repair, is a lacquer technique developed in the fifteenth century in Japan, and is often used to mend teabowls (see figure 34). It has an important role to play in Japanese ceramics, especially in *chanoyu* aesthetics, and today's resurgent interest in the technique has led to contemporary interpretations and developments as well.

Ceramics lore holds that *kintsugi* was created when a teabowl sent to China by the warlord Ashikaga Yoshimasa (1436–1490) to be mended was returned with a poor quality repair. The teabowl had been put back together using metal staples, a technique used widely at the time. The shogun was not impressed, and so began the search for a more aesthetically pleasing repair of ceramic cracks and chips.

Kintsugi is traditionally a repair made in *urushi* (lacquer) with gold powder added to the lacquer or applied on top, making the repair appear to be solid gold. Other forms of lacquer repair are done in silver, red and black, and sometimes these too are loosely referred to as *kintsugi*. The traditional technique uses a substance that can cause serious allergic reactions, requires great skill and is extremely time-consuming. A *kintsugi* repair, done by one of the masters, is very expensive, although it often significantly increases the value of a ceramic piece.

Figure 34: Korean teabowl (17th century) with *kintsugi* repair (likely 18th century). 10.5 × 7 cm. ORIGINALLY FROM PEER GROVES COLLECTION; NOW FROM KŌSHOSAI COLLECTION. PHOTO BY IAN OLSSON.

Rather than disguising the age or damage of an object, a good *kintsugi* repair can do much to increase the work's aesthetic qualities. Highlighting the repair can accentuate the form or give an otherwise dull piece a focus and interest, or a web of gold lines can make a piece that has no particular distinctiveness into something exceptional. The delicate channels of gold may suggest branches, a water cascade, a landscape or another trope from nature.

Kintsugi easily fed into the Japanese aesthetic of *wabi*. The fifteenth-century Tea master Jukō said, 'It is fine to have an excellent horse tethered to a straw-thatched hut.'[42] He felt that *wabi* embraced the strong contrast between the two qualities, just as *kintsugi* embraces the ugliness of breakage with the splendour of gold.

The complex Zen Buddhist concept of *mushin* ('no mind') speaks to the nature of *kintsugi*, as does *mono no aware* ('the pathos of things'), a concept associated with the Heian period (794–1185). *Mushin* refers to a state of being where there is no judgement, no fear or anxiety, no ego. It is a total acceptance of life as it is, as it has been and as it will be. *Mono no aware* expresses a sense of impermanence: the bloom will last only a day, the moon is full tonight but will soon be only a crescent, a person's life lasts but a moment. *Mono no aware* is the appreciation and acceptance of this. There is a feeling of sadness, but also a feeling that the world is as it should be.

Korean Ido teabowls

Trade, travel and then abduction of Korean potters by Japanese warlords ensured that those involved in the tea ceremony knew Korean ceramics well, both fine everyday ware and porcelain. During the sixteenth century, *wabi-cha* Tea masters and connoisseurs began to use roughly made bowls, which came to be called Ido bowls, rather than the fine Chinese and Korean bowls previously used. Originally produced as rice bowls, they were shipped to Japan in large numbers. The Tea elite's selection of some of them is what created the classification of the Ido *chawan*. Perhaps the most famous of these, indeed the most famous *chawan* in the world, is called *Kizaemon*. It is one of Japan's *kokuho*, or National Treasures, and gained much popularity outside of Japan because Yanagi Sōetsu wrote about it extensively in his much-acclaimed book *The Unknown Craftsman: A Japanese Insight into Beauty*. Yanagi imagined a story of the bowl's creation that stressed its 'low' origins in a way that may make present-day readers uncomfortable: 'In Korea such work was left to the lowest. What they made was broken in kitchens, almost an expendable item. The people who did this were clumsy yokels, the rice they ate was not white, their dishes were not washed.'[43] He goes on to describe the bowl: 'The plain and unagitated, the uncalculated, the harmless, the straightforward, the natural, the innocent, the humble, the modest: where does beauty lie if not in these qualities?'[44] This refers to a lack of self-consciousness on the part of the potter about the status the teabowls would carry later. A delicious contradiction is

that some of these bowls, as Yanagi would say, the lowest of the low, came to be some of the most highly valued ceramics in the world.

Yet we should not allow Yanagi's obvious romanticism and condescension belittle the appeal that such a bowl might have. *Kizaemon* is indeed a beautiful bowl, and its irregular shape and *kintsugi* repairs make it particularly appealing today, abetted by the popular interest in a make-do approach to life. Ido bowls can evoke the 'accident' of their making; you sense that the Korean potters who made them either hadn't the time to be careful or that perhaps the clay itself demanded their gently asymmetrical, imperfect shapes. Their glazing seems haphazard and has many flaws, the fire in the kiln seeming to have exerted as much influence on the finished bowls as the potter.

Kizaemon is an excellent example of the development of *meibutsu*, precious objects given names by owners or *chajin* (Tea practitioners), which in *Kizaemon*'s case was the name of one of its early owners. *Meibutsu* have careful pedigrees of illustrious provenance, the accrued history increasing an object's significance and value. Each distinguished owner inherited a duty of care for these precious items. As Louise Cort says,

> All Ido bowls that survive today have been transformed greatly from their original appearance through use for tea drinking. This physical transformation is closely associated with the history of ownership; a series of careful owners can promote changes that are welcomed in the chanoyu context as aesthetically pleasing and desirable, but a single careless owner can ruin a bowl. In properly venerated Ido bowls, brown tea tannin has been allowed to sink into the cracks and pits of the glaze. Oil from caressing hands has given a luster to the surface. Rough edges have been worn down.[45]

Just as the owner gains in reputation because of the *meibutsu*, so the value of the object can increase because of the status of the owner.

Another characterization of *meibutsu* can be seen in their storage boxes. An owner may have a wooden box made in which to house the teabowl, and subsequent owners would have new boxes made, the old box of each generation nesting inside the new and larger one like Russian dolls. According to Yanagi, *Kizaemon* had four such boxes and was also wrapped in wool and purple silk.[46]

Raku ware

In studio ceramics around the world, Raku is the most famous of all Japanese ceramic techniques. Ironically, this is because of the development of the often bright and flamboyant Western raku technique that developed in California in the twentieth

century. Japanese Raku and Western raku are disparate branches of an extended family, sharing a genetic heritage, but with divergent traits and appearances. To distinguish them, I use 'Raku' for wares made by the Raku family in Japan and 'Western raku' for the ceramic firing technique developed in the West.

In Japan, Raku, meaning 'enjoyment' or 'pleasure', is the family name given to a family of potters by the powerful warlord Toyotomi Hideyoshi. Tanaka Chōjirō was a roof-tile maker working on Hideyoshi's extravagant Kyoto palace, Jurakudai. In fact, early Raku wares were called *juraku* before the word was shortened, or even *ima-yaki* ('now' ware). The famous Tea master Sen no Rikyū is said to have seen Chōjirō's roof tiles and sculptures and then asked Chōjirō to make teabowls, establishing a collaborative relationship for the creation of *chanoyu* wares that had a lasting impact on Japanese ceramics aesthetics (see figure 35). However, Morgan Pitelka in his excellent book, *Handmade Culture: Raku Potters, Patrons, and Tea Practitioners in Japan*, challenges this claim, stating, 'Archaeological evidence indicates that it was the impact of global flows of ceramic culture on the local tea-ceramic market that stimulated the development of the Raku technique, rather than the aesthetic innovation of one Tea master and one potter.'[47] Whether true or fanciful, the strength of the mythology of Chōjirō and Rikyū's partnership has influenced the development of Raku ware's ongoing popularity.

The early Raku potters are said to be the first Japanese urban studio potters.[48] Prior to this time, potters worked anonymously in the many workshops that could be found in the great pottery districts, firing their work in huge communal kilns. Raku kilns were small and cylindrical and usually on-site, and pieces were often fired one at a time. This labour-intensive approach to pottery invested each piece with uniqueness, personality and value. Unlike thrown ware, the hand-building and firing techniques did not require years of training, and there were many talented amateur potters of Raku-style. Since the kilns could be located domestically, guests could be invited to firings, where they would glaze bowls made ahead of time, then have them fired while they waited. As the guests returned to the tearoom, the newly fired bowls then could be used to serve tea. This tradition continued for centuries. Indeed, Bernard Leach refers to attending such a gathering in *A Potter's Book*.[49]

The new Raku teabowls differed from the delicate Chinese and Seto bowls that had been used before Chōjirō's time. The Raku teabowls shared aesthetic qualities with the Korean Ido rice bowls that earlier Tea masters had been using. In *The Unknown Craftsman*, Yanagi is disdainful of Rikyū's preference for Raku teabowls, implying that the bowls are too contrived,[50] being consciously made for the tea ceremony by distinguished potters, rather than made by the 'poor', anonymous Korean potters who created the Ido *chawan*. This attitude exemplifies the disagreement about the 'accidental' nature of *wabi* teabowls, which continues to this day, especially among potters creating *chawan*.

Figure 35: Chōjirō, Teabowl, black Raku bowl, *c.*1575. 9.2 × 9.5 cm.
THE METROPOLITAN MUSEUM OF ART, WWW.METMUSEUM.ORG. ROGERS FUND, 1917.

Raku bowls were usually cylindrical, whereas most earlier bowls and the Ido bowls tended towards the conical. The bowls were low-fired rapidly, remaining only partially vitrified. This means they retained the heat of the tea so they didn't generally burn the hands. During a tea ceremony the bamboo tea scoop is gently tapped on the edge of the *chawan* to dislodge any remaining powdered tea. This is one of the few distinct sounds intentionally created in Tea, and the low vitrification of Raku gave them a pleasing 'thunk' sound, rather than the hard 'ping' of high-fired stoneware or porcelain. Raku bowls were made by hand, rather than on the wheel, thickly formed to begin with, then carved at the leather-hard stage. Hand-building is an important aspect of a Raku teabowl, even today; when a potter holds the clay in his or her hands, there is a conscious or unconscious consideration of how the shape will ultimately fit into the hands of the person drinking the tea.

There are two types of traditional Raku bowls, black and red, and with both, the forms are simple and unpretentious, fitting the aesthetics of Rikyū's *wabi-cha*. The black bowls were covered in a lead glaze that contained iron and manganese oxides from ground rock from the Kamo River in Kyoto. They were fired, removed from the kiln when the glaze was molten and left to cool. They often show the marks in the glaze made by the tongs used to remove them from the fire. In red Raku a red clay body was used, sometimes with a thin ochre slip, then thickly covered with lead glaze.[51]

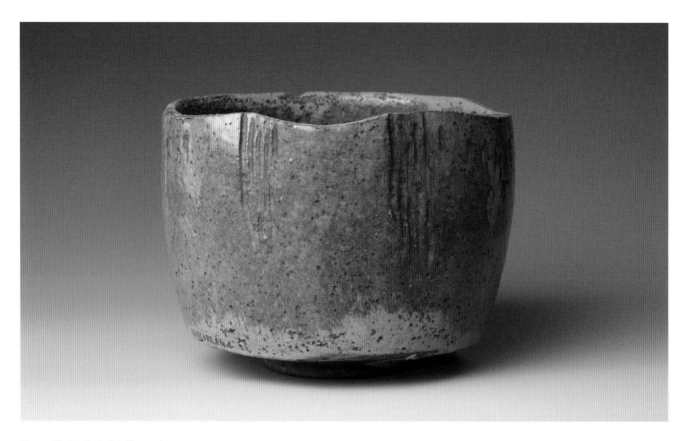

They were fired to an even lower temperature than the black bowls and often allowed
to cool in the kiln. The glazes were often applied unevenly, resulting in variations in
colour, an irregular presence of a milky quality, darkened areas created by the firing,
and crazing with thin shallow cracks.

In *chanoyu* and Japanese ceramics history a distinction is made between works
made by the designated Raku descendants and those made by other potters, some of
whom were other family members or apprentices, which are called Raku-style. Raku
has continued to develop with each generation to the present day; new techniques,
new glazes and new decoration have all been added to the Raku repertoire through
fifteen generations of makers.

The early years of Raku were a productive time for *chawan* development.
Continuing in the Raku tradition, Honami Kōetsu (1558–1637) not only developed a
new ceramic aesthetic, but also exerted significant influence in painting, calligraphy,
garden design and sword connoisseurship, which was his family's trade. He may
have studied with the eccentric Tea master Furuta Oribe, but was drawn to the Raku
family's quieter style of ceramics (see figure 36). He was taught how to make *chawan*
by the second generation Raku master, Jōkei II,[52] and it is thought that his bowls were
sometimes glazed in the Raku workshop.[53] He explored the teabowl shape, producing
bowls with rounded bodies and straight bodies, in white and red clays.[54]

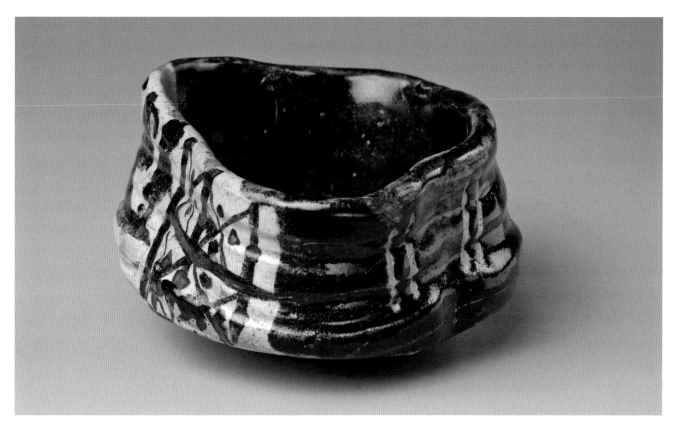

Oribe ware

Furuta Oribe was Sen no Rikyū's foremost student. He had a colourful nature that is evident in the ceramics created under his influence (see figure 37). If part of the unfolding of a quiet and reserved *wabi-cha* and the development of Raku teabowls was due to Rikyū's opposition to the great warlord Toyotomi Hideyoshi's love of gold, ostentation and lavishness (as seen in The Great Kitano Tea Ceremony and Hideyoshi's Golden Tearoom), then perhaps Oribe's exaggerated and sometimes whimsical ceramic taste was a reaction to his former teacher's sombre and unassuming style. However, although their tastes may have differed, they had one thing in common: they approached Tea as individuals, not relying unquestioningly on the styles and fashions of the day, but rather exploring their own tastes and preferences. Both were fundamental to the subsequent development of *chanoyu* and Japanese ceramics.

It should be said that Oribe was not a potter himself; the ware is named more for Oribe's ceramic taste than for either the place where it was created (as in Seto ware or Bizen ware) or the potter (as in Raku). It is not clear whether these dramatic styles were from Oribe's direct influence; from his patronage, which precipitated the production of certain designs; or were simply part of the growing development in ceramics created by the importation of new kiln technology.

Figure 37: Mino ware (black Oribe type), clog-shaped teabowl with design of plum blossoms and geometric patterns, Momoyama period (1573–1615). Stoneware with iron-black glaze. 7.6 × 14.3 cm (foot 5.7 cm). THE METROPOLITAN MUSEUM OF ART, WWW.METMUSEUM. ORG, DR AND MRS ROGER G. GERRY COLLECTION, BEQUEST OF DR AND MRS ROGER G. GERRY, 2000.

Rikyū sought out objects for *chanoyu* that carried a sense of age; even in the *chawan* made by Chōjirō (the first of the Raku family), there is a certain sense of time passing. Oribe, on the other hand, eschewed *meibutsu*, or famous and usually old works of art, and sought the new. He even used Delft ware brought in by Dutch traders. He turned Rikyū's love of accidental imperfections on its head by using *chawan* forms that had been intentionally distorted.

In his 2015 talk 'What Makes a Teabowl a *Chawan*?', American contemporary *chawan* maker John Baymore introduced a system of rating the difficulty in using teabowls with various characteristics. On Baymore's scale, Oribe ware teabowls would certainly be classified as 'most difficult' with their 'challenging forms' and 'highly complex surfaces and decoration'.[55] This level of difficulty in use may have made Oribe ware bowls more exclusive, since only accomplished Tea practitioners would have the experience, skill and confidence to handle such utensils.

Oribe ware often has iron oxide brushwork in geometric shapes and representations of flowers and other pictorial motifs, with clear glazes as well as decorative dark green copper glazes. Robert Yellin's comments on Oribe give a trenchant contemporary view:

> With its copper-green glazes and avant-garde designs more evocative of Joan Miro than Zen, Oribe ware burst onto the late-16th-century tea scene like a fireworks display. Yet it was Oribe's understanding – indeed mastery – of wabi-cha that gave him the skill and creativity to develop his own style of pottery.[56]

Around this time, the widely used *anagama*, or single-chambered climbing kiln, was being replaced by a kiln with a large central chamber under a vaulted roof, the *ogama* (large kiln), which allowed for higher firing temperatures and more control. Then in the late sixteenth century, knowledge of the *noborigama* kiln was brought over from Korea. This kiln consisted of a series of connected chambers running uphill, which could be stoked individually, thereby providing different atmospheres and temperatures within a single overlapping firing.[57] *Anagama* and *noborigama* kilns are still in use today, in Japan and beyond, although new environmental restrictions shut down many in Japan and have prevented the building of new wood-burning climbing kilns in urban areas.

Shino ware

Oribe ware is considered part of Mino, along with another ceramic type called Shino (see figure 38). It may be that Shino was also named eponymously. One story is that Shino Soshin (1444–1523), a great Tea master, had a white Chinese bowl of which he was very fond, so he commissioned potters in Mino to produce similar pots. However, there are other theories about the origin of the name as well.[58]

(opposite) Figure 38: Seto ware teabowl decorated in Shino style, 19th century. Stoneware with iron decoration under feldspathic glaze, 8.3 × 12.9 × 12.9 cm. FREER GALLERY OF ART, SMITHSONIAN INSTITUTION, WASHINGTON, D.C.: GIFT OF CHARLES LANG FREER, F1897.48.

Shino ware comprises different vessel forms and there are many variations. Indeed, Shino has always been an integral part of the potter's aesthetic, and is very popular in contemporary utilitarian ceramics today. There have been more than a few contemporary potters who have devoted their working lives to perfecting Shino glazes. It was also a favourite of Tea masters in Japan as far back as the sixteenth century. Although it is known as the first white glaze to be used in Japan,[59] its colour range can vary dramatically depending on its composition, its thickness, the clay body of the pot and the firing. Traditional Shino is opaque and satiny white when thickly applied, and contains a high content of feldspar, with ash and clay also in significant amounts.[60] Red Shino usually has a thinner application of glaze, allowing iron oxide in the clay to come through. Potters creating Shino wares were also the first in Japan to use a sgraffito technique,[61] where the glaze is applied, then scratched through to show the clay body underneath. One much sought-after quality of Shino glaze is a fine pin-holing of the surface; this is called *yuzuhada* (citron peel). Shino is also known for red iron brushwork.

The Pottery Wars

Although Korean potters had been working in Japan for centuries, the Korean influence on Japanese ceramics in the sixteenth century was sudden and dramatic. During one invasion of Korea in 1594–96, the army of the warlord Toyotomi Hideyoshi captured and enslaved tens of thousands of Koreans, a huge portion of the population, bringing them back to Japan to work as farm labourers, domestic servants, concubines and skilled craftsmen. Forced into exclusively Korean settlements, they were largely kept apart from the Japanese population. Most were never allowed to return home. Some scholars believe that one of the main objectives of the invasion of Korea, along with the ultimate aim of moving on to conquer China, was to bring back skilled potters, since the practice of *chanoyu* had raised the value of Korean ceramic wares to astronomical heights. Potters, in particular, were targeted by the Japanese troops led by their *daimyō* (warlords), and whole pottery families were brought to Kyushu, Japan's large southern island. In fact, Hideyoshi's wars at this time are sometimes called the Pottery Wars or Teabowl Wars.

The loss of Korea's potters seriously damaged Korean pottery production for at least two generations.[62] However, their arrival in Japan marked a dramatic advance in Japanese ceramics. Korean potters brought the *noborigama*, but importantly, they also brought a different aesthetic. Among the stoneware ceramics centres that arose or further developed as a result of this influx of Korean pottery families are Karatsu, Agano, Hagi, Satsuma and Takatori.

Karatsu and Hagi are both closely associated with *chanoyu*. In considering *wamono* (ceramic tea ceremony wares), the saying goes, 'One Raku, two Hagi, three Karatsu'.

Like Korean wares, Hagi and Karatsu kilns produced everyday utilitarian vessels that came to be highly valued because of their incorporation into *chanoyu*, and soon after the influx of Korean potters, Hagi and Karatsu began to produce wares specifically for *chanoyu*. Milky glazes characterize the highly treasured Hagi wares. Because it is low-fired it retains some absorbency, and the glaze colours of Hagi darken and appear warmer with use and age. The new techniques also included *mishima* (inlay), *kohiki* (white slip) and *hakeme* (brushed white slip).

Karatsu wares are known for their iron underglaze designs, and are usually broken down into eight different types, from plain to figured, and include green, yellow and black glazing, sometimes with iron underglazing (see figure 39). One of the original Korean families, the Nakazato, continues to produce traditional wares in Karatsu. The current Nakazato is the fourteenth generation potter. The twelfth Nakazato Taroemon (1895–1985) was named a Living National Treasure.

Figure 39: Jar, Karatsu ware, Momoyama period (1573–1615). Stoneware with painted decoration in underglaze brown iron, 11.4 × 15.2 cm. THE METROPOLITAN MUSEUM OF ART, WWW.METMUSEUM. ORG, DR AND MRS ROGER G. GERRY COLLECTION, BEQUEST OF DR AND MRS ROGER G. GERRY, 2000.

Kyoto ware

In Kyoto, the Raku family had become established as successful potters, providing *chawan* for the Tea masters of the day. Alongside, a new, more ornate ceramic aesthetic also developed. Much of this work, called *kyō-yaki* (Kyoto ware), was specifically created for use in the tea ceremony. Just as the Raku family potters were recognized individually, so were those working in the new Kyoto style. Two men in particular were influential in crystallizing this new ceramic aesthetic for *chanoyu*. They were Nonomura Ninsei and Ogata Kenzan.

Figure 40: Workshop of Nonomura Ninsei (1598–1666), *Ninsei-Style Incense Burner with Flowers of the Four Seasons.* Stoneware with overglaze enamels, 17.1 × 18.4 cm. THE METROPOLITAN MUSEUM OF ART, WWW.METMUSEUM.ORG, H. H. HAVEMEYER COLLECTION, BEQUEST OF MRS H. H. HAVEMEYER, 1929.

The potter Nonomura Ninsei (1598–1666) worked in the style called *kirei-sabi*, or elegant simplicity, which the Tea master Kobori Enshū advocated. He worked under the guidance of the tea master Kanamori Sōwa (1584–1656). Ninsei was particularly known for his incense burners, on which he used an overglaze enamel technique for stoneware, which he developed (see figure 40). He also produced many teabowls characterized by the application of highly refined graphic designs to the outsides of the bowls.

Ogata Kenzan (1663–1743) was a student of Ninsei's, and like Ninsei, he specialized in brushwork, using his skills as a noted painter and calligrapher. Often the designs drew on popular tropes found in Chinese literature and painting (see figure 41). Kenzan was also noted for his *utsushi* pieces, where he reinterpreted designs from other ceramics, such as Oribe and Karatsu wares, and from further afield, such as wares from Holland and Southeast Asia.

Figure 41: Ogata Kenzan, Incense burner with design of mountain retreat, 1712–*c*.1731. 6.1 × 8 cm. FREER GALLERY OF ART, SMITHSONIAN INSTITUTION, WASHINGTON D.C.: GIFT OF CHARLES LANG FREER, F1898.440.

Porcelain in Japan

Porcelain ware, which was developed in China in the eighth century, had been brought back to Japan from China and Korea for centuries by the many Japanese monks, scholars and government officials who travelled abroad. Japanese potters lacked some of the raw material used in porcelain, as well as the knowledge and techniques needed to use it, and were late in developing it themselves. Porcelain differs from other ceramics significantly. It can be fired to a higher temperature and is generally more vitrified (harder and less absorbent) than earthenwares and stonewares. The clay body is often whiter, giving a good colour response to glazing, and when thin, it can be translucent. It is unclear who exactly produced the first porcelain ware in Japan, and it is likely to be a complex and interweaving story, but by legend it was Korean potters brought back in the Pottery Wars. It is said that the Japanese also brought porcelain clay back in some quantity at the same time, and when supplies dwindled, the feudal lord Naoshige Nabeshima tasked Yi Sam-pyeong (known in Japan as Kanegae Sanbei or Ri Sampei), one potter who was brought back from Korea, to find a local source of kaolin or china clay, one of porcelain's necessary ingredients. In this narrative, Kanegae finally found it in 1616 in Arita, marking the beginning of porcelain production in Japan. Potters in the area went on to set up porcelain production of many types there, challenging the exclusivity of imports from south China, some of which had been specifically produced for the Japanese market.

The first porcelain ware produced in Japan is called early Arita (or Hizen), after where it was made, or early Imari, after the port from which it was shipped. Only a few decades after production was set up in Japan, unrest in China caused a decline in their porcelain exports, and through Dutch traders in Nagasaki, Japanese porcelain centres began to export wares directly to Europe (see figure 42). Initially, the exports were based on Chinese examples provided by the Dutch. These pieces, which did not necessarily reflect Japanese taste, or not Tea taste, were the first ceramics out of Japan to arrive in Europe and the United States in quantity, and therefore the first wares to which many Europeans and Americans were exposed, greatly influencing their view of Japan (see figure 43). Porcelain production spread to other sites in Japan, and its development resulted in many styles. One of the most famous is *Kakiemon*, known for its fine decorative overglaze enamelling.

The *wabi* aesthetics set down for teabowls by Sen no Rikyū and others around the sixteenth century shifted attention away from porcelain, which was seen as a luxury item, and it is, arguably, *wabi* teabowls that have had the greatest influence on contemporary studio pottery and ceramics. Most of the porcelain production that developed in Japan in the seventeenth century veered away from the more subdued *wabi-cha* ceramics and aesthetics, although some porcelain centres did make production teabowls. One development in contemporary teabowls has been the use of porcelain in teabowls aimed at *wabi* aesthetics.

(opposite) Figure 42: Arita ware, plate with monogram of the Dutch East India Company, *c.*1660. Underglaze blue, 31.4 × 6 cm. THE METROPOLITAN MUSEUM OF ART, WWW.METMUSEUM.ORG, DR AND MRS ROGER G. GERRY COLLECTION, BEQUEST OF DR AND MRS ROGER G. GERRY, 2000.

The Meiji era

The period of *sakoku* (1630s–1850s), so-called 'closed country', can in many ways be seen as a time of Japanese aesthetic consolidations, a time when the grand masters of the various Tea schools exerted tremendous influence through teaching, patronage and the *iemoto* system of granting names to utensils, which goes back to the Muromachi era (1336–1573). This was an important part of *chanoyu* heritage, each 'naming' clarifying and solidifying the aesthetic. As Allen Weiss says in *Zen Landscapes: Perspectives on Japanese Gardens and Ceramics*, 'To name an object, whether univocally or equivocally, is to situate it within a symbolic and historical matrix … '[63] He continues, 'Zen aesthetics are exemplified by suggestion and allusion, valorizing the attenuation of the literal by the indistinct, the shadowy, the obscure, the hazy.'[64] Names often draw attention to indistinct and shadowy qualities, such as seeing Mount Fuji in the glaze of a teabowl, and may allude to poetical phrases or words. The quality of this complex understanding of landscape in a teabowl is known as *keshiki*.

Internal and external pressures resulted in the fall of the shogunate in 1868, and a new government was established, with the emperor, now called Emperor Meiji, or 'Enlightened Rule', reinstated as its head. Japan officially 're-opened' in 1854 with treaties with the Americans, and trade with the United States and Europe expanded dramatically, although this was initially one-sided, mostly benefitting the West. The importation of cheap Western goods undermined traditional craftsmen in Japan, and many traditional arts, such as *chanoyu* and ceramics, suffered for a time. The Japanese embraced modernity and foreign influences, again eagerly looking outward to the world beyond its shoreline. However, as the Japanese were looking out, those in Europe and North America were looking in, and for the first time, more than just a handful of people in the West began to see more of the arts specific to Japanese culture and the aesthetics they reflected.

(opposite) Figure 43: Dish with rocks, flowers and birds (1710–1730), Hizen ware, Imari type. Hard-paste porcelain with coloured enamels under transparent glaze, 19.4 cm. THE METROPOLITAN MUSEUM OF ART, WWW.METMUSEUM. ORG, THE HANS SYZ COLLECTION, GIFT OF STEPHAN B. SYZ AND JOHN D. SYZ, 1995.

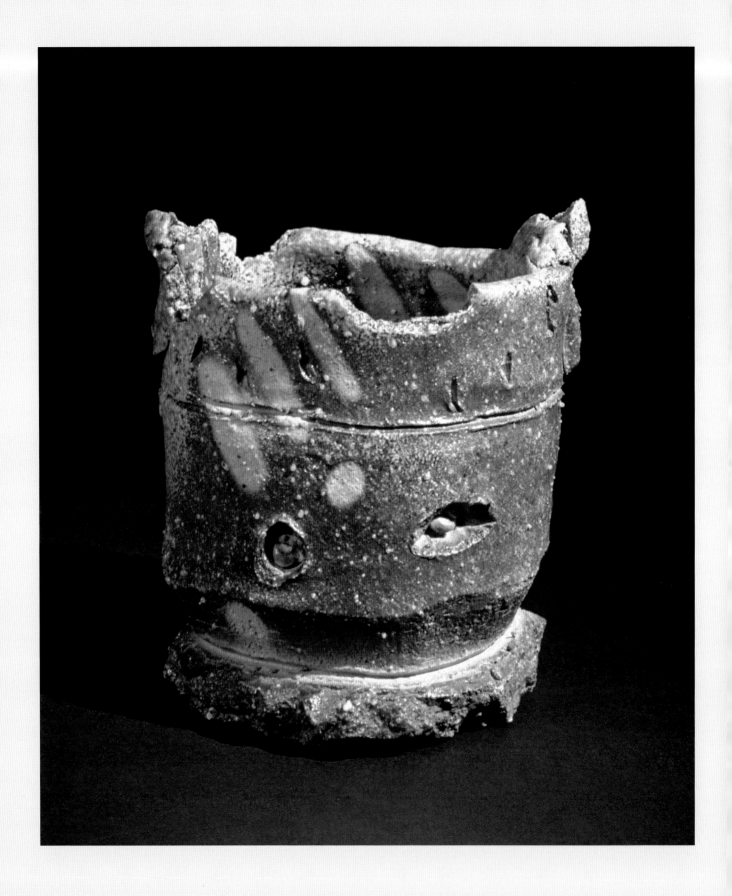

CHAPTER THREE

The teabowl travels

By the late nineteenth century, colourful and elegant Japanese porcelain wares had been imported into Europe for many years (and copied there). With the ending of *sakoku*, the period of isolation, many products other than porcelain flowed out of Japan, increasing Europe and America's desire for what were perceived as exotic Japanese goods. Although the Aesthetics movement, Japonisme, Impressionism, the Arts and Crafts movement and Art Nouveau were all influenced by the surge in these imports, Japanese influence in these movements was not uniform and homogeneous. Some artists 'grazed', picking out objects and ideas that struck their fancy and including them in their paintings with little understanding of their contexts. Others became entranced with Japanese culture, studying and practising Zen Buddhism, for instance.

With the Meiji era, the popularity of Japanese artefacts at world's fairs and expositions in London, Paris, Vienna and the United States further boosted the infatuation with Japan, as did the publication of books and stories by writers such as Lafcadio Hearn, Arthur Waley and Ernest Francisco Fenollosa, who was curator of Oriental Art at the Boston Museum of Fine Arts. In the United States in particular, the acquisition by the Boston Museum of Fine Arts of a significant collection of Japanese ceramics gathered by Edward Morse in his visits to Japan in the 1870s and 1880s did much to acquaint the American public with Japanese ceramics. Morse collected over 5,000 pieces of Japanese pottery and coined the term 'Jōmon'.

As the Japanese began to travel abroad and foreigners were allowed into Japan, the interest in Japanese culture and aesthetics in Europe and North America continued to grow. However, outside of a few museums and private collections, the Japanese ceramic aesthetic that Europeans and Americans were exposed to was largely limited to recently developed industrial porcelain production. It seems there was little more than a whisper of teabowls and the tea ceremony aesthetic reaching the general public before the twentieth century.

In the wider art world the Japanese approach to art and Zen Buddhism exerted influence well into the twentieth century. For instance, in this passage, written by the painter Wassily Kandinsky, we see references that could mirror a Zen approach:

> Again and again; so much of what belongs to Western art becomes clear when one sees the infinite variety of the works from the East, which are nonetheless subordinated to and united by the same fundamental 'tone'! It is precisely this

(opposite) Figure 44: Peter Voulkos, *Untitled Tea Bowl*, 1999. Soda-fired stoneware, 20.3 × 18.4 × 16.5 cm. © SCHOPPLEINSTUDIO.COM, COURTESY OF THE VOULKOS & CO. CATALOGUE PROJECT.

general 'inner tone' that is lacking in the West. Indeed, it cannot be helped: we have turned away, for reasons obscure to us, from the internal to the external. And yet, perhaps we Westerners shall not, after all, have to wait too long before that same inner sound, so strangely silenced, reawakens within us and, sounding forth our innermost depths, involuntarily reveals its affinity with the East – just as in the very heart of all peoples – in the now darkest depths of the spirit, there shall resound one universal sound, albeit at present inaudible to us – the sound of the spirit of man.[65]

Many artists of the time sought to create work not only through technical skill and the intellect, but within a kind of direct experience – a Zen approach. Artists were beginning to gain a different view of Japan, which included a far more nuanced understanding.

The early twentieth century

The publication of Kakuzō Okakura's *The Book of Tea*, in the United States in 1909 and in 1929 in France, further contributed to the European/American understanding of Japanese culture and Zen aesthetics with it. The book served as an apology or an explanation of the underpinnings of *chanoyu* by grounding the tea ceremony in its Japanese context.

The Mingei movement, a significant influence in ceramics in Japan, Britain and the United States, was started by Yanagi Sōetsu, Hamada Shōji, Bernard Leach and others in 1926. Developing as a countermeasure to Japan's rapid industrialization, and aiming for a return to a pre-industrialized folk craft aesthetic, the Mingei movement mirrored some of the tenets of the Arts and Crafts movement in Britain. Hamada Shōji and Bernard Leach (who had studied ceramics with Ogata Kenzan VI) moved from Japan to Britain in 1920 and opened a pottery in Cornwall (figure 45). Hamada returned to Japan in 1923, settling in the pottery town of Mashiko. Many of the ceramic wares created within the movement held to the aesthetics of *chanoyu*, even though Yanagi himself felt that *chanoyu* had become stultified and advocated that new styles of tea ceremony be created with new utensils. Both Leach and Hamada made teabowls, as did those who studied with them or followed them. Warren MacKenzie (US) is a good example, as he influenced many American potters after him.

During the Second World War the love affair with all things Japanese conflicted with the idea of Japan as a reviled enemy. In some American museums, Japanese artefacts were stored away for the duration of the hostilities. It wasn't long after the war, however, that the passion for Japan blossomed again, especially in the United States. American G.I.s flooded into Japan during the Allied Occupation (1945–1952). By the end of 1945 there were over 400,000 servicemen there, two-thirds in the

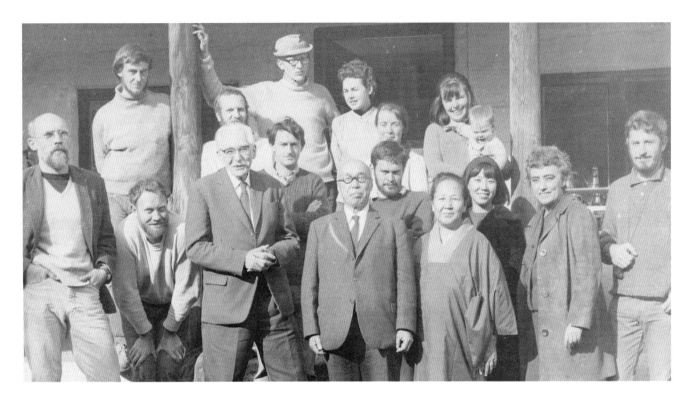

Tokyo area. These soldiers, sailors and airmen experienced Japan first-hand, although usually from the tilted and skewed perspective of the American victors in a country devastated by bombing and deprivation. Starting at the end of the Occupation, American soldiers serving in the Korean War were regularly sent to Japan for five-day R&R (rest and recuperation), and Tokyo was also a destination for US soldiers in Vietnam. It is no wonder that Americans were keen to learn more about Japanese culture, art, religion and craft. Returning stateside, these young servicemen were entitled to free education under the G.I. Bill of Rights, and many ceramics courses were added to college curriculums to accommodate them.[66]

Zen in the West

Published in Germany in 1948 and in the United States in 1953, Eugen Herrigel's *Zen in the Art of Archery*, which spoke less about the objects of Japan and more about one man's quest to comprehend Japanese and Zen culture, deepened the perception of the mystique of Japan. This was followed over the years by a plethora of 'Zen in … ' books, from *Zen in the Art of Flower Arranging* (1958) to *Zen and the Art of Motorcycle Maintenance* (1974), and on into the present day, as individuals strove to understand this foreign worldview and to some extent, absorb it into their own.

The early and middle part of the twentieth century saw more Japanese scholars visiting abroad. The most influential was Suzuki Daisetsu (Daisetz), a professor of

Buddhism, who lived for many years in the United States. He lectured extensively, including in the United States, Britain and Germany, and taught a series of seminal classes in Zen Buddhism in the early 1950s at Columbia University in New York. Some of those influenced by Suzuki include the composer John Cage, psychologist Carl Jung, writer Thomas Merton, poet Allen Ginsberg and potter Bernard Leach. Suzuki's books, especially *Zen and Japanese Culture* (1959), secured his position as the leading authority outside of Japan on Zen and Japan. As George Lazopoulos writes, 'Suzuki almost single-handedly introduced Zen to the West … [and] had a truly massive impact on 20th-century global thought.'[67] Zen, with its emphasis on individual self-enlightenment, seemed to many to further their quests for personal expression.

Zen, art and ceramics

In ceramics, the impact of Suzuki's Zen can be seen not only through Bernard Leach's legacy in Britain, but also through the impact of Zen on the American art and craft scenes. Helen Westgeest suggests in her book *Zen in the Fifties: Interaction in Art between East and West* that artists in the United States were ripe for Zen because influences such as Transcendentalism, seen in the writings of noted figures such as Ralph Waldo Emerson, Henry David Thoreau and Walt Whitman, were already woven into the fabric of American culture.[68]

Existentialism and psychoanalysis, both based on understanding the individual, undergirded much aesthetic understanding at the time, and Zen seemed a continuation of personal development. Many artists, such as Kandinsky, Mark Tobey and Yves Klein, embraced the precepts of Zen aesthetics.

The art historian Jenni Sorkin has done extensive work into the Black Mountain College Pottery Seminar held 15–29 October 1952. Black Mountain College in North Carolina already had a reputation for being experimental and avant-garde (with artists such as Willem de Kooning, Robert Motherwell and Robert Rauschenberg creating artwork there) when they brought in Yanagi, Leach and Hamada as speakers and demonstrators for the pottery seminar. Those attending were professional potters and instructors, who took the knowledge they gained about Japanese ceramics and Zen Buddhism back to their ceramics communities.[69] Two of the potters who taught at the college went on to write influential books in ceramics. M. C. Richards' book *Centering in Pottery, Poetry, and the Person* (1962), had an impact on many potters of the time. Daniel Rhodes wrote one of the ceramics bibles, *Clay and Glazes for the Potter*, in 1957, and in 1970 he wrote a book titled *Tamba Pottery: The Timeless Art of a Japanese Village*.

Sorkin reports that at the pottery seminar Leach and Hamada performed a kind of double act, with Hamada throwing silently and Leach narrating. In this way Hamada presented the image of the enlightened Zen Buddhist monk, fully in the moment and of the moment.[70]

It is easy to see how this 'of the moment' experience would appeal to potters. The creation of ceramic works is a full-body experience that sometimes demands utter concentration. From the first instance, we wedge the clay using our whole bodies. On the wheel our whole torso bends forward towards the clay. To make clay coils we hold the clay in our hands just in front of our chests. To pinch a pot, we may cradle the developing forms in our laps. Because of this, potters have always felt a natural closeness with their material, and this bodily experience is a very personal one. Hamada's meditative throwing resonated with this, resounding loudly around America and beyond, and the teabowl, held in both hands, sharing the warmth of the tea, was on its way to becoming an iconic form in contemporary ceramics.

A loud form of Zen

Peter Voulkos, the driving force behind the 1950s movement variously called the California Clay Movement, the American Clay Revolution and the Craft-to-Art Movement, was one of the most influential ceramic artists of the twentieth century. He taught at Black Mountain College the summer following the pottery seminar. There he met the musician John Cage and the dancer Merce Cunningham. Both were exploring Zen, searching for new approaches in their fields. This period at Black Mountain College is often cited as pivotal for Voulkos.[71] Like Cage and Cunningham, Voulkos focused attention away from the finished object and onto the process, allowing the making and the material to be read from the finished piece, and bringing to light the performative nature of creating ceramics. Voulkos's early, careful teabowls, functional and quiet in aesthetic, were soon replaced with more experimental work, culminating in the 1990s with his most dynamic, forceful and challenging teabowl forms (figure 44). It was as if becoming familiar with Japanese *wabi* ceramics allowed him to gush forth with what can be seen as a precursor of the 'sloppy craft' movement of today.

The teabowl was clearly important to Voulkos. When asked in an interview for *Clay Times*, 'If you had a chance to own any piece of art in the world, what would it be?', he replied:

> … I do love the old Japanese tea bowls. Millions of bowls were made to get to that one. It takes them days and days and days, just like me workin' on a stack [one of his signature forms], to get the whole universe in a tea bowl. I had a vision once that I was a potter out of Kyoto someplace, dressed in those weird robes and stuff. The year was about 1250 A.D. I swear to Christ that I was around at that time. The Kamakura period. The last time I was in Japan, I found this little cup in an antique shop. The guy said it was made in the Kamakura period. I was just taken by it, of all the stuff in that store. It was pretty cheap, so I decided I'd better buy it – I might have made it! Yeah, yeah … [72]

Outside of the art world, the 1950s are often seen as a time of conformity, a time when a generation recovering from a long and horrendous war wanted peaceful lives. Not surprisingly, many young artists sought the opposite of conformity, striving to express their individuality loudly and fully. Doing just this, Voulkos, with a full-body theatrical style, demonstrated his clay craft to students, other clay artists and the wider public, influencing and inspiring a generation. Collette Chattopadhyay feels that 'Voulkos melded interests in Zen flux and change with the concern for self-expression inspired by psychoanalysis.'[73] There is a delightful contradiction inherent in this: an American using a Zen approach to explore individualism and self-expression, when in Zen, the principle of *mushin*, or 'no mind', predicates that in reaching self-enlightenment, an individual attains a state of no ego – hardly a state that characterized many artists of the era.

Western or American raku

In the first half of the twentieth century, many potters learned of Raku firing (where ceramic wares are taken out of the kiln while the glaze is molten) through Bernard Leach's *A Potter's Book*, first published in 1940. In it he described a Japanese Raku party he attended in 1911. It was clearly a defining moment for Leach: 'As a result of this experience a dormant impulse must have awakened, for I began at once to search for a teacher and shortly afterwards found one in Ogata Kenzan … By him I was taught how to make raku and stoneware according to Japanese tradition.'[74] He went on to give recipes and explanations of the technique. At the time of the publication of *A Potter's Book*, Warren Gilbertson, who had learned the technique in Japan prior to 1940, was already practising raku firing in the United States, and gave a lecture on it to the American Ceramic Society in 1942. Hal Riegger was also making raku wares, and as a harbinger to what was about to happen to raku in America, he was also experimenting with post-firing reduction (where the ceramic ware is deprived of oxygen after removal from the kiln). He was teaching raku techniques as early as 1958 at Haystack Mountain School of Crafts, and published articles on it in *Ceramics Monthly* in 1965. Jean Griffith was also experimenting with raku and post-firing reduction at the University of Washington, using Leach's book as a guide.[75]

It is Paul Soldner (1921–2011), who also read Leach's book, who is hailed as the Father of America raku.[76] In an address to the International Ceramics Symposium in 1989 he explained how American raku was invented:

Had it not been for a serendipitous hunch, I doubt whether I would have ever again tried to make raku. Dissatisfaction with the results gave me the courage to roll the red-hot pots in some pepper tree leaves, hoping that the accompanying smoke might improve the surface. The rest is history. I was hooked and began

to explore this process. It changed my life. It also changed my work. I developed an appreciation for the imperfect, for the beauty of asymmetry, and for the value of an organic aesthetic. I found a new freedom of openness and acceptance.[77]

Soldner, who was Peter Voulkos's first graduate student at Los Angeles County Art Institute (now Otis College of Art and Design), followed in his teacher's footsteps in presenting ceramics as spectacle, giving over four hundred lectures, seminars, demonstrations and workshops, as well as exhibiting internationally. In Western raku, the red-hot pot is removed from the fiery kiln, just as it is in Japanese Raku, but it is then placed into some kind of container with combustible material, commonly sawdust, paper, leaves or seaweed. The hot pot ignites the material with dramatic, flaming results. More material is put on top and the container is closed. As the fire continues to burn, it runs out of oxygen, causing a reduction atmosphere, and the fire 'takes' oxygen from the clay and glazes. This significantly changes some glaze materials, such as copper, often resulting in bright metallic lustres. In addition, the dark smoke of the atmosphere permeates the ware, darkening the exposed parts of the clay and seeping into cracks and crevasses to give distinctive accentuating crackle effects.

Soldner referred to raku as 'fun, quick, and exciting'.[78] A raku firing can indeed be a spectacle: the heat, the sense of danger, the crackling and spitting, the pops and bangs of pots exploding if not dried properly before firing, the loud hissing of the pots as they suddenly cool in water, the oohs … the aahs … of the audience and participants. Western raku is a very physical experience, and can be a very noisy, aggressive and macho business. All of this no doubt appealed to the showman in Soldner as much as did the vibrant colours, textured surfaces and the unpredictability of the final results (figure 46).

The new, dramatic, irregular surfaces created through post-reduction treatments appealed to those artists who had already absorbed something of the Zen aesthetic of traditional raku firing, and also inspired those new to ceramics. Raku was the way that many European and American potters discovered the teabowl. In his 1990 speech Soldner credited Gilbertson with being 'the first to call attention to the making of Japanese raku tea bowls'.[79] This shows how closely teabowls and Western raku have been linked from the start. Soldner does not leave the Zen of the teabowl behind:

It is a feeling of rakuness. Can a simple tea bowl be imbued with this quality? Yes, if it is special enough. Understanding raku in this more elite and spiritual way broadens its scope – beyond the limited process we once thought it was – and challenges each of us to embrace the effort needed to set our own work free. The struggle to attain rakuness can consume a lifetime – with only fleeting moments of success.[80]

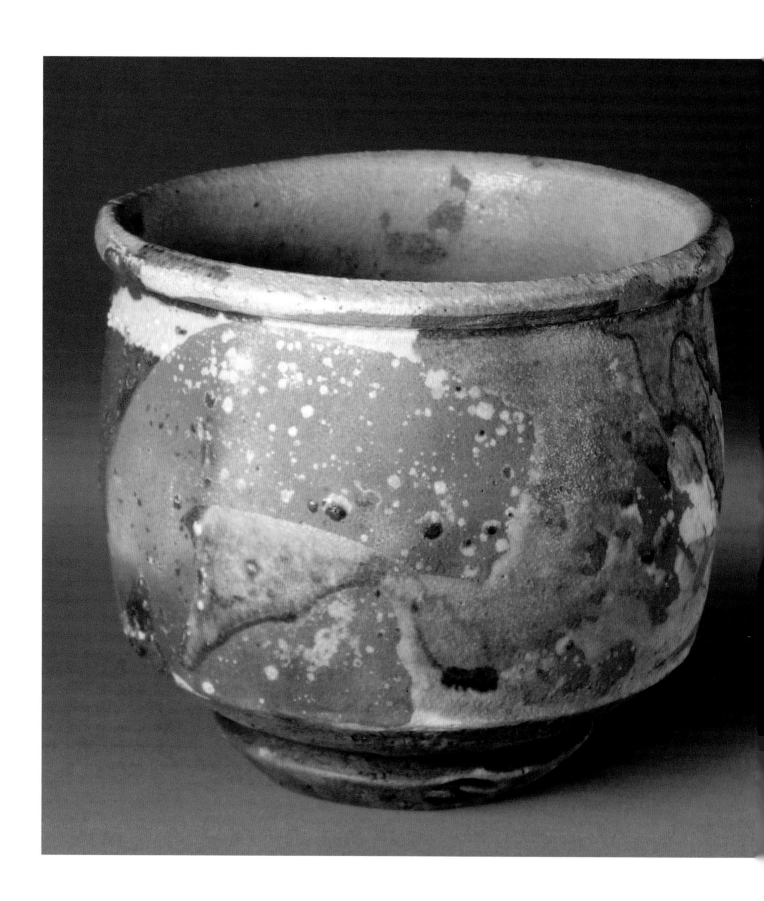

Richard Hirsch was another pioneer in Western raku, who along with Soldner visited Raku Kichizaemon XIV in Japan in 1978. It was at a demonstration attended by Crown Prince Akihito and Kichizaemon that Soldner and Hirsch discovered that the Japanese did not use post-reduction after Raku firing. Kichizaemon was insistent that their firing technique not be called Raku, but Western raku in America was already so popular by then that there was no going back. Those who understand the differences do, however, now distinguish between Raku and Western raku.

Although an early teabowl maker, Hirsch is now known mostly for his strong, abstracted ritual-like forms. His approach exemplifies how the Zen of raku (and therefore the teabowl) has continued into other contemporary genres:

Raku, for me:
Encompasses acceptance of the unexpected
Seeks out discovery and joyful surprise
Rejects the notion that the accidental is always fortuitous
Relies on experience, discipline and focus to achieve success
Incorporates the utilization of intuition and improvisation
Balances spontaneity and looseness with controlled skilfulness
Strives for a seamless fluidity between concept, material, process and technique
Ultimately, in spending most of my working career as an artist seeking to define this term, raku has become my personal philosophy, not merely a way of working, but a way of life.[81]

Although many teabowls created in this genre were and are used, the teabowl in these artists' raku repertoires signals a significant development in contemporary ceramics, a moment when a utilitarian item, a Japanese teabowl, became a sculptural object, having lost its function through cultural relocation.

Wood-firing and Western *anagama*

While some potters outside Japan were exploring the new raku technique, others were experimenting with *anagama* and other wood-firings (figures 47, 48). The *anagama* kiln and teabowls are closely tied, historically and contemporarily. A few of the many potters who make *chawan* and fire in *anagama* or wood-fired kilns include Janet Mansfield, Chester Nealie, Steve Harrison, Ian Jones, Peter Rushforth and Cher Shackleton in Australia; Rob Barnard, Tim Rowan, Steve Sauer, Lucien M. Koonce, Jeff Shapiro, and Judith Duff in the United States; Nic Collins, Svend Bayer, and Stephen Parry in the UK; and Uwe Löllmann in Germany. Many of these potters, such as Peter Callas (US), were pioneers; others, such as Tom Charbit (France), have come into a well-established wood-firing tradition and have taken the aesthetic in different directions.

(opposite) Figure 46: Paul Soldner, *Tea Bowl*, 1960s. Earthenware, 13.97 × 12.7 cm. LOS ANGELES (CA), LOS ANGELES COUNTY MUSEUM OF ART (LACMA), GIFT OF PAULINE BLANK, 2015. ©PHOTO SCALA, FLORENCE. DIGITAL IMAGE MUSEUM ASSOCIATES/LACMA/ARTRESOURCE NY/SCALA, FLORENCE.

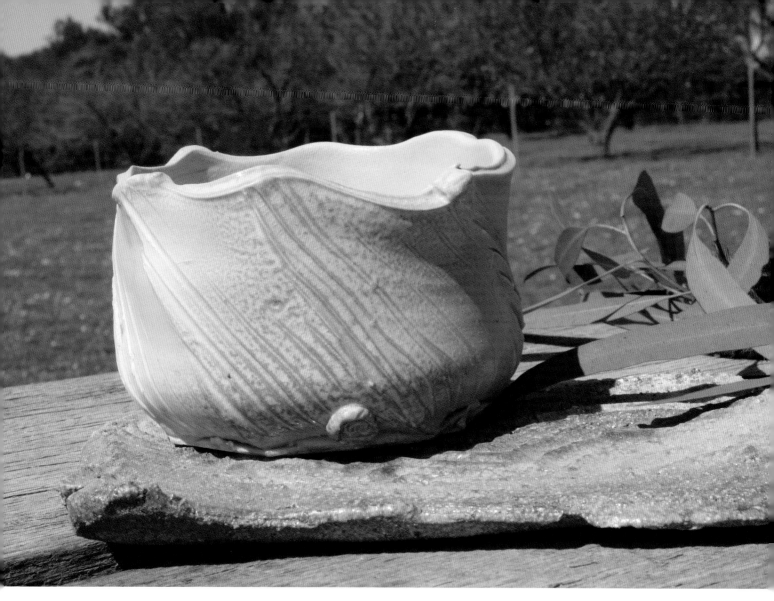

Figure 47: Cher Shackleton, *Chawan*, 2011. *Anagama* wood-fired textured porcelain, 8 × 10 cm. PHOTO BY THE ARTIST.

One European technique that is often associated with teabowls is salt, sodium or soda glazing, which originated sometime around the twelfth to fifteenth century in Germany and was well established in Britain by the late seventeenth century. Bernard Leach wrote about salt glazing in *A Potter's Book*, and Hamada Shōji introduced the technique to Japan in the 1950s. The potential unevenness of the surface, the 'orange peel' texture and the possible accidental flashes of this glaze technique, especially when used with other glazing, suit the *wabi* aesthetic of the teabowl. Like fly ash glazes, where the ash coming from the burning wood settles on the pots and creates a glaze, salt glazes are created through firing rather than applied beforehand. In salt firing, salt is introduced when the kiln temperature is hot enough for the salt to vaporize, and as the vapour moves through the kiln it reacts with the clay on the surface of the pots and forms a glaze. Slips and glazes can be applied before salt firing, achieving different colours and qualities.

In the 1970s, in an effort to produce the same results that are achieved in salt glazing without the possible environmental risks (resultant hydrochloric acid and caustic soda), students at Alfred University in New York State began firing with soda.

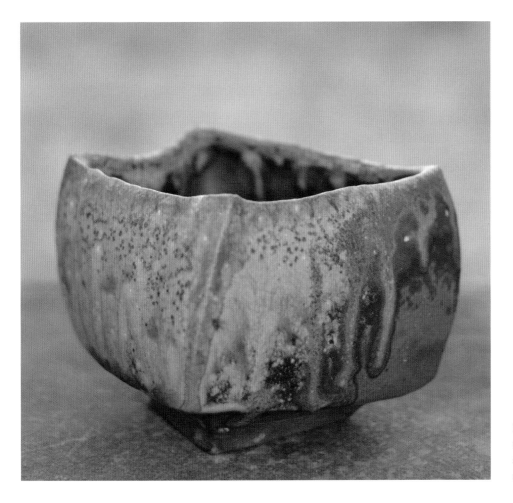

Figure 48: Tim Rowan, untitled teabowl, 2014. Wood-fired stoneware, 7.6 × 10.1 cm. PHOTO BY LINDA MORIARTY.

It did not take long for soda firing to become established, and soon potters were developing an aesthetic for soda firing that was independent of salt firing. Many say it produces brighter colours but with a softer definition, with more variation in the surface texture and glaze distribution. Many teabowl makers use or have used salt or soda firing, including Tatsuzō Shimaoka in Japan; Jane Hamlyn, Lisa Hammond (see figure 49), Phil Rogers, Ruthanne Tudball, Peter Starkey and Jack Doherty in the UK; Gail Nichols and Greg Crowe in Australia; and Jack Troy, Jeff Oestreich and John Chalke in North America.

Even using Japanese kilns, like the *anagama*, and creating an iconic Japanese form, such as the teabowl, one's own cultural heritage can never be lost or fully discarded. For example, Milton Moon says of his *'Outback' Chawan* (figure 50), 'The dry feeling of this tea-bowl expresses the Australian "outback" lands. The contradiction, of course, is that anything as culturally refined as a tea ceremony is the last thing one would expect in this outback land.'[82]

Some artists have stayed close to the Zen aesthetics of *chanoyu*, studying the art or its ceramics. American Richard Milgrim has devoted his working life to *chanoyu*,

Figure 49: Lisa Hammond, untitled *chawan*, shown 2014. Stoneware with Shino glaze, 12 × 10 cm. PHOTO BY MICHAEL HARRIS, COURTESY OF OXFORD CERAMICS GALLERY.

(below) Figure 50: Milton Moon, *'Outback' Chawan, c.*1980s. Stoneware, wood and gas fired with ash glaze. PHOTO BY THE ARTIST.

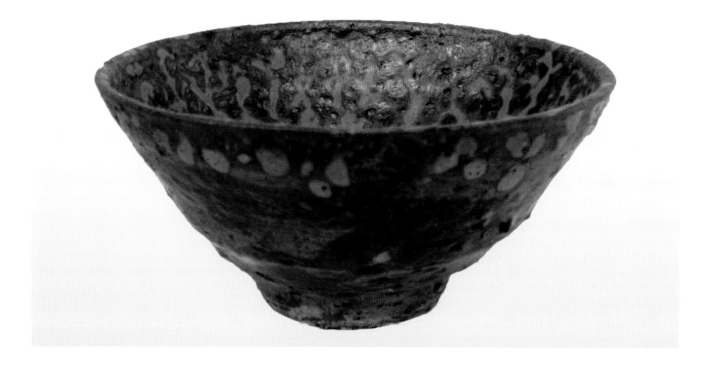

Figure 51: John Baymore, *Chawan*, 2015. Hand-built, *anagama* fired with thin American-style Shino glaze and *shizenyu* (natural fly ash), 12.8 × 12.5 × 9.5 cm. PHOTO BY THE ARTIST.

both as a Tea practitioner and as a producer of ceramic utensils for *chanoyu*, and has gained the patronage of Sen Genshitsu, the fifteenth Grand Master of Urasenke Tea school. Yet even Milgrim, who lives and works in Japan, reflects his American-ness in his *chawan*. As Robert Yellin has said of him:

> While making *chawan* the potter says he experiences many varied thoughts, feelings and moods. Those emotions come out very clearly in his *chawan*; there's joy, moodiness and humor as well as a certain austerity here. Almost all his *chawan* draw on classical examples of the Momoyama period (1568– 1615), yet there is certainly that "something" about them that is all-Milgrim, especially in the imaginative use of design on his Shino *chawan* and the way he overlaps glazes on others.[83]

Another American contemporary *chawan* maker who acknowledges and works within the *chanoyu* tradition is John Baymore, who fires a *noborigama* kiln. Baymore also teaches a '*Chawan* for *Chanoyu*' class, which includes some tea ceremony instruction, in the Ceramics Department of the New Hampshire Institute of Art (figure 51).

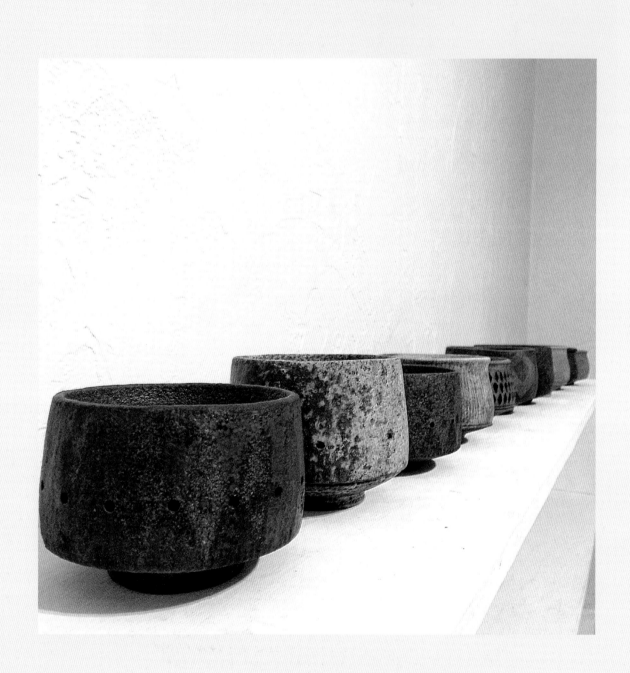

From tearoom to gallery

Ceramic artists in Europe and North America began to make teabowls as soon as they learned about them. From the start, experimentation was inescapable, if for no other reason than the difference in available materials demanded it; even those who were trying to replicate the classic Japanese *chawan* were discovering new approaches. In addition, although pottery is a hands-on activity, in fact many decisions, conscious and unconscious, are made throughout the making, glazing and firing, and ceramicists outside Japan making teabowls make those decisions within the context of their own training, education, and cultural heritage (see figure 52).

Although some ceramicists developed teabowls through or alongside experience of Japanese culture, most contemporary teabowl makers outside Japan know little, or sometimes nothing, about *chanoyu*. Some have been drawn to the *chawan* through exposure to Zen Buddhism and European and American-based arts that embraced Zen, such as some forms of painting. Others have fallen under the teabowl's spell through raku firings or simply by seeing teabowls as they began to appear at ceramics fairs and in exhibition. For some, the teabowl is simply a form to be explored, technically and aesthetically, a tabula rasa onto which an artistic voice can be projected. For these potters, the teabowl's original function has, if considered at all, become a secondary concern. In this way, all contemporary teabowls made outside Japan, and increasingly some contemporary teabowls made within Japan, fall into natural, if sometimes overlapping, divisions: the functional and the non-functional. Some might say that teabowls not made to be used can no longer be referred to as teabowls. However, if not clearly teabowls, they should at least be considered the teabowl's offspring, and many, in fact, continue to express *wabi* and other aesthetic understandings inherent in more traditional teabowls, and therefore deserve the label, or perhaps the more specific designation of 'contemporary teabowl'.

Within the category of functional teabowls, the twentieth and twenty-first centuries have brought innovations or developments within traditional ceramic techniques, such as decorative brushwork, slip trailing, *nerikomi* (a technique using coloured clays), the use of calligraphy and *kintsugi*. European techniques new to Japan, such as salt and soda firing, have also been incorporated into the contemporary teabowl aesthetic.

Once we enter into the world of the sculptural teabowl, the influence of European, North American and Australian contemporary ceramicists have made an even more distinctive mark. Contemporary graphic techniques have been introduced to the

(opposite) Figure 52: Ernest Gentry, *Tea Bowl*, 2015. Reduction-cooled wood-fired iron-rich stoneware, various sizes. PHOTO COURTESY OF SCHALLER GALLERY.

teabowl, and those graphics now communicate contemporary themes and concerns, such as political satire, popular narrative and social commentary. The teabowl as a form of expression of intimately personal issues, such as grief and compassion, is also being explored. Finally, the teabowl is now being incorporated into the wider spheres of sculpture, with site-specific work, installations and performance art.

Some contemporary Japanese makers

As do all artists, Japanese potters produce teabowls within the framework of their own heritage. Even for those who know little about tea ceremony, and this is common in younger generations, the teabowl is never a blank slate because tea ceremony is woven into the fabric of Japanese culture. Some potters are born into a strong ceramic legacy and continue to produce *chawan* in the particular styles they inherit. Some have chosen to turn away from the teabowl heritage, challenging the form and all it stands for. Others are born into the legacy but have sought ways of extending their particular inheritances. This can be seen in the work of young Bizen potters Ishida Kazuya, Yuta Shibaoka, Baba Takashi, Fujita Masahiro, Mori Ichiro and Mori Toshiaki, all sons of established Bizen potters. Ishida Kazuya has pushed our awareness of the pottery wheel's centrifugal force with bowls that twist and flow (figure 53). Fujita Masahiro often uses the traditional Bizen rice straw wrapping on his pots. His rare *Aochawan* (blue teabowls; figure 54) are created through the close control of the reduction atmosphere in the ten-day firing. Potters have also absorbed European,

Figure 53: Ishida Kazuya, *Hikidashi Chawan*, 2013. Bizen stoneware, reduction fired in *noborigama* kiln, twisting technique on electric wheel, 10 × 11 cm. PHOTO BY MATSUKUMA FUMIE.

(opposite) Figure 54: Fujita Masahiro, *Aochawan*, 2015. *Nobirigama*-fired Bizen clay with *hidasuki* markings (rice straw wrapping), 8.5 × 11.1 cm. PHOTO BY AIZAWA SHINYA.

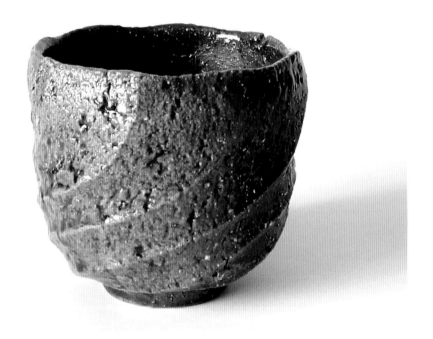

North American and Australian influences through art schools, by working abroad and through ceramic exhibitions, and now have a wide aesthetic palate from which to draw. This means that in Japan today the teabowl form is challenged as often as it is in other countries.

Contemporary *kintsugi*

The symbolism embedded in *kintsugi*, or gold repair, is universal, and the metaphoric richness of a broken pot made stronger and more beautiful has cultural and personal resonance. In addition, the philosophy of *kintsugi* feeds directly into the move towards sustainability. Pui Ying Kwan suggests in a paper on emotionally durable design that in the West our culture pushes us towards having new products rather than old or repaired ones.[84] Jonathan Chapman states, 'Modern consumers are short-distance runners, promiscuous debauchees who only stay for the getting-to-know-you period, when all is fresh, new and novel. In this way, it is clear to see that waste is nothing more than a symptom of a failed relationship, a failure that led to the dumping of the static one by the newly evolved other.'[85] Chapman suggests that the failure of the user/object relationship occurs when the object is no longer perfect, thus breaking our emotional attachment to it.

Kintsugi suggests a different paradigm. This is not to say that all things in Japan are revered and cherished. Japan is a modern state and carries all the modern problems of profligate waste arising from heightened consumerism. However, Japan has entered the 'throw-away' culture relatively recently, long embracing *mottainai*, a sense of loss when something has been lost or wasted, and *kintsugi* may be one of the best examples of the legacy of a culture new to an economic pattern of over-consumption and disposal.

Like the 'discovery' of the teabowl, contemporary makers have discovered *kintsugi*, and contemporary ceramicists have embraced it, although many use modern materials such as epoxy and other glues. Between 2012 and 2014 five contemporary craftspeople, supported by Arts Council England, produced work in a project titled *The Journey: Exploring the Nature of Mending*, exploring the concept of repair through cultural and emotional layers of meaning. One of the participants, Paul Scott (UK), has continued to use *kintsugi* in his artwork. In *Fukushima* (figure 55), part of *Scott's Cumbrian Blue(s)*, the artist's 'wave' is joined to a broken and reassembled *Willow* pattern platter, which is marked 'Japan (c.1965)'. The wave uses the motif of Hokusai's *Great Wave off Kanagawa*, and is carefully outlined in *kintsugi* gold. Even Grayson Perry (UK), the bad boy of pottery, has resorted to using *kintsugi* as an expressive technique. *The Huhne Vase* is a classically shaped vase in Chinese grey/green with images of penises and speed cameras around it. The pot has been broken and *kintsugi* mended. The butt of Perry's joke is Chris Huhne, a British political figure who served a jail sentence for perverting the course of justice over a speeding violation.

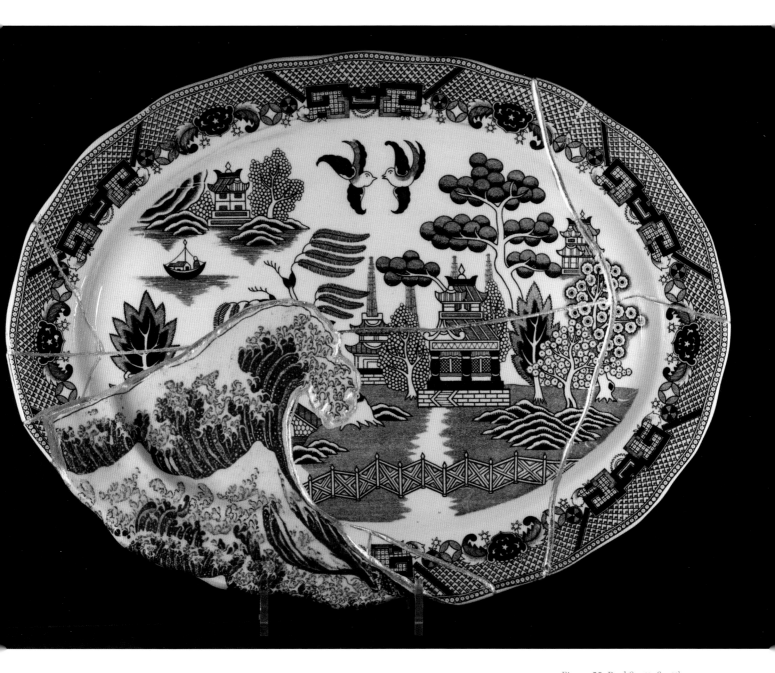

Figure 55: Paul Scott, *Scott's Cumbrian Blue(s), Fukushima*, 2014. In-glaze decal collage on broken and reassembled *Willow* pattern platter, marked 'Japan (c.1965)'. Wave insert from erased *Willow* platter (c.1840). Gold leaf, tile cement and epoxy resin. 45 × 30 cm. PRIVATE COLLECTION. PHOTO BY THE ARTIST.

One of the most striking examples of the contemporary use of *kintsugi* can be seen in Suzuki Goro's (Japan) joyful *yobitsugi* teabowls. *Yobitsugi* means 'borrowed patches'. In this intriguing technique substitutions from other pots are made for some of the missing pieces, giving an even stronger patchwork appearance by contrasting patterns, colours and designs. In Suzuki's case he breaks the pots, decorates each piece in a different style, then reassembles them with gold. Although *kintsugi* is often thought of as a technique that lends itself to the *wabi* aesthetic, not so in the case of Suzuki, who has taken it into whimsy and playfulness.

Raku in the twenty-first century

Although Japanese Raku is traditionally linked to *wabi*, Western raku does not necessarily feed into the *wabi* feeling. Western raku tends to be thought of as a firing technique, whereas Raku in Japan is a more comprehensive approach from beginning to end. It also does not involve post-firing reduction, which is what gives Western raku its dramatic qualities.

In Japan, from Chōjirō in the sixteenth century through to the current Raku master, Kichizaemon XV, each Raku successor has added to the strong Raku tradition. Unlike other potters in earlier centuries, Raku masters have never worked anonymously or mass produced their bowls. Instead, each successive master develops and refines his own distinctive style, just as studio ceramicists do now. That is not to say that they start with a blank slate. They build on the strong heritage of those who have gone before. Raku Kichizaemon XV chose to study sculpture in Japan and then in Rome. Reading his eloquent writing on his practice, it seems that he has never taken his position for granted; rather, he has questioned it, confronting twentieth- and twenty-first-century issues head on. Raku XV produces stunningly beautiful *chawan*, boldly sculptural in quality. These teabowls are highly prized among *chajin* of the various Tea schools, and are much sought after by ceramics collectors around the world.

Use of European/American techniques

Slab construction is not an unusual technique in traditional Japanese ceramics in general. However, there is something very Western in the overlapping and clearly defined slabs we see in the strong, colourful teabowl forms of Elke Sada (Germany) (figure 56) and the softer, heavily textured bowls by Marion Angelica (US) (figure 57). The making process is clear and tangible, a statement in its own right. Textures, as in Angelica's bowls, are a strong theme in contemporary teabowls. Some textures are directly applied, as in Angelica's work, in much of the work of Gary Wood (UK) and in the almost-modernist bowls of Ernest Gentry (US). Claire Briant's (France) *chawan* are textured through her use of fine, dense slip trailing. The Japanese

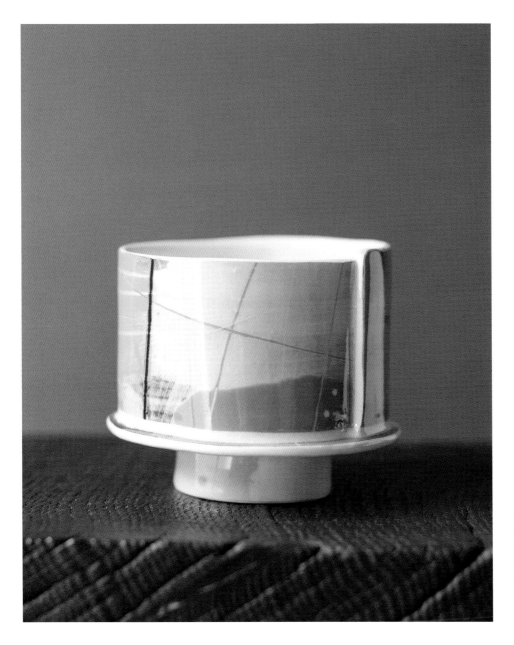

Figure 56: Elke Sada, *Capriccio Teabowl*, 2014. Hand-built white earthenware (casting slip), reversed monoprint. 7 × 9 cm. PHOTO BY MICHAEL HARRIS, COURTESY OF OXFORD CERAMICS GALLERY.

ceramic artist Hoshino Kayoko, who is known for her intriguingly angled, heavily textured sculptures, has also made a bowl that some might say is a teabowl, even though she herself says it is not. The piece, named *Yuwan* (Playful Bowl) (figure 58), well represents her beautiful surfaces. Textures can also be created through glazing and other treatments. James Lovera (US) is known for his crater glazes, often on wide-rimmed, narrow-based teabowls. Robin Welch (UK) produces solidly shaped teabowls, some with roughly textured, vividly coloured designs. Eddie Curtis (UK) is known for his use of deep red in his teabowls, but his experiments have also led him to rough, engaging textures (figure 59).

Figure 57: Marion Angelica, *Dotted Celadon Teabowl*, 2013. Hand-built Grolleg porcelain, reduction fired to cone 10, 11.4 × 12.7 cm. PHOTO BY PETER LEE.

(below) Figure 58: Hoshino Kayoko, *Yuwan (Playful Bowl)*, 2004. Dark stoneware with linear texture on outside, silver on inside, 8 × 15.5 (max) cm. PHOTO BY IAN OLSSON.

(opposite) Figure 59: Eddie Curtis, *Teabowl*, from *The Blast* series, 2015. Thrown and faceted stoneware clay, applied copper and iron bearing textures and porcelain engobes, reduction fired in oil kiln to 1300°C, 9 × 12 cm. PHOTO BY THE ARTIST.

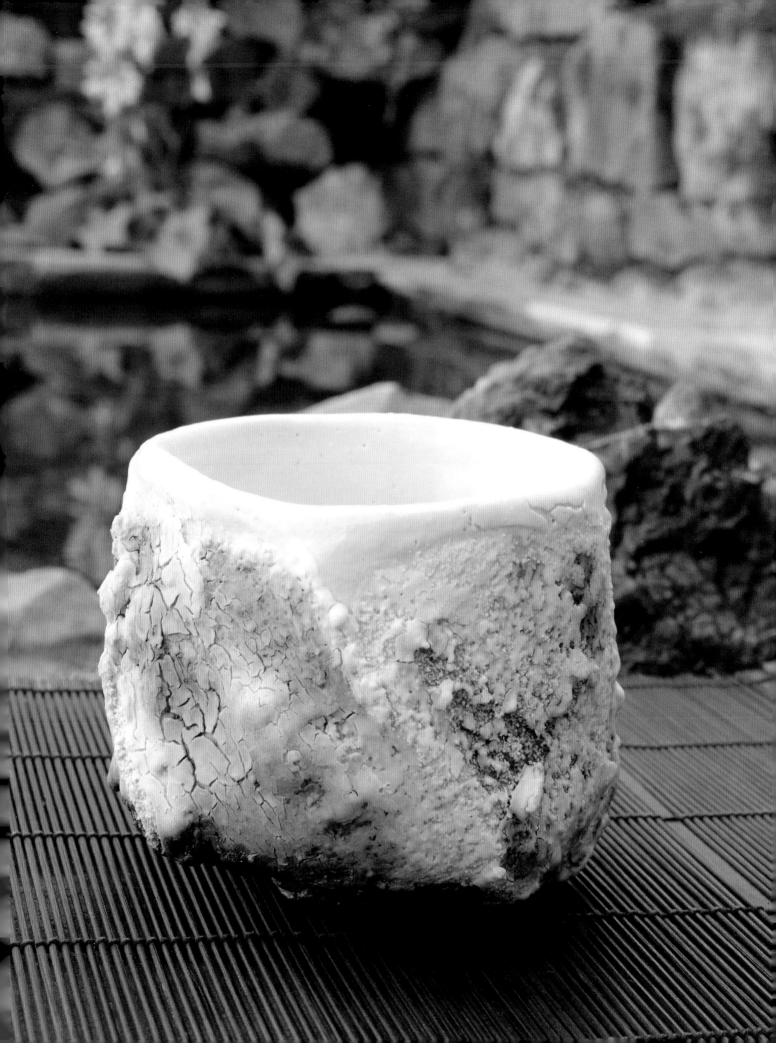

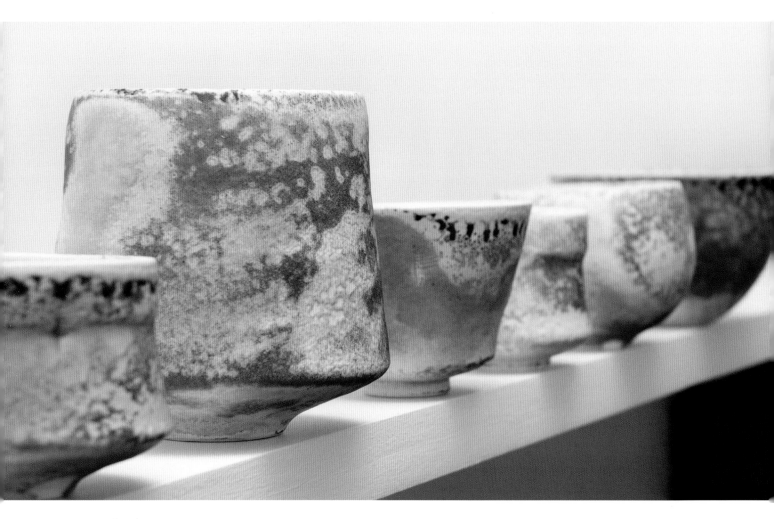

Figure 60: Jack Doherty, *Line of teabowls, c.*2014. Soda-fired porcelain, 11.5 × 13 cm. PHOTO BY REBECCA PETERS.

Different firing techniques produce characteristic surface textures. Using soda firing, Jack Doherty (UK) creates a coolly colourful, dry, mottled surface that is infinitely seductive (figure 60), whereas some of Gail Nichols' (Australia) work has appealing surfaces that seem warm and almost wet. Salt firing is now widely used, especially in conjunction with other techniques, and has also continued to be developed in Japan.

Another Western surface treatment new to the teabowl is the use of terra sigillata, a very fine slip, sometimes burnished and smoke fired. It can give an extremely smooth appearance and a warm, caressable surface. These techniques do not result in particularly durable surfaces or ones that can withstand the repeated use of a bamboo whisk, but as we have seen, many contemporary artists give only a nod to the teabowl's original use. Both Roland Summer (Austria) and Dalloun (France) use terra sigillata and raku firing, allowing the smoke from post-reduction to 'draw' fine lines on the surfaces of their pots. Summer's pots stand firm and strong. Dalloun fosters tactility in his soft, whirling bowls, which beg to be held (figure 61).

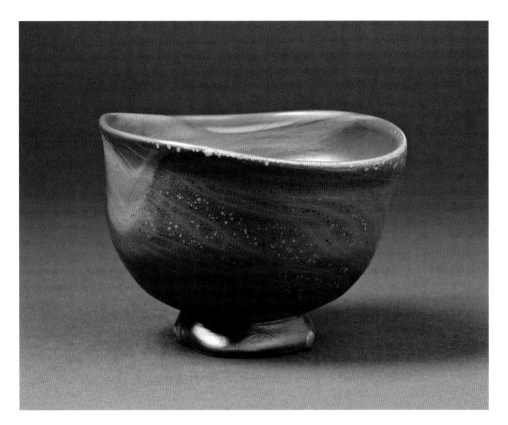

Figure 61: Dalloun, *Red Sky*, 2015. White faïence wheel-thrown off-centre, terra sigillata slip, gas fired to 1050°C, 8 × 11 cm. PHOTO BY P. VANGYSEL.

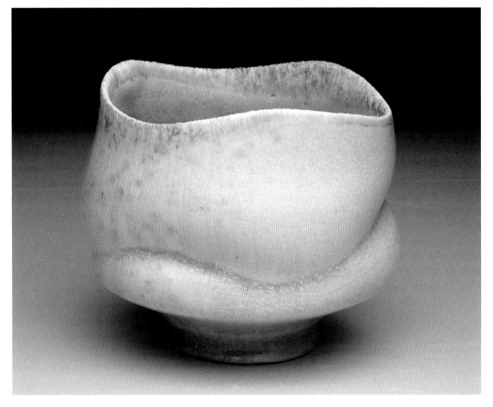

Figure 62: John Oles, *Wood fired Teabowl*, 2010. Wheel-thrown and altered porcelain with Shino glaze, *anagama* fired to cone 12, 10.1 × 10.1 cm. PHOTO BY THE ARTIST.

Others who exploit the loose and flowing quality of clay include Martin Lungley (UK), Claude Champy (France), Asato Ikeda (Japan) and John Oles (US) (figure 62). Another kind of looseness, but one that is not necessarily flowing, can be seen in the work of British artists Sandy Brown (figure 63), Dylan Bowen and Ashley Howard. All are highly skilled artists who choose to create works that eschew over-refinement. Brown's and Bowen's styles can be seen as early examples of the 'sloppy craft' movement. Their boldly slip-decorated teabowls are heavy, distinctive and filled with energy. Howard has produced a range of *chawan*, all fresh in form and subtly delicate (figure 64). On some he has used ceramic pencils to create distinctive skittish lines, then used enamels and gold lustre, resulting in strong, colourful bowls that exude a sense of grace.

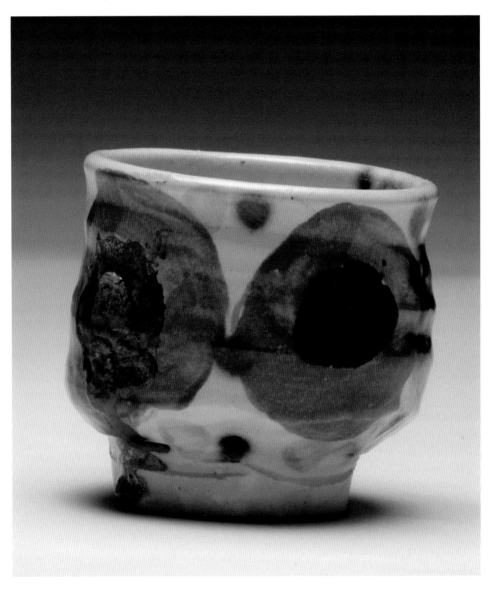

Figure 63: Sandy Brown, *Pax Harmonica*, 2013. Stoneware clay softly thrown on a slow-turning Japanese kickwheel, coloured glazes, 14 cm high. PHOTO BY JOHN ANDOW.

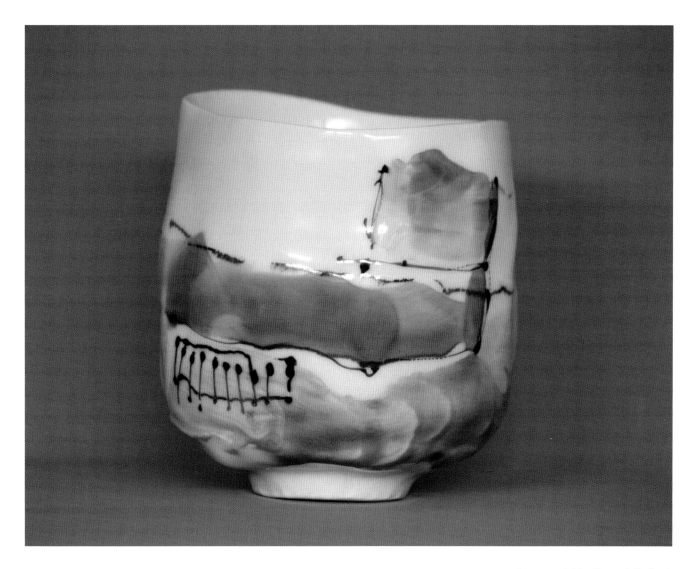

Figure 64: Ashley Howard, *Teabowl*, 2015. Porcelain, thrown and altered with on-glaze enamels and lustre, 12 × 12 cm. PHOTO BY THE ARTIST.

Graphic teabowls

Japan has a very long tradition of slip decoration. Fusible slips were used as early as the fifteenth century in Japan, and white and red clay slips have been used decoratively since the late sixteenth century, notably on Shino and Oribe ware.[86] These include all-over slip and clear decorative imagery, such as the geometric shapes, hatch-markings and designs from nature done in iron brushwork on Oribe ware. In motif, Oribe ware and traditional English slip trailing share similar themes. However, Hannah McAndrew (UK), who produces some teabowls decorated with traditional English slip-trailed designs, says, 'Slipware and the teabowl don't generally sit together that comfortably.'[87] Perhaps this is because English slipware has as strong a historic load as the teabowl, resulting in a clash of cultures. Other potters using English slipware techniques on teabowls include Clive Bowen, Mike Dodd, Philip Leach and Doug Fitch (figure 65).

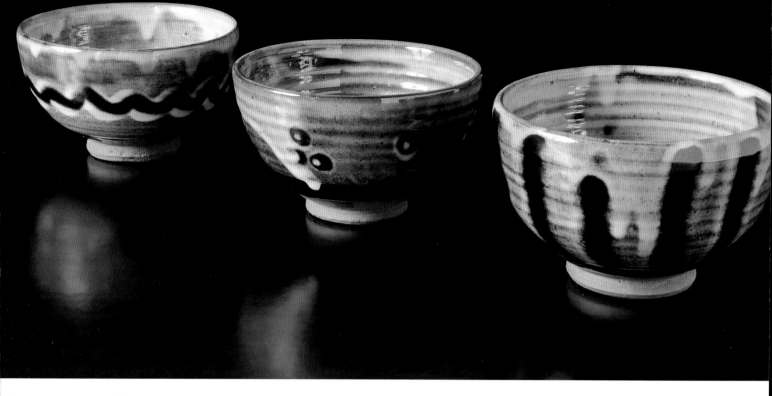

Figure 65: Doug Fitch, *Slipware Teabowls*, 2013. Wood-fired, thrown in red earthenware with coloured slips and honey glazes. PHOTO BY JONATHAN THOMPSON.

(opposite) Figure 66: Richard Heeley, *Blue & White Chawan*, various designs, 2014. Thrown porcelain in oxidized firing to 1300°C, hand-painted designs in *gosu* cobalt pigment, varied sizes from 12–15 × 8–10 cm. PHOTO BY THE ARTIST.

Although representational images, rather than abstract motifs or designs, have appeared on traditional *chawan*, there is a qualitative difference in many contemporary teabowls that have images, as the images often demand attention in a way that traditional *chawan* graphics do not. The *chawan*, for many contemporary makers, serves as an expressive medium for concepts outside of the tea ceremony. For instance, among the *chawan* made by Suzuki Goro (Japan), are those with a light-hearted take on classical Oribe ware designs, with images of contemporary life, including drawings and paintings of light fittings, cars, cartoon-like crows and Miro-esque abstract drawings. Unlike many contemporary teabowls, even in the wildest Suzuki *chawan*, there is still a sense that tea ceremony has informed it.

Looking further at graphics, two contemporary artists who specialize in cobalt drawings on teabowls are Richard Heeley (UK), who uses *gosu* (a natural cobalt pigment) to create peaceful brush illustrations of natural scenes (figure 66), and Kurt Weiser (US), whose dense cobalt underglaze paintings depict complex and skewed narratives on porcelain. Shannon Garson (Australia), who trained as a painter, uses the teabowl as a canvas to portray positive images of the swampland of southeast Australia. In some of her teabowls Jill Fanshawe Kato (UK/Japan) uses paper stencils to create her clear-cut soaring bird designs (figure 67).

Hakeme is a well-known Japanese slip technique, where the beauty of the brush mark itself is the goal. Usually in white on a darker body, the brushwork is distinct and contrasts the colour of the clay. A good example of another version of this can be seen in the teabowls of Marcio Mattos (UK), whose boldly brushed lines contrast a very dark stoneware clay body (figure 68). John Pollex (UK) makes slipware bowls with bold colourful brushwork.

There has been calligraphy on Japanese teabowls for centuries. Contemporary artists use calligraphy both as decoration and as commentary. Jim Gottuso (US) makes colourful *chawan* with calligraphy-like designs by using a shellac-resist technique that results in well-defined, highly refined bowls (figure 69). Sylvian Meschia (France) creates *chawan*-like bowls, although his influences are more from his Algerian childhood than from Japan. Script is the starting point for much of his work, including Arabic, French and a personal calligraphic style all his own (figure 70). Sara Ben Yosef (Israel) produces Judaica, including a bowl titled *Solomon's Song Bowl* with Hebrew script on the inside.

(opposite) Figure 67: Jill Fanshawe Kato, *Flying Bird Teabowl*, 2015. Hand-built stoneware reduction gas fired to 1270°C, slips and glazes, 9 × 12 cm. PHOTO BY THE ARTIST.

Figure 68: Marcio Mattos, *Blue Wave* (left) and *Autumn Grass* (right), 2014. Paperclay stoneware, 12 × 12 cm approx. PHOTO BY IAN OLSSON.

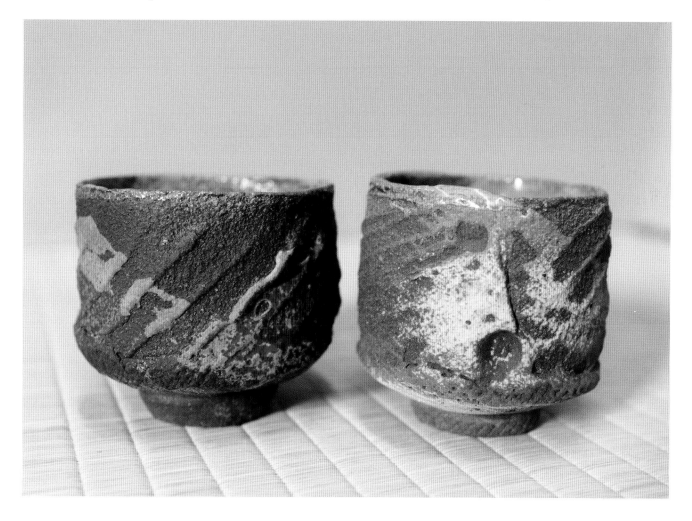

Figure 69: Jim Gottuso, *Etched Porcelain Bowl*, 2015. Grolleg porcelain, terra sigillata slip, and glaze, 10.7 × 15.8 cm. PHOTO BY THE ARTIST.

Figure 70: Sylvian Meschia, *Bol*, 2013–2014. Earthenware and local clays with white engobe applied, then fired. Successive layers of oxide-coloured engobes, with graphic designs inscribed before second firing. Dilute transparent glaze before third firing. 10 × 10 cm approx. PHOTO BY THE ARTIST.

Nerikomi and *neriage* are Japanese techniques, similar to agateware, that use coloured clays to create intricate patterns. Specifically shaped pieces of coloured clays are press-moulded together in *nerikomi*. *Neriage* uses the coloured clays in throwing, creating swirls and spiral markings. It was not a common technique in Japan until the twentieth century, and not often used for teabowls. However, Matsui Kosei (1927–2003), designated a Living National Treasure in 1993, experimented with the technique, and although known for his large jars, he also produced teabowls. The young artist Sakai Mika (Japan), who initially studied fashion, has been exploring *nerikomi chawan* in stoneware for more casual use (figure 71). She explores colour combinations using computer software before executing her designs. In contrast, Dorothy Feibleman (Japan/US/UK) has developed a *nerikomi* technique using porcelain for teabowls, which is new to Japan. The translucency of the material and her skilful use of colour results in brightly coloured, finely patterned teabowls of great refinement and discernment. Susan Nemeth (UK) also uses the technique, with bolder and looser figuring, but still exploiting porcelain's translucence (figure 72). Porcelain provides potters with a potential windfall of colour, as its natural white or light hues can result in bright, distinctive colouring, with high contrasts of vivid hues.

Figure 71: Sakai Mika, *Fletching* (yabane) *Pattern Tea Bowl*, 2014. *Nerikomi* (coloured clays) with clear glaze, 8.2 × 12.7 cm. COURTESY OF STUDIO KOTOKOTO LLC.

Figure 72: Susan Nemeth, *Bowl with Blue Squares*, 2008. Press-moulded porcelain with layers of coloured clays and slips inlaid, 9 × 15 cm. PHOTO BY STEPHEN BRAYNE.

Landscape

Keshiki, sometimes translated as 'landscape', is an important concept in understanding the Japanese teabowl. In a European understanding of art, landscapes often use representational imagery, although they might also carry cultural, or even political allusions. *Keshiki* is all this, but it also makes a direct link to the physicality of the *chawan*, for instance, where the clay comes from and how it is fired, and may allude to poetry and other cultural tropes. What Allen Weiss says about Zen gardens holds true as well for the *chawan*: ' ... landscape is never dissociated from metaphor, symbolism, transcendence'.[88] The list of characteristic *keshiki* qualities seems almost endless and includes some that have been mentioned before, such as *goma* (sesame), *hakeme* (brushed slip) and *hidasuki* (fire cord markings). Others include *ishihaze* (stone explosion), *kairagi* (crawling), *koge* (burning or scorch marks) and perhaps the most difficult to define, *tsuchiaji* (clay flavour). Many Western *chawan* have these qualities. Some of the most engaging have an accidental quality, with hints and suggestions of the land coming through the glazes and the firing. You can see some of these highly desirable qualities in the work of Lisa Hammond (UK), Chester Nealie (Australia), Janet Mansfield (Australia), Peter Callas (US), Judith Duff (US), Randy Johnston (US) (figure 73), Paul Drapkin (Ukraine) and Kang Hyo Lee (Korea), to name just a few.

Figure 73: Randy Johnston, *Tea bowl*, 2011. *Anagama* fired with natural ash and crackle Shino glazes over iron, 9.5 × 12.7 × 12 cm. PHOTO BY PETER LEE.

Figure 74: Ellen Schön, *Eddy*, 2012. Wheel-thrown coloured clays, fired in electric oxidation to cone 6, 8.2 × 11.4 cm. PHOTO BY JACKIE SCHON.

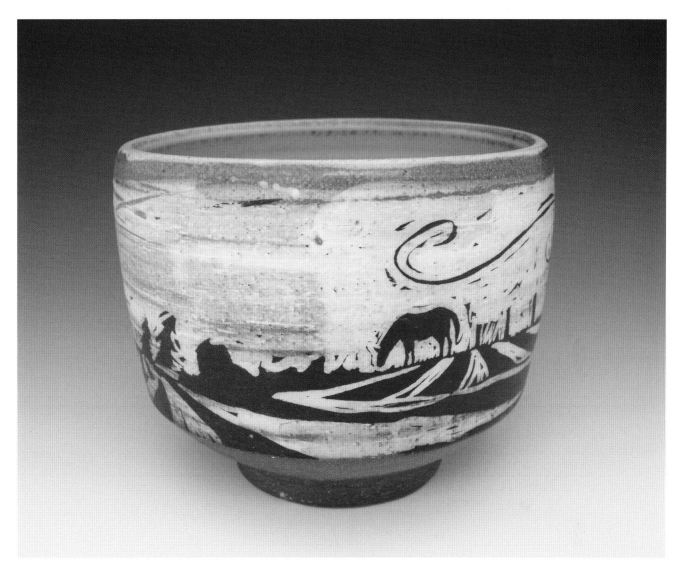

Some non-Japanese potters use landscape more literally. For example, Ellen Schön (US) throws coloured stoneware clays, which when scraped and sanded reveal impressive desertscapes (figure 74). Maggie Zerafa (Scotland) seeks to respond to the dramatic hills and sea of her home in the Isle of Skye, not by creating a landscape design, but by layering four or five glazes of the environment's colours to evoke the feeling of the landscape (figure 75). Stacey Stanhope Dundon (US) uses the teabowl form to make casual work with wax resist, slip and salt firing (figure 76). The bowls have clear-cut, literal images of rural life in Vermont, especially of local farming scenes. Jeff Mincham (Australia) expresses the 'harsh dry windswept lands, of the shimmering distance beneath brooding skies'[89] of the Adelaide Hills in Australia (figure 77).

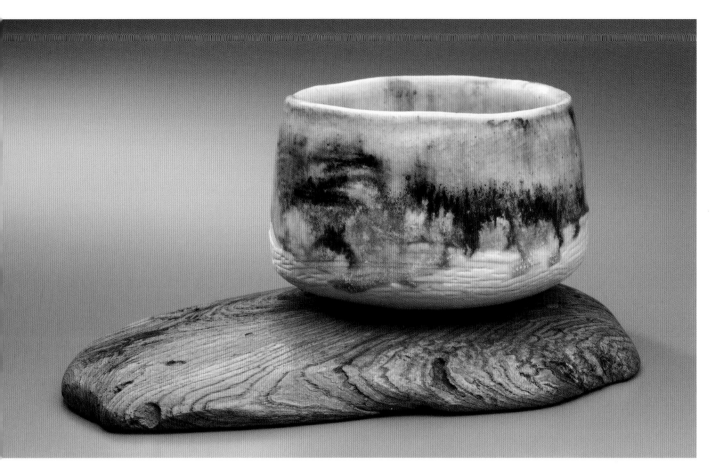

Figure 77: Jeff Mincham, *Dry Lake*, from a series about the changing landscapes of severe drought, 2014. Ceramic and timber from ancient mangrove wood retrieved from drought-stricken lake, 8.5 × 11.5 cm. PHOTO BY GRANT HANCOCK.

(opposite) Figure 78: Angela Mellor, *Tea bowls*, 2015. Slip-cast bone china with paperslip inclusions, 6 × 10 cm. PHOTO BY STEPHEN BOND.

Non-Japanese themes

Traditionally in the tearoom, colours tend to be subdued, so that no one object stands out to the exclusion of others; utensils do not vie for our attention, as nothing should distract from the moment. As Kakuzō Okakura says in *The Book of Tea*, 'Not a colour to disturb the tone of the room, not a sound to mar the rhythm of things, not a gesture to obtrude on the harmony, not a word to break the unity of the surroundings, all movements to be performed simply and naturally, – such were the aims of the tea-ceremony.'[90] Even the whiteness of thin, clear-glazed porcelain can be visually disturbing in this setting. In Japan, this type of uniform whiteness may also be perceived as a funereal colour. But since many teabowls are not made for the tearoom, the parameters of the aesthetic are shifting, especially because in countries of European heritage the colour white carries a positive cultural loading of feelings of purity and preciousness. Contemporary potters, such as Kevin Millward (UK), are exploiting these qualities of porcelain in their teabowls (see figure 2). Angela Mellor (UK) uses bone china, which is also white, and paper slip, with patterns and designs that offer contrast to the translucency (figure 78).

Figure 79: Emmanuel Cooper, *Tea bowls*, 2010. Hand-built porcelain, 10 × 9 cm approx. PHOTO BY DEWI TANNATT LLOYD, COURTESY OF RUTHIN CRAFT CENTRE.

Some of the artists mentioned, such as Ashley Howard, Elke Sada, Sandy Brown and Dorothy Feibleman, are known for their brightly coloured ceramics. Others who have also exploited a contemporary colour range to the fullest include Emmanuel Cooper (UK), known for his bright yellow as well as volcanic glazes (figure 79); Tony Laverick (UK), who draws on modern abstraction in both his white and black porcelain; and Tae Kwon Ryu (South Korea), who makes warm and appealing *chasabal* (Korean teabowls) with subtle crazing and liquid colours. The bowls of Elaine Coleman and Tom Coleman (US), with carefully carved birds, frogs and other animals, are glazed in bright blue and green celadons (figure 80).

A response to our world

(opposite) Figure 80: Elaine Coleman and Tom Coleman, *Two Frog Tea Bowl*, 2014. Coleman porcelain with apple green celadon glaze, 9.5 × 9.5 cm. Thrown by Tom Coleman; incised by Elaine Coleman. PHOTO BY KELLY MCLENDON.

Among Tea practitioners the teabowl is not seen as the most important utensil. Usually that role is held by the scroll, followed by the tea caddies (*chaire* and *natsume*), then the tea scoop (*chashaku*), and finally the teabowl. However, the teabowl is the object imbued with the greatest intimacy between host and guest. It is held in both hands and touched to the lips; it is experienced as much through its tactile qualities as through its appearance. It is the physical link between host, guests and even the potter.

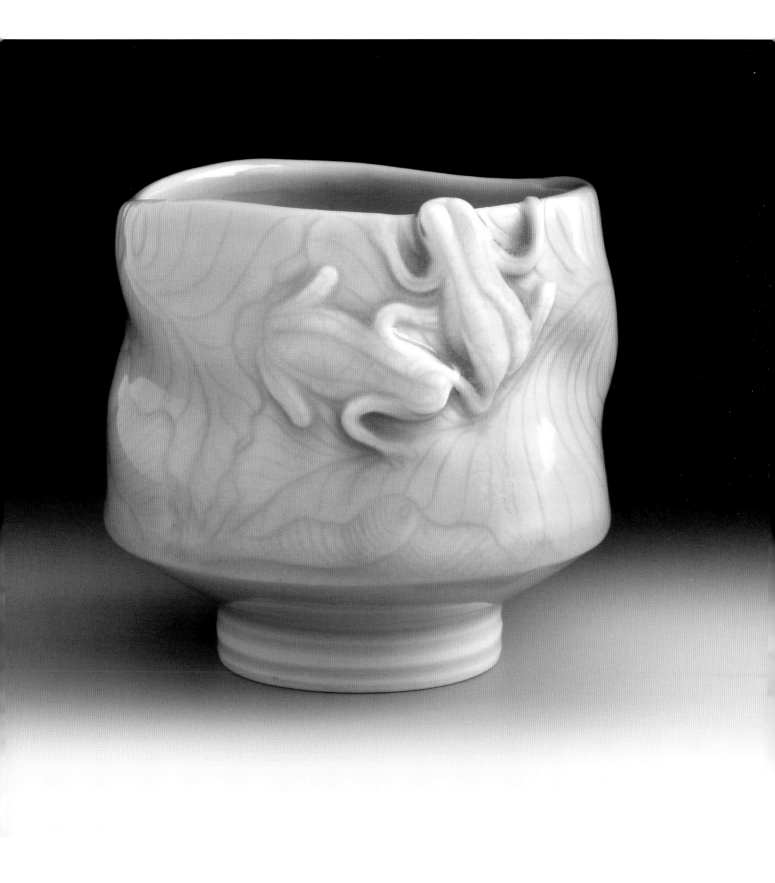

It is this inherent personal quality that has drawn many ceramicists to the *chawan* and led to its iconic status. Some potters have responded to tragedies in their lives through the teabowl. During the year following his son's death, Steven Branfman (US) created a teabowl each day (figure 81). 'For a year they were the only pots I made. One *chawan* each day no matter where I was. My wife Ellen, son Adam, and I, together in Shul, said Kaddish [the Jewish mourning ritual] every day for a year. My daily *chawan* making at my wheel was my own personal Kaddish.'[91] Ten years later Branfman exhibited the teabowls in a powerful exhibition titled *A Father's Kaddish: The Celebration of (a) Life in the Aftermath of Death.*

Other artists have responded to local and global tragedies through the teabowl, marking the fragility of our world. Anna Lambert (UK) creates earthenware teabowls with paintings that express the Yorkshire countryside in which she lives, including, for instance, the aftermath of the floods of 2012 (figure 82). Alastair Whyte (Australia) created *chawan* using human ash in the glaze to mark the seventieth anniversary of the dropping of the first atomic bomb on Hiroshima (figure 83).

Figure 81: Steven Branfman, installation photo with *Kaddish Chawan 235/365, May 19, Jared's Birthday* in foreground. Thrown 2005; glazed and fired 2015. Wheel-thrown stoneware with brushed raku and commercial low-fire glaze, raku fired, 7.6 × 10.1 cm. PHOTO BY THE ARTIST.

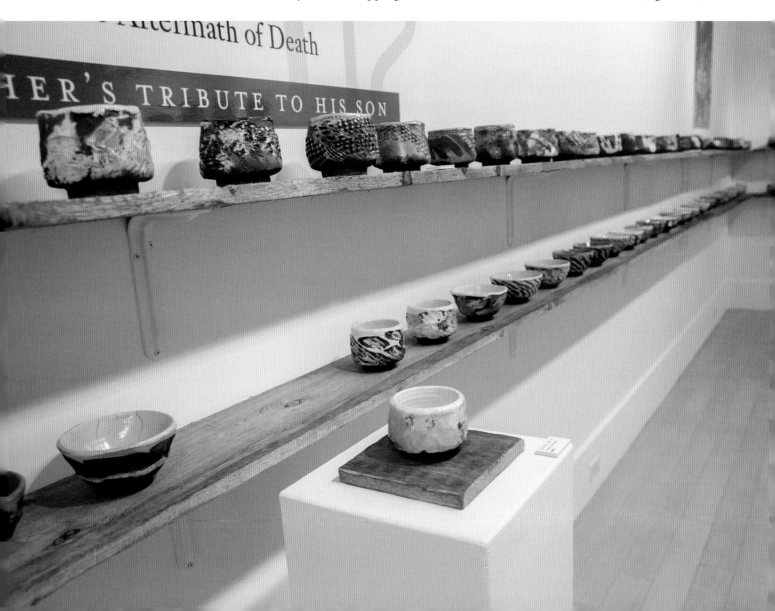

Figure 82: Anna Lambert,
Flood Chawan: Evening Rooks,
2015. Altered soft slabs of white
earthenware and stoneware, painted
with layered slips and underglazes,
9 × 14 cm. PHOTO BY THE ARTIST.

125

Figure 83: Alastair Whyte,
Hiroshima, in memory of all those
vaporized and turned to ash when
the bomb was dropped, 2014.
Porcelain with a copper red glaze
with human ash, 7 × 13.5 cm.
PHOTO BY THE ARTIST.

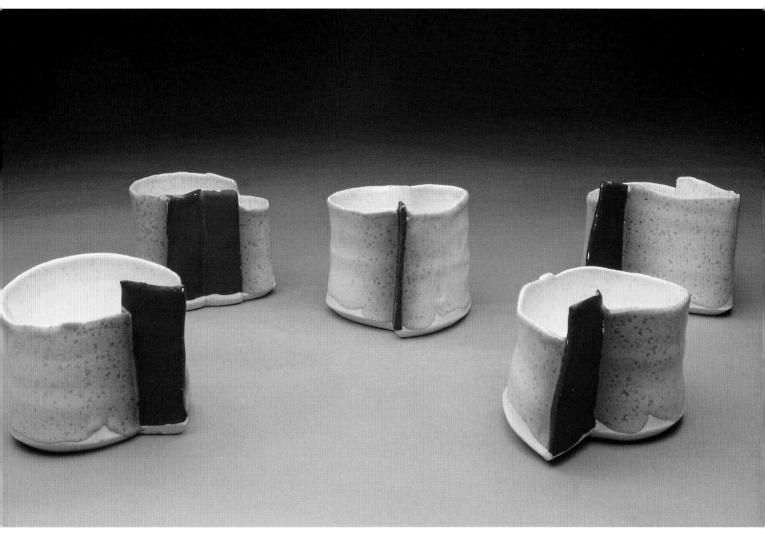

Rob Fornell (US) responded to the 2011 earthquake, tsunami and subsequent nuclear disaster at Fukushima through a small series of *chawan* carved from ice, 'which of course with their use destroyed their function/existence. Life's temporality held in one's hands, as it were.'[92] He also produced a two-part series of bowls. The first was an immediate reaction to the 2011 tragedy. *Black Chawan*, which have an industrial appearance, were thrown as tubes on the wheel, ripped and cut apart to symbolize the destructive nature of the events, then reassembled. Of these, Fornell says, 'While the disaster was natural in origin, it, like Chernobyl, became a toxic, nuclear industrial catastrophe … Over time, however, communities were rebuilt, lives somewhat restored albeit scarred, having been violently torn apart, and what nature had been affected by the nuclear fallout, began its unceasing process of rebirth.'[93] The second set is called *Pink Chawan* (figure 84), and they carry an even stronger message of hope and rebirth.

Figure 84: Rob Fornell, *Pink Chawan*, 2012–2014. Wheel-thrown tubes that distort with lifting, cut and torn, then reassembled. Thick white glaze with pink colouration from outgassing of black glaze, with intentional 'flashing'. Size range 7–9.5 × 8–12 cm. PHOTO BY THE ARTIST.

From personal to universal

Usually the intimacy and immediacy of tea ceremony means that the host and guests leave issues from the wider world outside. However, contemporary teabowls, which serve a different purpose, are sometimes used to express social and political causes, often through the use of ceramic transfers, which can present well-known imagery. For instance, Dan Anderson (US), known for his ceramic references to long-gone industrial artefacts, has made a series of teabowls with the images of famous figures, including Kim Jung-il and Mao Zedong. In her series *Mud Larking*, Raewyn Harrison (UK) has used ceramic transfers from Victorian maps to position her teabowls within a historical narrative of London (figure 85). Using transfers he has drawn, Philip Eglin (UK) produces ceramics laden with cultural references, often humorous. One such is a teabowl with drawings of generic popes and scantily clad figures both inside and out (figure 86). Eglin intends for this bowl to be 'mildly irreverent, flippant and also an oblique reference to the recent transgressions of the Catholic Church. Tea drinking is often a shared activity and I like the incongruous (and perhaps uncomfortable for some) mix of popes and pin-ups together.'[94]

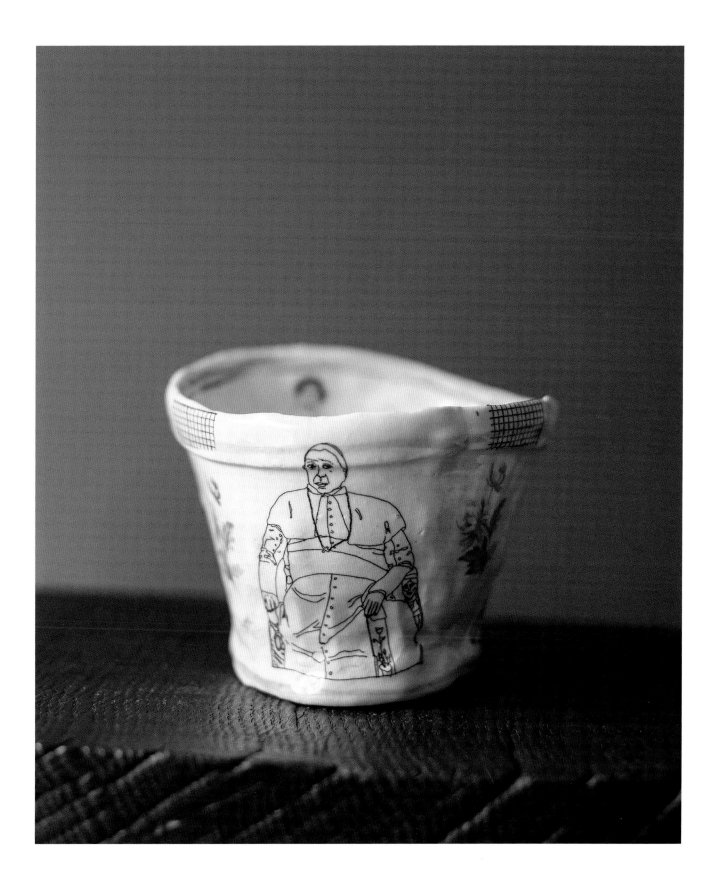

Moving far from the spirit of tea, Ron Meyers (US) threatens us with menacing, yet humorous, animals on his *T-Bowls* (figure 87). Intense and cartoon-like, the teabowls of Kirk Mangus (US) demand that we try to understand the stories behind his sour-faced women, insects, animals, skulls – all wildly drawn and demandingly coloured.

Less overt commentary may be seen in a teabowl by Tanaka Takashi (Japan) titled *The Armor of Moonlight* (figure 88), which seems to reference industry and industrial processes in its almost metallic finish and structural perfection. Does this bowl juxtapose traditional *wabi* tea aesthetics with the new world of steel and concrete, or is it just exploiting a post-industrial trope? Kevin A. Myers (US) throws his teabowls in porcelain, applies a heavy porcelain slip, then re-throws them to give a soft flowing quality (figure 89). He then puts them on raised pedestals that appear 'aged', highlighting and magnifying the iconic status of the *chawan*. Very different in tone, but with the same clarity of form, Carina Ciscato (UK) creates her white and celadon teabowls by throwing, cutting and reassembling (figure 90). They are fluid and graceful, yet give a sense of architectural strength.

Figure 87: Ron Meyers, *T-Bowl with Hog*, 2014. Earthenware with slips, engobes and transparent glaze, fired to cone 03, 8.9 × 12.7 cm. PHOTO BY JEN BROWN, COURTESY OF SNYDERMAN-WORKS GALLERIES.

(opposite, top) Figure 88: Tanaka Takashi, *The Armor of Moonlight (Tea Bowl)*, 2014. Ceramic, 7 × 12.7 cm. PHOTO BY JURATE VECERAITE, COURTESY OF CAVIN-MORRIS GALLERY.

(opposite, bottom) Figure 89: Kevin A. Myers, *Tea Bowl 1000*, 2010. Thrown and altered porcelain with porcelain slip added, then re-thrown celadon glaze. Plinth (20.3 × 21.5 × 14 cm): hand-built with surface treatment of raw ash and carbon trap Shino PHOTO BY ANTHONY CUNHA.

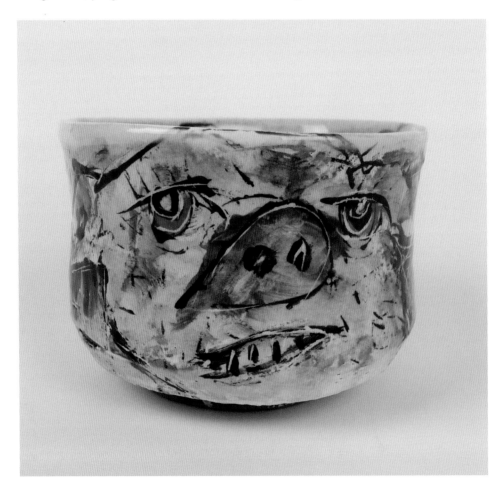

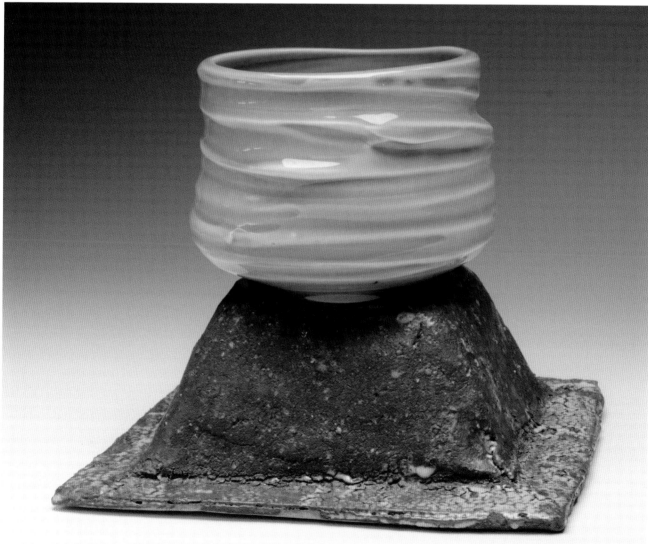

Figure 90: Carina Ciscato, *White Constructed Teabowl*, 2012. Porcelain with clear glaze, 12 × 13 × 10 cm. PHOTO BY MICHAEL HARVEY.

Sculptural *chawan*

Clays in Japan have historically been linked to specific kilns and ceramics styles, and some are very distinctive, like the clay in Shigaraki, with its warm orange colour, bits of feldspar, kiln flashing and dripping green ash glaze. Even when porcelain production began in Japan, the traditional kilns, using local clays, continued to produce stoneware ceramics. No doubt this was partly due to famous Tea masters preferring it. In Europe and the United States, the upper classes and royal courts set the standards and determined the aesthetics for ceramics through patronage and purchasing power, and their desire was for pure, smooth, highly decorated white porcelain. With the development in Europe, North America and Australia of studio pottery and then studio ceramics, stoneware and earthenware products gained value, and as ceramicists experimented more with mixing clays and using rough clay additives, an aesthetic similar to the appreciation of individual Japanese clays developed. Ewen Henderson (UK) and Claudi Casanovas (Spain), among others, were well known for their teabowls made of mixed clays. Both produced highly dramatic, sculptural forms, far from the utilitarian form used in tea ceremony. Henderson layered fragments of different kinds and colours of clay (figure 91). Although often coarse and craggy, many of his teabowls retain the appearance of teabowls. Casanovas' teabowls, on the

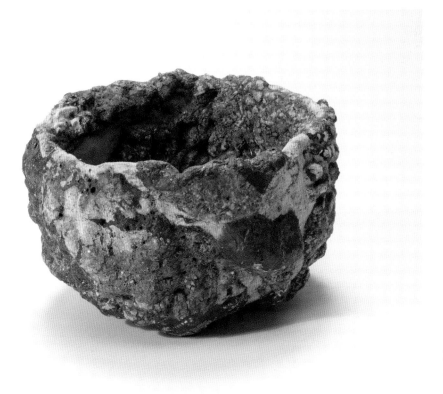

Figure 91: Ewen Henderson, *Tea Bowl*, 1990s. Stoneware, 10 × 15 cm. PHOTO COURTESY OF ERSKINE, HALL & COE.

Figure 92: Charles Bound, untitled *chawan*, shown in 2014. Wood-fired stoneware, 13.5 × 10 cm. PHOTO BY MICHAEL HARRIS, COURTESY OF OXFORD CERAMICS GALLERY.

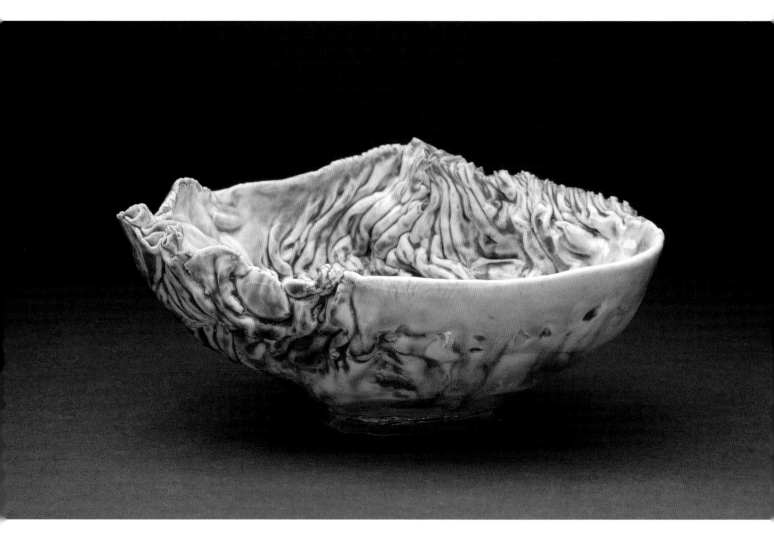

Figure 93: Kawabata Kentaro, *Shuwari Chawan*, 2012. Porcelain, 8.9 × 16.5 × 18.4 cm. PHOTO BY JURATE VECERAITE, COURTESY OF CAVIN-MORRIS GALLERY.

(opposite) Figure 94: Colin Pearson, *Vessel on Raised Foot*, c.1985. Porcelain, 12 × 12 cm. PHOTO COURTESY OF ERSKINE, HALL & COE.

other hand, nod to the roundness and scale of teabowls, but to little else. The complex, heavy, masculine forms 'look as though they were found rather than made, naturally occurring phenomena rather than intelligently directed products'.[95]

Other ceramicists have made teabowls that are more sculpture than pot. Takeuchi Shingo (Japan) has created intricately inlaid teabowls that echo his strongly structured, almost anatomical sculptures. The teabowls of Charles Bound (UK/ US) seem monumental in their earthy strength and boldness (figure 92). Kawabata Kentaro (Japan) has used soft porcelain to create a strange, scrunched teabowl of vivid colour (figure 93). Colin Pearson (UK), known for his winged vessels, subverted the iconicity of the teabowl by giving his teabowls impossibly high, narrow bases (figure 94). Andrew Deem (UK) placed his cone-shaped, wobbly, thrown *Haptic Bowls on Cladding* (figure 95) on found architectural objects from a private residence where the bowls were in exhibition, taking the *chawan* into the contemporary arena of the site-specific.

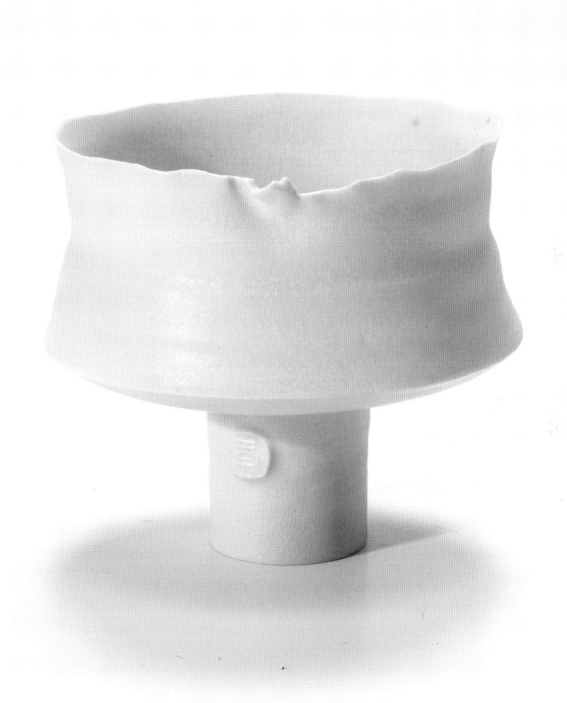

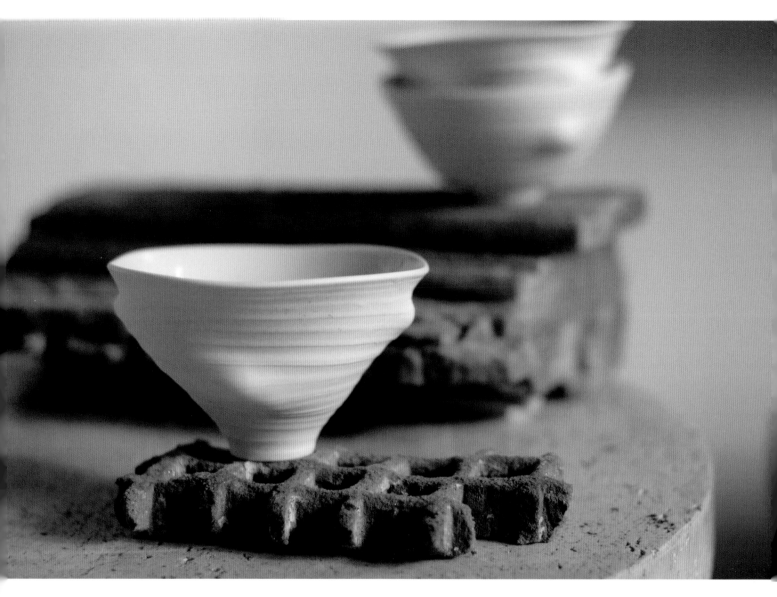

Figure 95: Andrew Deem, *Haptic Bowls on Cladding*, 2013. Porcelain, celadon, terracotta, 15 × 12 cm. PHOTO BY THE ARTIST.

Monika Patuszyńska (Poland) has been called 'an accident tamer'.[96] With a true postmodernist twist, she collects old factory moulds, which she breaks, reassembles, then uses to cast porcelain, leaving the sharp and threatening seams intact. These teabowls challenge the very essence of the teabowl – they are not to be handled and they are highly conspicuous – yet through her innovative technique she captures the imperfect, harnesses the accidental (figure 96). Kuwata Takuro (Japan) also creates teabowls that defy the rules of the *chawan* (figure 97). His cracked, peeling, brightly coloured *chawan*, intriguing and threatening at the same time, dare you to touch them. Kuwata holds an understanding of tea ceremony within his forms, stating, 'The tea ceremony bowl has both a specific function and a more abstract aesthetic. My work, I think, shares this dual sensitivity.'[97]

Figure 96: Monika Patuszyńska, from the series *TransForms*, 2011. Wood-fired porcelain, slip cast from modified plaster moulds, 6–7 cm high. PHOTO BY THE ARTIST.

Figure 97: Kuwata Takuro, *Bowl*, 2015. Porcelain, 13 × 18 × 15 cm.
PHOTO COURTESY OF THE ARTIST AND SALON 94, NEW YORK.

Conceptual *chawan* and installations

Just as trends in sculpture have changed, there have been associated developments in sculptural ceramics, and teabowls have not been exempt. A move away from emphasizing a single object has resulted in concept-based work and installations, including multiples. An installation by Steven Lee Young (US), called *Red, Blue and White*, displayed three hundred bowls divided into three ten-by-ten grids of the mis-ordered patriotic colours, each bowl similarly shaped but distinctively glazed. In a large exhibition in New Delhi called *71 Running*, a tongue-in-cheek reference to his years, Ray Meeker (US/India), known for his large architectural works, displayed teabowls in a six-by-twelve grid, with one missing. In these works the teabowl has gone from its tearoom intimacy into the stark exhibitionist culture of the gallery.

In 2014 nag Gallery installed an exhibition of teabowls by Suzuki Masashi (Japan) at Bedford House, Dublin Castle, that offered perspectives of the *chawan* as individual, a collective entity and monumental (figure 98). Each teabowl sat on a plinth, open front and back with its *kiribako* (signed wooden box of pawlonia) placed below; an atmospheric film ran on a large screen at the back, filling the room with music titled

Figure 98: From the exhibition *Masashi Suzuki at Bedford House Dublin Castle*, 2014. *Chawan* by Suzuki Masashi; exhibition curated by Mark St John Ellis, nag Gallery. PHOTO BY KATE-BOWE O'BRIEN, COURTESY NAG GALLERY.

Morning by Alva Noto and Ryuichi Sakamoto. The music and fade-in/fade-out images, matched both the austere display and the fullness of the concept of the *chawan*.

Tom Sachs (US), a sculptor rather than a ceramicist, says he became obsessed with teabowls. This obsession resulted in his spending two years training in ceramics and an exhibition titled *Chawan* in 2014, which presented cabinets filled with gas-fired porcelain teabowls, each handmade and each bearing the NASA logo, which Sachs considers the 'ultimate brand' (figure 99).

Where there is contemporary art, there is usually some form of performance art also. Where better than in ceramics, which is such a performative art form? Glenn Grishkoff (US) used teabowls in *Marking My Life*, in which two rows of two hundred *chawan*, from bright bisque to darkly glazed, run down the floor on either side of a long scroll of childhood drawings (figure 100). The performance element was Grishkoff using his body as a brush.

From the irregular beauty of an early Japanese *chawan* to the challenge of a contemporary teabowl as a performance piece, the iconic teabowl has become many things to many people.

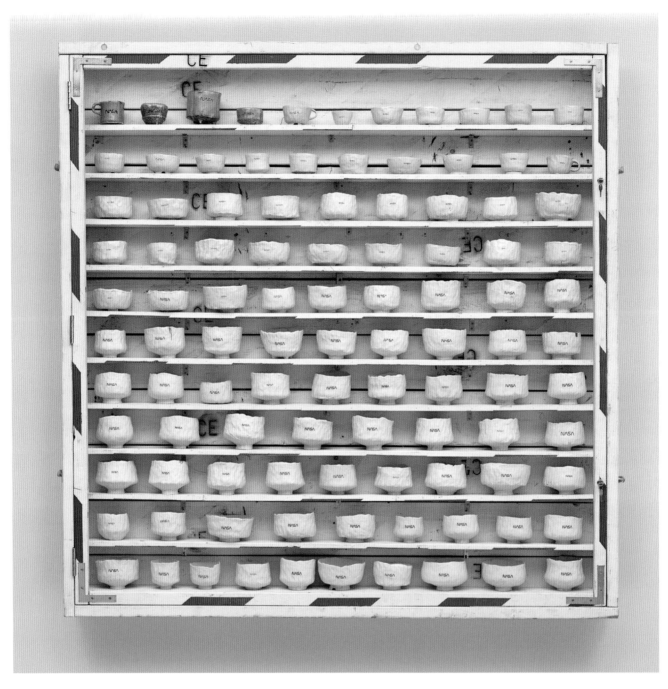

Figure 99: Tom Sachs, *Large Chawan Cabinet*, 2014. English porcelain, temple white glaze, NASA Red engobe (reduction fired), pine, latex, glass beads and museum glass, 186.7 × 193 × 22.9 cm. PHOTO COURTESY OF THE ARTIST AND SALON 94, NEW YORK.

(opposite) Figure 100: Glenn Grishkoff, from the performance *Marking My Life*, in collaboration with Jane Brucker and Mark LaPointe, 24 September 2014. Four hundred ceramic teabowls, scroll book of childhood drawings, large horsehair brush, jewellery, sound-making instruments. PHOTO BY CASEY DOYLE.

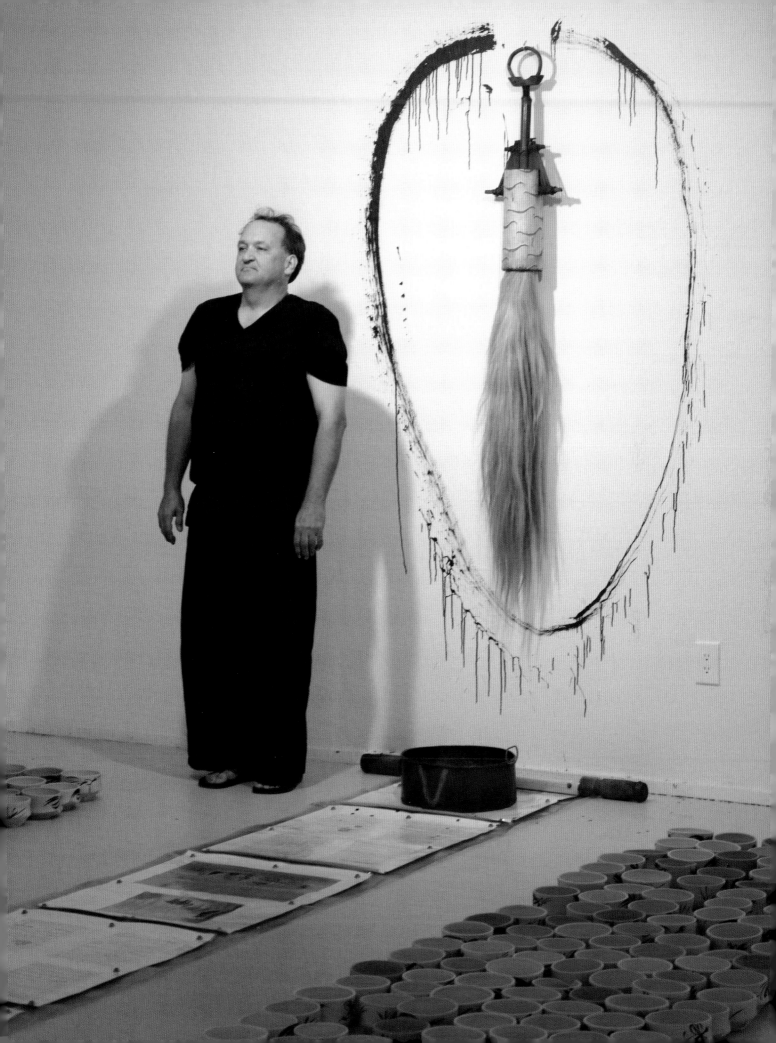

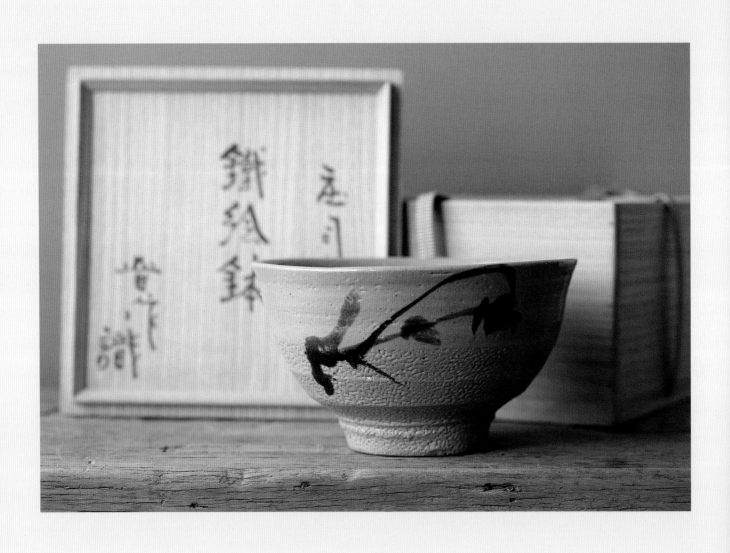

The iconic teabowl – past and present

How do we know about the past? How do we acquire this essential awareness? We remember things, read or hear stories and chronicles, and live among relics from previous times. The past surrounds and saturates us; every scene, every statement, every action is laden with its residues. All present awareness is grounded on past perceptions and acts; we recognize a person, a tree, a breakfast, an errand because we have sensed or done it before. Pastness is integral to our very being.[98]

The 'pastness' that David Lowenthal describes is the quality that imbues the teabowl and gives it a 'presence', as a pastness always implies a presentness. We do not venerate the morning coffee mug or even the figurine that sits by the clock on the bookcase; they do not carry the historical and cultural weight of the teabowl. It may seem strange that an object so completely invested with Japanese-ness should also resonate within cultures that come from European roots, but you need only see how many contemporary ceramic artists produce teabowls and how many collectors buy them to know that the teabowl's monumental legacy, its pastness, has accompanied it as it travelled beyond Japan's shores. Just as the concept of *wabi* is ambiguous and more charged with feeling and hazy awareness than hard analysis, so the teabowl's legacy is also a luminous mist that we sense rather than prescribe.

In the twenty-first century the teabowl has found new cultural territories to inhabit in Japan and beyond. Just as the great Tea masters Sen no Rikyū with his *wabi* taste, Furuta Oribe with his eccentricity and Nonomura Ninsei with his elegance added new styles to the form and new complexities to the aesthetic, the teabowl has continued to evolve. The classic *chawan* used in tea ceremony, held in both hands and placed on tatami in the spare beauty of the tearoom, is still found in *chanoyu*. These include contemporary teabowls that have been influenced by contemporary potters working within their own cultural paradigms and ceramic knowledge bases, with materials and techniques new to the teabowl.

The teabowl is adapting to fit its new cultures and habitats, and as styles and techniques have shifted in contemporary ceramics, so has this enigmatic ceramic form. The contemporary teabowl represents many things. It can be traditional, like a Lisa Hammond teabowl that quietly insinuates its way into the tearoom, or it can

(opposite) Figure 101: Hamada Shōji, untitled *chawan* with fitted and signed wooden box, shown in 2014. Stoneware with brushed iron oxide decoration and Shino glaze, 19 × 10.5 cm. PHOTO BY MICHAEL HARRIS, COURTESY OF OXFORD CERAMICS GALLERY AND HAMADA TOMOO.

be loud and belligerent, like Tom Sachs's NASA teabowl, which mocks the iconic position in which the teabowl has found itself. It can represent the best of functional ceramic ware, fitting perfectly into the hands as does a Richard Milgrim bowl, or it can sit alone on a white plinth, untouchable in its fragility, like a Kuwata Takuro teabowl. It may honour its past or debase it. Yet, these are all teabowls. Just as Japanese Raku and Western raku should be seen as related, but different, so the contemporary teabowl shares the *chawan*'s history and some of its characteristics, but has emerged as a distinct descendant.

If the teabowl is no longer being made for the tearoom, if it challenges the very essence of what it is, why has the form resonated so greatly in ceramics today? And why has it appealed to traditionalists and the avant-garde alike?

First and foremost, the teabowl is a vessel. Potters creating functional ware can glory in the elegant proportions and perfect suitability of the teabowl form. It may serve as just another form, or it may be chosen by potters because it offers a template that is at once familiar but exotic. In Europe, North America and Australia the teabowl does not carry the cultural burden that the jug, mug and vase do, yet it remains a pot, one that carries its own significant conceptual weight, which inherently implies a certain profoundness.

For many outside Japan, the teabowl remains a functional object permeated with qualities that cohabit easily with the legacy of Bernard Leach and the inherited values of the Arts and Crafts movement. These include truth to materials, authenticity, humility or a lack of pretension and an anti-industrial attitude. The best of functional teabowls reflect all these attributes.

Remarkably, as pottery splintered into the art versus craft divisions that arose in the last century (a very tired trope finally undergoing a slow death), the teabowl continued to appeal to both potters and ceramicists. In much of contemporary ceramic work there is a veneration of the vessel form beyond its function. Some, like Felicity Aylieff's (UK) towering ceramic columns, Thomas Bohle's (Austria) double-walled constructions and Avital Sheffer's (Australia) totemic bottles, celebrate the vessel, stretching our perception of the form. Others, like Tamsin van Essen's (UK) eroded *Vanitas* vases and Karin Lehmann's (Switzerland) two hundred unfired, water-filled urns, challenge the vessel form's integrity. The contemporary teabowl can also celebrate the vessel form, as in Jim Malone's (UK) slip-decorated teabowls and Michael Coffey's (US) dramatic teabowls, or it can reject it, as do Paul Drapkin's (US) oddly footed teabowls and Hoshino Kayoko's *Yuwan* (Playful Bowl). The teabowl as a vessel offers something to everyone.

The teabowl's embeddedness in the Japanese aesthetic concept of *wabi* is another lure for contemporary makers and collectors. With its stress on the imperfect and the asymmetrical, the *wabi* aesthetic fell on fertile ground during developments in twentieth- and twenty-first-century studio ceramics. Potters already searching for

artistic outlets that focused on individual discovery found a new concept to explore, which offered them independence from the dictates of their own training and heritage. Western cynicism abhors tradition and regimentation, yet often we find ourselves drawn to the mysteries of others' traditional customs. The teabowl form, which does not come from the European/American ceramic canon, still offers a certain amount of restriction, which can be freeing. As an artist, there is nothing more terrifying than the virgin first page of a new sketchbook, or as a writer, the empty screen below the title.

Finally, for potters and ceramicists alike, the functionality of the teabowl through its actual use, or its implied sense of function when it is not used, is appealing. Even those with limited knowledge of *chanoyu* know that the teabowl is held in the hands, and the ceramic form itself invites the palm to caress it. As humans we are inherently attracted to objects we can touch for pleasure, and ceramics has long been an art form that encourages touch. With the development of contemporary ceramics, especially sculptural ceramics, we have drifted away from this significant aesthetic component. When tea was introduced to the West in the seventeenth century, the fine porcelain tea cup imported from China and later replicated in Europe began to replace the beaker, which for centuries had been used for beer and other beverages. No longer did the hand wrap around a cylindrical ceramic form. Over the following years the tea cup developed a handle, so even less of the cup was actually touched; a thumb and a finger sufficed. This was followed by the heavier, yet still handled, twentieth-century mug.

The finest china was reserved for the most affluent members of society, who most likely handled their ceramics least of all, as they left their care to servants. In Japan, where tea ceremony was the apogee of high culture, the handleless teabowl, along with the smaller everyday *yunomi* for steeped teas, still held sway. These demand physical interaction. Indeed, most *chajin* care for their own precious tea utensils, and the tea ceremony itself involves holding and wiping the teabowl.

With the loss of tactile engagement, it is not surprising that in the twentieth century those involved in both making and collecting pottery, that most sensual and earthy craft, would gravitate to the teabowl's physical immediacy, tactility and hand-held scale. The tactile qualities of the teabowl are integral to its appreciation; nestling the bowl in the palms creates an intimacy between the maker and those who handle it, and between the individual and the bowl itself.

With the teabowl's totemic status, layers of meaning, veneration and cultural depth, it is not, as one rather cynical potter has said, 'just a cereal bowl with a bigger price tag'.[99] Even contemporary teabowls, which may never hold matcha and may not even be held within the palms, carry some of the teabowl's rich heritage and cultural significance. Its shape and proportions please us. Its simplicity draws us. The subtlety of its colour and the accidental quality of its glazing slow down and deepen the way we perceive it, satisfying us with a quiet complexity and a subtle timeless strength. This is the iconic teabowl.

You are seated in the tearoom. The warm colours of the unfinished walls surround you. It is quiet; the only sound is the soft, almost-simmer of the water in the kettle. The host has made a bowl of tea for you. You have performed the required thankful obeisance, and have turned the front of the bowl away from where you will drink. The teabowl now rests in the palm of your left hand as you cradle it with your right. You cradle the bowl that cradles the tea. It is slightly rough against your skin. With the palm of your right hand you feel an almost imperceptible asymmetrical indentation that you had not seen. Inside, the bright green of the tea contrasts the soothing quiet colour of the bowl. The tea is covered in a fine froth that peaks slightly in the centre. As you put the teabowl to your lips you notice that the rim is not perfect, although it fits your lip comfortably and snugly. You drink the tea in three considered sips. Turning the teabowl so the front is again facing you, you place it in front of yourself. After placing your hands together on the tatami, you look at the teabowl. What you have felt with your body you now perceive with your eyes: a glaze of depth and subtlety that is not uniform; a round shape that is not perfectly so; a flowing, undulating rim that gracefully forms the curve you have felt on your lips. Then you put your elbows on your knees and lean forward so you can safely lift the bowl. You can now look at its profile, inspect the rim closely and turn it over to consider the way the body falls away from its base and the foot ring. You place it back on the tatami, bow once, then return the bowl to the host.

Figure 102: Jack Doherty, *Small tea bowl on the blue cupboard*, 2012. Soda-fired porcelain, 6.5 × 7.5 cm. PHOTO BY REBECCA PETERS.

Endnotes

INTRODUCTION: the iconic teabowl

1 Robert Yellin, 'Chawan: Simply, some of the hardest works to create', *Japan Times*, 25 September 2013, www.japantimes.co.jp/culture/2013/09/25/arts/chawan-simply-some-of-the-hardest-works-of-pottery-to-create/#.VjyX2c6YVus, accessed 6 November 2015.

2 Robert Yellin, 'Redeemers with Feet of Clay', *Japan Times*, 8 January 2003, www.japantimes.co.jp/culture/2003/01/08/arts/redeemers-with-feet-of-clay/#.Vlm9dXuYVus, accessed 6 November 2015.

3 Katō Shūichi, in NHK, *Japanese Tea Bowls* (1989), uploaded to YouTube 9 December 2014, www.youtube.com/watch?v=pSP6Ec7kJbo, accessed 6 November 2015.

4 Faye Chua et al., 'Cultural Variation in Eye Movements during Scene Perception', *PNAS* (*Proceedings of the National Academy of Sciences of the United States of America*) 102/35 (2005), 12629–12633, doi:10.1073/pnas.0506162102, accessed 28 October 2015.

5 Samuel Lurie and Beatrice Chang, *Fired with Passion: Contemporary Japanese Ceramics*, New York: Eagle Art Publishing Inc., 2006, 231.

6 Sandy Brown, personal communication.

7 a1architects, http://www.a1architects.cz/en/works/black-teahouse, accessed 28 October 2015.

CHAPTER ONE: tea and the tea ceremony

8 Bert Vallee, 'Alcohol and the development of human civilization', in *Exploring the Universe: Essays on Science and Technology*, P. Day (ed.), Oxford: Oxford University Press, 1997, 126.

9 Lu Yü, quoted in Sen Sōshitsu XV, *The Japanese Way of Tea: From Its Origins in China to Sen Rikyū*, V. Dixon Morris (trans.), Honolulu: University of Hawai'i Press, 1998, 17.

10 Sen Sōshitsu XV, *The Japanese Way of Tea: From Its Origins in China to Sen Rikyū*, V. Dixon Morris (trans.), Honolulu: University of Hawai'i Press, 1998, 54.

11 James A. Benn, *Tea in China: A Religious and Cultural History*, Honolulu: University of Hawai'i Press, 2015, 14.

12 Lu Yü, *The Classic of Tea*, Francis Ross Carpenter (trans.), Boston: Little, Brown and Company, 1974, 116.

13 Li Baoping, 'Tea Drinking and Ceramic Tea Bowls: An Overview through Dynastic History', *China Heritage Quarterly*, No. 29 (March 2012), www.chinaheritagequarterly.org/features.php?searchterm=029_li.inc&issue=029, accessed 19 June 2015.

14 Benn, *Tea in China*, 43.

15 Rand Castile, *The Way of Tea*, New York: John Weatherhill Inc., 1971, 40.

16 Murai Yasuhiko, 'The Development of *Chanoyu*: Before Rikyū', in Paul Varley and Isao Kumakura (eds.), *Tea in Japan: Essays on the History of Chanoyu*, Honolulu: University of Hawai'i Press, 1989, 7–9.

17 Kinhiko, quoted in Sen Sōshitsu XV, *The Japanese Way of Tea*, 52.

18 Found in Sen XV, *The Japanese Way of Tea*, 54.

19 Dōgen, quoted in Sen XV, *The Japanese Way of Tea*, 79.

20 Sen XV, *The Japanese Way of Tea*, 121.

21 Castile, *The Way of Tea*, 43–44.

22 Ikkyū, *Wild Ways: Zen Poems of Ikkyū*, John Stevens (trans.) [ebook], Buffalo: White Pine Press, 2003, www.whitepine.org/wildways.pdf, accessed 8 July 2015.

23 From *Wakan Chashi*, quoted in Sen XV, *The Japanese Way of Tea*, 128–9.

24 Kumakura Isao, 'Sen no Rikyū: Inquiries into His Life and Tea' in *Tea in Japan: Essays on the History of Chanoyu*, Paul Varley (trans.), Paul Varley and Kumakura Isao (eds.), Honolulu: University of Hawai'i Press, 1989, 60.

25 Nicole Coolidge Rousmaniere, *Vessels of Influence: China and the Birth of Porcelain in Medieval and Early Modern Japan*, London: Bristol Classic Press, 2012, 89.

26 Castile, *The Way of Tea*, 63.

27 Omotesenke Fushin'an Foundation, *Japanese Tea Culture: The Omotesenke Tradition* (2005), http://www.omotesenke.jp/english/list3/list3-2/list3-2-2/, accessed 1 July 2015.

28 Sen Sōshitsu XV, *Tea Life, Tea Mind*, Tokyo: John Weatherhill Inc., 1979, 44.

29 Castile, *The Way of Tea*, 82.

30 A. L. Sadler, *Cha-no-yu: The Japanese Tea Ceremony*, Vermont/Tokyo: Charles E. Tuttle Company Inc., 1933/1962, 138.

31 Castile, *The Way of Tea*, 87.

32 Kristin Surak, *Making Tea, Making Japan*. Stanford: Stanford University Press, 2013, 69.

33 Kato Etsuko (ed.), *The Tea Ceremony and Women's Empowerment in Modern Japan: Bodies Re-Presenting the Past*, London: RoutledgeCurzon, 2004, 62.

CHAPTER TWO: the teabowl's ceramic heritage

34 Wu Xiaohong et al., 'Early Pottery at 20,000 Years Ago in Xianrendong Cave, China', *Science* 336/6089 (29 June 2012), 1696–1700, doi:10.1126/science.1218643, accessed 8 September 2015.

35 Richard L. Wilson, *Inside Japanese Ceramics: A Primer of Materials, Techniques, and Traditions*, New York/Tokyo: Weatherhill, an imprint of Shambhala Publications Inc., 1995, reprint 1995, 23.

36 Victor Harris, *Shintō: The Sacred Art of Ancient Japan*, London: British Museum, 2001, 52.

37 Morgan Pitelka, *Handmade Culture: Raku Potters, Patrons, and Tea Practitioners in Japan*, Honolulu: University of Hawai'i Press, 2005, 5.

38 Helen Westgeest, *Zen in the Fifties: Interaction in Art between East and West*, Zwolle: Waanders Publishing, 1996, 12.

39 Frank Hamer and Janet Hamer, *The Potter's Dictionary of Materials and Techniques*, 3rd edn, London: A & C Black, 1991, 318.

40 Castile, *The Way of Tea*, 193.

41 Ono Yoshihiro, 'Tenmoku Teabowls', Melissa M. Rinne (trans.), Kyoto National Museum www.kyohaku.go.jp/eng/dictio/touji/tenmoku.html, accessed 24 July 2015.

42 From Kumakura Isao, quoted in 'Sen no Rikyū: Inquiries into His Life and Tea' in *Tea in Japan: Essays on the History of Chanoyu*, Paul Varley (trans.), Paul Varley and Kumakura Isao (eds.), Honolulu: University of Hawai'i Press, 1989, 60.

43 Yanagi Sōetsu, *The Unknown Craftsman: A Japanese Insight into Beauty*, adapted by Bernard Leach, New York: Kodansha International Ltd., 1972/1989, 192.

44 Ibid.

45 Louise Allison Cort, 'The Kizaemon Teabowl Reconsidered: The Making of a Masterpiece', *Chanoyu Quarterly: Tea and the Arts of Japan*, No. 71, Kyoto: Urasenke Foundation, 1992, 18–19.

46 Yanagi, *The Unknown Craftsman*, 191.

47 Pitelka, *Handmade Culture*, 39.

48 Metropolitan Museum of Art, 'Momoyama: Japanese Art in the Age of Grandeur', catalogue of an exhibition at the Metropolitan Museum of Art organized in collaboration with the Agency for Cultural Affairs of the Japanese Government, New York: Metropolitan Museum of Art, 1975, 105.

49 Bernard Leach, *A Potter's Book*, London: Faber and Faber, 1940/1976, 29–30.

50 Yanagi, *The Unknown Craftsman*, 125.

51 Daniel Rhodes, *Clay and Glazes for the Potter*, rev. edn, London: A & C Black, 1973, 295.

52 Hayashiya Seizo, 'Hon'ami Koetsu – His Ceramic Works', *Chanoyu Quarterly: Tea and the Arts of Japan*, No. 14, Kyoto: Urasenke Foundation, 1976, 42.

53 Pitelka, *Handmade Culture*, 55.

54 Ibid.

55 John Baymore, 'What Makes a Teabowl a *Chawan*?' [video] conference presentation, NCECA 2015 (published 15 July 2015), http://blog.nceca.net/what-makes-a-teabowl-a-chawan-now-online, accessed 9 August 2015.

56 Robert Yellin, 'Oribe Overseas: Pottery to Get on a Plane For', *Japan Times*, 26 November 2003, www.japantimes.co.jp/culture/2003/11/26/arts/pottery-to-get-on-a-plane-for/#.Vlrlt2ThB90, accessed 29 July 2015.

57 Wilson, *Inside Japanese Ceramics*, 118.

58 Kuroda Ryoji and Murayama Takeshi, *Classic Stoneware of Japan: Shino and Oribe*, previously published separately as *Shino* (1984) and *Oribe* (1982), Robert N. Huey (trans. Shino) and Lynne E. Riggs (trans. Oribe), Tokyo: Kodansha, 2002, 9.

59 Kuroda, *Classic Stoneware*, 8.

60 John Britt, *The Complete Guide to High-Fired Glazes*, New York: Lark Books, 2004, 80.

61 Wilson, *Inside Japanese Ceramics*, 110.

62 Robert Finlay, *The Pilgrim Art: Cultures of Porcelain in World History*, part of California World History Library, Berkeley: University of California Press, 2010, 182.

63 Allen S. Weiss, *Zen Landscapes: Perspectives on Japanese Gardens and Ceramics*, London: Reaktion Books Ltd, 2013, 69.

64 Ibid.

CHAPTER THREE: the teabowl travels

65 Wassily Kandinsky, 'Letters from Munich' in *Kandinsky, Complete Writings on Art* by Wassily Kandinsky and Kenneth C. Lindsay, New York: Da Capo Press. After new edition from Boston, 1982/1994, 59.

66 Jenni Sorkin, 'Black Mountain, Heart Mountain: Ceramics at Camp, 1942–1952', [video], YouTube (recorded 12 October 2013, uploaded 1 November 2013), www.youtube.com/watch?v=-MX3CtjevIQ, accessed 6 August 2015.

67 George Lazopoulos, 'Zen Again: Reconsidering D.T. Suzuki' [book review], *Los Angeles Review of Books*, 16 February 2015, https://lareviewofbooks.org/review/sage-works-d-t-suzuki, accessed 6 August 2015.

68 Westgeest, *Zen in the Fifties*, 54.

69 Jenni Sorkin, 'Zen Veterans and the Vernacular: The Black Mountain Pottery Seminar', *Live Form: Women, Ceramics and Community*, Chicago: University of Chicago Press, 2016, 105–151.

70 Ibid.

71 Smithsonian American Art Museum, 'Peter Voulkos: biography' [website], http://americanart.si.edu/collections/search/artist/?id=5183, accessed 14 August 2015.

72 Peter Voulkos in 'Voulkos Speaks', Rick Berman (interviewer), *Clay Times*, November/December 1996, www.claytimes.com/articles/voulkos.html, accessed 16 August 2015.

73 Collette Chattopadhyay, 'Peter Voulkos: Clay, Space, and Time', *Sculpture Magazine*, Vol. 20, No. 2, March 2001, www.sculpture.org/documents/scmag01/march01/voulkos/voulkos.shtml, accessed 14 August 2015.

74 Leach, *A Potter's Book*, 29–30.

75 Steven Branfman, *Mastering Raku: Making Ware, Glazes, Building Kilns, Firing*, New York: Lark Books, 2009, 15.

76 Elizabeth Ryan, 'Remembering: Paul Soldner', *American Craft Council*, 6 January 2011, http://craftcouncil.org/post/remembering-paul-soldner, accessed 26 August 2015.

77 Paul Soldner, 'The American Way of Raku' [speech in the Everson Museum of Art in Syracuse, New York], printed in *Ceramic Review*, No. 124, July/August 1990, 10.

78 Ibid.

79 Soldner, 'The American Way of Raku', 8.

80 Soldner, 'The American Way of Raku', 11.

81 Richard Hirsch in Scott Meyer, *With Fire: Richard Hirsch: A Life Between Chance and Design*, Rochester: RIT Cary Graphic Arts Press, 2012, XI.

82 Milton Moon, www.miltonmoon.com/Gallery/56.html, accessed 2 September 2015.

83 Robert Yellin, 'Japan's Tea Pots Made by an American Potter', *The Japan Times*, 9 August 2004, www.japantimes.co.jp/culture/2004/08/09/arts/japans-tea-pots-made-by-an-american-potter/#.VebyU84Z1us, accessed 2 September 2015.

CHAPTER FOUR: from tearoom to gallery

84 Kwan Pui Ying, 'Exploring Japanese Art and Aesthetic as Inspiration for Emotionally Durable Design', *DesignEd Asia Conference* 2012, Hong Kong, 2012/3, www.designedasia.com/2012/Full_Papers/Exploring%20Japanese%20Art%20and%20Aesthetic.pdf, accessed 2 April 2015.

85 Jonathan Chapman, *Emotionally Durable Design: Objects, Experiences and Empathy*, Abingdon: Routledge, 2015, 65.

86 Wilson, *Inside Japanese Ceramics*, 103.

87 Hannah McAndrew, personal communication.

88 Weiss, *Zen Landscapes*, 103.

89 Jeff Mincham, quoted in 'Australian Potter Jeff Mincham', Venice Clay Artists, August 5, 2011, www.veniceclayartists.com/tag/jeff-mincham/, accessed 12 September 2015.

90 Okakura Kakuzō, *The Book of Tea*, New York: Dover Publications, 1964, 18.

91 Steven Branfman, 'A Father's Kaddish', posted 7 September 2015, www.thayer.org/page.cfm?p=1523&newsid=411, accessed 29 October 2015.

92 Rob Fornell, personal communication.

93 Ibid.

94 Philip Eglin, exhibition gallery notes, *Teabowl: Form, Function, Expression*, Oxford Ceramics Gallery, 24 October–16 November 2014.

95 Geraint Roberts, 'Filling the Silence: Towards an Understanding of Claudi Casanovas' Blocks', in *Interpreting Ceramics*, Issue 5, 2004, www.interpretingceramics.com/issue005/fillingthesilence. htm, accessed 16 September 2015.

96 Puls Contemporary Ceramics, 'Monika Patuszynska', www.pulsceramics.com/exhibitions/ monika-patuszynska-2014/, accessed 5 August 2015.

97 Kuwata Takuro, quoted in Erica Bellman, 'Breaking the Mold: Takuro Kuwata', *New York Times*, 17 January 2013, http://tmagazine.blogs.nytimes.com/2013/01/17/breaking-the-mold-takuro-kuwata/?_r=0, accessed 12 September 2015.

CONCLUSION: **the iconic teabowl – past and present**

98 David Lowenthal, *The Past Is a Foreign Country – Revisited*, Cambridge: Cambridge University Press, 2015, 289.

99 Personal communication.

Bibliography

Baymore, John. 'What Makes a Teabowl a *Chawan?*', conference presentation, NCECA 2015, Providence, Rhode Island. http://blog.nceca.net/what-makes-a-teabowl-a-chawan-now-online, accessed 9 August 2015.

BBC. 'Mending Cracks with Gold'. *Something Understood*, Radio 4, 1 September 2013. www.bbc.co.uk/programmes/b039b67b, accessed 13 May 2015.

Benn, James A. *Tea in China: A Religious and Cultural History*. Honolulu: University of Hawai'i Press, 2015.

Berman, Rick (interviewer). 'Voulkos Speaks', *Clay Times*, November/December 1996. www.claytimes.com/articles/voulkos.html, accessed 16 August 2015.

Branfman, Steven. *Mastering Raku: Making Ware, Glazes, Building Kilns, Firing*. New York: Lark Books, 2009.

Britt, John. *The Complete Guide to High-Fired Glazes*. New York: Lark Books, 2004.

Castile, Rand. *The Way of Tea*. New York: John Weatherhill Inc., 1971.

Chapman, Jonathan. *Emotionally Durable Design: Objects, Experiences and Empathy*. Abingdon: Routledge, 2015.

Chattopadhyay, Collette. 'Peter Voulkos: Clay, Space, and Time'. *Sculpture Magazine*, Vol. 20, No. 2, March 2001. www.sculpture.org/documents/scmag01/march01/voulkos/voulkos.shtml, accessed 14 August 2015.

Chiba, Kaeko. *Japanese Women, Class and the Tea Ceremony: The Voices of Tea Practitioners in Northern Japan*. Abingdon: Routledge, 2011. www.scribd.com/doc/213379075/8/Glossary, accessed 7 July 2015.

Chua, Hannah Faye, Julie E. Boland and Richard E. Nisbett. 'Cultural Variation in Eye Movements during Scene Perception'. *PNAS* (*Proceedings of the National Academy of Sciences of the United States of America*), 2005 102 (35) 12629–12633; *published ahead of print 22 August 2005*, doi:10.1073/pnas.0506162102, accessed 28 October 2015.

Cooper, Emmanuel. 'Bernard Leach in America', *Ceramics in America*. Robert Hunter (ed.), New Hampshire: Chipstone Foundation, 2004, 130–142. http://www.chipstone.org/article.php/154/Ceramics-in-America-2004/Bernard-Leach-in-America, accessed 27 April 2016.

Corbett, Rebecca. 'Researching the History of Women in Chanoyu.' In *New Voices*. Sydney: The Japan Foundation, December 2006, 1. www.newvoices.jpf-sydney.org/1/vol1.pdf#page=32, accessed 7 July 2015.

Cort, Louise Allison. 'The Kizaemon Teabowl Reconsidered: The Making of a Masterpiece', *Chanoyu Quarterly: Tea and the Arts of Japan*, No. 71, Kyoto: Urasenke Foundation, 1992, 7–30.

de Bary, Theodore (ed.). 'The Vocabulary of Japanese Aesthetics I, II, III'. In *Japanese Aesthetics and Culture: A Reader*. Nancy G. Hume (ed.), Albany: State University of New York Press, 1995, 43–76. First published in Sources of Japanese Tradition, 1958.

Dougill, John. *Kyoto: A Cultural History*. New York: Oxford University Press, 2006.

Finlay, Robert. *The Pilgrim Art: Cultures of Porcelain in World History*, part of California World History Library, Berkeley: University of California Press, 2010.

Flickwerk: The Aesthetics of Mended Japanese Ceramics. Exhibition publication. Herbert F. Johnson Museum of Art, Cornell University 28 June–10 August 2008. Museum für Lackkunst, a division of BASF Coatings AG Münster, Germany. www.bachmanneckenstein.com/downloads/Flickwerk_ The_Aesthetics_of_Mended_Japanese_Ceramics.pdf, accessed 2 April 2015.

Ford, James L. 'Buddhist Materiality: A Cultural History of Objects in Japanese Buddhism (review)', *The Journal of Japanese Studies* 35.2 (2009): 368–373. *Project MUSE*. https://muse.jhu.edu/ login?auth=0&type=summary&url=/journals/journal_of_japanese_studies/v035/35.2.ford.pdf, accessed 14 August 2015 (excerpt only).

Frank Lloyd Gallery. 'Peter Voulkos: biography'. www.franklloyd.com/dynamic/artist_bio. asp?ArtistID=34, accessed 14 August 2015.

Fujioka, Ryoichi. *Tea Ceremony Utensils*, Arts of Japan 3, New York: Weatherhill, Tokyo: Shibundo, 1973.

Glassman, Hank. 'Buddhist Materiality: A Cultural History of Objects in Japanese Buddhism (review)'. *Monumenta Nipponica* 63.2 (2008): 405–408. *Project MUSE*. Web. 9 April 2015. https:// muse.jhu.edu/, accessed 14 August 2015.

Gopnik, Blake. 'At Freer, Aesthetic Is Simply Smashing', *The Washington Post*, 3 March 2009. www. washingtonpost.com/wp-dyn/content/article/2009/03/02/AR2009030202723.html, accessed 2 April 2015.

Haga, Kōshirō. 'The Wabi Aesthetic through the Ages'. In *Japanese Aesthetics and Culture: A Reader*. Nancy G. Hume (ed.), Albany: State University of New York Press, 1995, 245–278.

Hamer, Frank, and Janet Hamer. *The Potter's Dictionary of Materials and Techniques*, 3rd edn, London: A&C Black, 1991.

Harris, Victor. *Shintō: The Sacred Art of Ancient Japan*. London: British Museum, 2001.

Hayashiya, Seizo. 'Hon'ami Koetsu – His Ceramic Works'. *Chanoyu Quarterly: Tea and the Arts of Japan*. No. 14, Kyoto: Urasenke Foundation, 1976, 34–53.

Herring, James. 'The Mingei Movement and Contemporary Ceramics in America'. www.academia. edu/3670308/The_Mingei_Movement_and_Contemporary_Ceramics_in_America, accessed 23 Jan 2014.

Hightower, Marvin. 'Traveling Exhibition Offers Once-in-a-Lifetime Look at Golden Age of Brown-Black-Glazed Wares', *The Harvard University Gazette*, 15 February 1996. http://news.harvard.edu/ gazette/1996/02.15/ChineseCeramics.html, accessed 19 June 2015.

Hume, Nancy G. (ed.). *Japanese Aesthetics and Culture: A Reader*. Albany: State University of New York Press, 1995.

Ikkyū, *Wild Ways: Zen Poems of Ikkyū*. Rengetsu (ed.), John Stevens (trans.), Buffalo: White Pine Press, e-publication, 2003. www.whitepine.org/wildways.pdf, accessed 8 July 2015.

Juniper, Andrew. *Wabi Sabi: the Japanese Art of Impermanence*. Vermont: Tuttle Publishing, 2003.

Kandinsky, Wassily (1994/1982), 'Letters from Munich'. In *Kandinsky, Complete Writings on Art* by Wassily Kandinsky and Kenneth C. Lindsay. New York: Da Capo Press. After new edition from Boston, 1982.

Kato, Etsuko (ed.). *The Tea Ceremony and Women's Empowerment in Modern Japan: Bodies Re-Presenting the Past*. London: RoutledgeCurzon, 2004.

Kawahara, Masahiko. 'Early Kyoto Ceramics'. Abridgement, translation and adaptation of 'Shoki Kyo-yaki Shogama no Doko-Bunken Shiryo o Chushin to suru Sobyo', which appears in exhibition catalogue *Chanoyu to Kyo-yaki I-Ninsei, Kenzan, Kokiyomizu*, by Chado Research Center, Kyoto, 1981. *Chanoyu Quarterly: Tea and the Arts of Japan*, No. 31, 1982. Kyoto: Urasenke Foundation, 31–46.

Keene, Donald. 'Japanese Aesthetics'. *In Japanese Aesthetics and Culture: A Reader*. Nancy G. Hume (ed.), Albany: State University of New York Press, 1995, 27–41.

Kemske, Bonnie. 'The Beauty of Imperfection: Teabowls', *Ceramic Review* 225, May/June 2007, 30–33.

Koo, Tae-hoon. 'Flowering of Korean Ceramic Culture in Japan', *History Review*, Winter 2008, reprinted in *Korea Focus*. www.koreafocus.or.kr/design2/features/view.asp?volume_id=82&content_id=102438&category=H, accessed 1 August 2015.

Koren, Leonard. *Wabi-sabi for Artists, Designers, Poets & Philosophers*. Point Reyes, California: Imperfect Publishing, 1994/2008.

Kumakura, Isao. 'Kan'ei Culture and *Chanoyu*'. In *Tea in Japan: Essays on the History of Chanoyu*. Paul Varley (trans.), Paul Varley and Kumakura Isao (eds.), Honolulu: University of Hawai'i Press, 1989, 135–160.

Kumakura, Isao. 'Sen no Rikyū: Inquiries into His Life and Tea'. In *Tea in Japan: Essays on the History of Chanoyu*. Paul Varley (trans.), Paul Varley and Kumakura Isao (eds.), Honolulu: University of Hawai'i Press, 1989, 33–70.

Kuroda, Ryoji and Murayama Takeshi. *Classic Stoneware of Japan: Shino and Oribe*. Previously published separately as *Shino* (1984) and *Oribe* (1982). Translated by Robert N. Huey (Shino) and Lynne E Riggs (Oribe). Tokyo: Kodansha, 2002.

Kwan, Pui Ying. 'Exploring Japanese Art and Aesthetic as Inspiration for Emotionally Durable Design', *DesignEd Asia Conference 2012*, Hong Kong. www.designedasia.com/2012/Full_Papers/Exploring%20Japanese%20Art%20and%20Aesthetic.pdf, accessed 2 April 2015.

Lazopoulos, George. 'Zen Again: Reconsidering D.T. Suzuki', book review, *Los Angeles Review of Books*, February 16, 2015, https://lareviewofbooks.org/review/sage-works-d-t-suzuki, accessed 6 August 2015.

Leach, Bernard. *A Potter's Book*. London: Faber and Faber, 1940/1976.

Li, Baoping. 'Tea Drinking and Ceramic Tea Bowls: An Overview through Dynastic History'. *China Heritage Quarterly*, No. 29, March 2012. www.chinaheritagequarterly.org/features.php?searchterm=029_li.inc&issue=029, accessed 19 June 2015.

Lipske, Michael. 'Broken tea bowls display precious golden repairs in Freer exhibit', *Inside Smithsonian Research*, No. 23, Winter 2009, Smithsonian Institution, 3–5.

Lowenthal, David. *The Past Is a Foreign Country – Revisited*. Cambridge: Cambridge University Press, 2015.

Lu, Yü. *The Classic of Tea*. Francis Ross Carpenter (trans.), Boston: Little, Brown and Company, 1974.

Lurie, Samuel J., and Beatrice L. Chang. *Fired with Passion: Contemporary Japanese Ceramics*. New York: Eagle Art Publishing, Inc., 2006.

Macfarlane, Alan, and Iris Macfarlane. *Green Gold: The Empire of Tea*. London: Ebury Press, 2003.

Metropolitan Museum of Art. *Momoyama: Japanese Art in the Age of Grandeur*, catalogue of an exhibition at the Metropolitan Museum of Art organized in collaboration with the Agency for Cultural Affairs of the Japanese Government, New York: Metropolitan Museum of Art, 1975.

Meyer, Scott. *With Fire: Richard Hirsch: A Life Between Chance and Design*. Rochester: RIT Cary Graphic Arts Press, 2012.

Mikami, Tsugio. *The Art of Japanese Ceramics*. Ann Herring (trans.), New York: Weatherhill, Tokyo: Heibonsha, 1972.

Milton Moon. www.miltonmoon.com/Gallery/56.html, accessed 2 September 2015.

Moon, Milton. *Wabi and the Chawan*. Waverley: The Australian Ceramics Association and Milton Moon, 2009.

Murai, Yasuhiko. 'Furuta Oribe'. *Chanoyu Quarterly*, No. 42, Kyoto: Urasenke Foundation, 1985, 24–48.

Murai, Yasuhiko. 'The Development of *Chanoyu*: Before Rikyū', in *Tea in Japan: Essays on the History of Chanoyu*. Paul Varley and Kumakura Isao (eds.), Honolulu: University of Hawai'i Press, 1989, 3–32.

NHK. 'Japanese Tea Bowls'. No. 6 in series: *Japan Spirit and Form*. (1989), Edited by Yoshioka Masaharu, directed by Funakoshi Yuichi, produced by Takahashi Mitsutaka. English version: Directed by Yoshida Masao, Produced by Furuta Hisateru. 1989. www.youtube.com/watch?v=pSP6Ec7kJbo, accessed 6 Nov 2015.

Okakura, Kakuzō. *The Book of Tea*. New York: Dover Publications, 1964.

Okuda, Naoshige. 'The Temmoku Teabowl'. Translated from the catalogue *Temmoku* for the exhibition with the same name organized by the Tokugawa Bijutsukan and the Nezu Bijutsukan in October 1979. In *Chanoyu Quarterly: Tea and the Arts of Japan*, No. 26, Kyoto: Urasenke Foundation, 1981, 7–32.

Omotesenke Fushin'an Foundation (2005). *Japanese Tea Culture: The Omotesenke Tradition*. www.omotesenke.jp/english/list2/list2-1/list2-1-3/, accessed 1 July 2015.

Ono, Yoshihiro (n.d.). 'Tenmoku Teabowls'. Melissa M. Rinne (trans.). Kyoto National Museum website, www.kyohaku.go.jp/eng/dictio/touji/tenmoku.html, accessed 24 July 2015.

Parkes, Graham. 'Ways of Japanese Thinking'. *In Japanese Aesthetics and Culture: A Reader*. Nancy G. Hume (ed.), Albany: State University of New York Press, 1995, 77–108.

Pitelka, Morgan. 'Case Studies: Mino and Hizen'. In 'Unearthing Ceramic Histories in Sixteenth- and Seventeenth-Century Japan: Sources, Themes, and Methods'. www.unc.edu/~mpitelka/unearthing_ceramics/case_studies.html, accessed 30 July 2015.

Pitelka, Morgan. *Handmade Culture: Raku Potters, Patrons, and Tea Practitioners in Japan*. Honolulu: University of Hawai'i Press, 2005.

Pitelka, Morgan. *Japanese Tea Culture: Art, History and Practice*. Abingdon: Routledge, 2003.

Raku Museum. 'Rakuware', website, www.raku-yaki.or.jp/e/history/index.html, accessed 29 July 2015.

Rhodes, Daniel. *Clay and Glazes for the Potter*, rev. edn London: A & C Black, 1973.

Richards, M. C. *Centering in Pottery, Poetry, and the Person*. Hanover NH: Wesleyan University Press, 1962.

Roberts, Geraint. 'Filling the Silence: Towards an Understanding of Claudi Casanovas' Blocks'. In *Interpreting Ceramics*, Issue 5, 2004. www.interpretingceramics.com/issue005/fillingthesilence.htm, accessed 16 September 2015.

Rousmaniere, Nicole Coolidge. *Vessels of Influence: China and the Birth of Porcelain in Medieval and Early Modern Japan*. London: Bristol Classical Press, 2012.

Ryan, Elizabeth. 'Remembering: Paul Soldner', *American Craft Council*. 6 January 2011, http://craftcouncil.org/post/remembering-paul-soldner, accessed 26 August 2015.

Sadler, A. L. *Cha-no-yu: The Japanese Tea Ceremony*. Vermont/Tokyo: Charles E. Tuttle Company, Inc., 1933/1962.

Saito, Yuriko. *Everyday Aesthetics*. Oxford: Oxford University Press, 2007.

Saito, Yuriko. 'The Moral Dimension of Japanese Aesthetics', *The Journal of Aesthetics and Art Criticism*, 2007. 65: 85–97. doi: 10.1111/j.1540-594X.2007.00240.x, accessed 15 October 2015.

Scott, Paul. *The Nature of Mending*, blog. www.natureof.co.uk/artist/paul-scott/, accessed 2 May 2015.

Sen, Sōshitsu XV. 'A Cuckoo Singing!', *Chanoyu Quarterly: Tea and the Arts of Japan*, No. 14, Kyoto: Urasenke Foundation, 1976, 5–6.

Sen, Sōshitsu XV. *Chado: The Japanese Way of Tea*. New York: Weatherhill/Tankosha, 1979.

Sen, Sōshitsu XV. *Tea Life, Tea Mind*. New York/Tokyo: John Weatherhill, Inc., 1979.

Sen, Sōshitsu XV. *The Japanese Way of Tea: From Its Origins in China to Sen Rikyū*. V. Dixon Morris (trans.), Honolulu: University of Hawai'i Press, 1998.

Sen, Sōshitsu XV. *Urasenke Chanoyu Handbook Two*. Kyoto: Urasenke Foundation, 1980.

Simpson, Penny, and Sodeoka Kanji. *The Japanese Pottery Handbook*. New York: Kodansha USA, 1979/2014.

Smithsonian American Art Museum, 'Peter Voulkos: biography', http://americanart.si.edu/collections/search/artist/?id=5183, accessed 14 August 2015.

Soldner, Paul. 'The American Way of Raku', [speech in the Everson Museum of Art in Syracuse, New York], printed in *Ceramic Review*, No. 124, July/August 1990, 10.

Sorkin, Jenni. 'Black Mountain, Heart Mountain: Ceramics at Camp, 1942–1952', [video], YouTube (recorded 12 October 2013, uploaded 1 November 2013) www.youtube.com/watch?v=-MX3CtjevIQ, accessed 6 August 2015.

Sorkin, Jenni. 'Zen Veterans and the Vernacular: The Black Mountain Pottery Seminar', *Live Form: Women, Ceramics and Community*. Chicago: University of Chicago Press, 2016.

Surak, K. 'From Selling Tea to Selling Japaneseness: Symbolic Power and the Nationalization of Cultural Practices'. *European Journal of Sociology*, 52(2), (2011). 175–208. http://eprints.soas.ac.uk/17999/1/Surak%20-%20EJS%20symbolic%20power.pdf, accessed 6 July 2015.

Surak, Kristin. *Making Tea, Making Japan*. Stanford: Stanford University Press, 2013.

Tanihata, Akio, 'Tea and Kyoto Ceramics in the Late Edo Period'. Translation and adaptation of 'Edo Jidai Goki no Chanoyu to Kyo-yaki', which appeared in the exhibition catalogue *Chanoyu to Kyo-yaki II: Nin'ami, Hozen o Chushin ni*, Chado Research Center, 1982. *Chanoyu Quarterly: Tea and the Arts of Japan*, No. 39, Kyoto: Urasenke Foundation, 1984, 7–27.

Tanikawa, Tetsuzo. 'The Esthetics of *Chanoyu*, Part 3', a translation and adaptation of the author's *Cha no bigaku* (The Esthetics of Tea) published in 1977 by the Tankosha Publishing Company. *Chanoyu Quarterly: Tea and the Arts of Japan*, No. 26, Kyoto: Urasenke Foundation, 1981, 33–49.

Theroux, Marcel. *In Search of Wabi Sabi with Marcel Theroux*, BBC4, 2009. www.youtube.com/watch?v=Z2P8z7kYJW0 (published on 19 June 2014), accessed 20 July 2015.

Thrasher, William, with Caroline Graboys. 'The Beginnings of *Chanoyu* in America'. *Chanoyu Quarterly: Tea and the Arts of Japan*, No. 40, Kyoto: Urasenke Foundation, 1984, 7–35.

Totman, Conrad. *A History of Japan*, 2nd edn Malden MA, Oxford, Victoria Australia: Blackwell Publishing, 2000/2005.

Uenishi, Setsuo. 'Bizen-ware Ceramics', *Chanoyu Quarterly: Tea and the Arts of Japan*, No. 38, Kyoto: Urasenke Foundation, 1984, 7–22.

Urasenke Foundation San Francisco, 2003–2009, www.urasenke.org/tradition, accessed 1 July 2015.

Urushiart.com (2009), 'When Mending Becomes an Art', 8 December 2009, www.youtube.com/watch?v=k3mZgs0vkDY. (Uploaded 8 December 2009), accessed 13 May 2015.

Vallee, Bert. 'Alcohol and the development of human civilization'. In P. Day (ed.), *Exploring the Universe: Essays on Science and Technology*. Oxford: Oxford University Press, 1997.

Varley, Paul, and Kumakura Isao (eds.), *Tea in Japan: Essays on the History of Chanoyu*. Honolulu: University of Hawai'i Press, 1989.

Walford Mill. 'The Journey: Exploring the Nature of Mending', exhibition catalogue 14 September–27 October 2013. Farnham: Craft Study Centre, 2013.

Weiss, Allen S., *Zen Landscapes: Perspectives on Japanese Gardens and Ceramics*. London: Reaktion Books, 2013.

Westgeest, Helen. *Zen in the Fifties: Interaction in Art between East and West*. Zwolle: Waanders Publishing, 1996.

Wilson, Richard L. *Inside Japanese Ceramics: A Primer of Materials, Techniques, and Traditions*. New York/Tokyo: Weatherhill, an imprint of Shambhala Publications Inc., 1995, reprint 1995.

Wilson, Richard L. 'Oribe Ceramics and the Oribe Imagination'. In *Turning Point: Oribe and the Arts of Sixteenth-Century Japan*. Murase Miyako (ed.), New York: Metropolitan Museum of Art, 2003, 114–121.

Wu Xiaohong, Zhang Chi, Paul Goldberg, David Cohen, Pan Yan, Trina Arpin, and Ofer Bar-Yosef, 'Early Pottery at 20,000 Years Ago in Xianrendong Cave, China'. *Science* 29 June 2012: 336 (6089), 1696–1700. [DOI:10.1126/science.1218643] http://www.sciencemag.org/content/336/6089/1696, accessed 8 September 2015.

Yanagi, Sōetsu. *The Unknown Craftsman: A Japanese Insight into Beauty*. Adapted by Bernard Leach. New York: Kodansha International Ltd., 1972/1989.

Yellin, Robert. '*Chawan*: Simply, some of the hardest works to create', *Japan Times*, 25 September 2013. www.japantimes.co.jp/culture/2013/09/25/arts/chawan-simply-some-of-the-hardest-works-of-pottery-to-create/#.VjyX2c6YVus, accessed 6 November 2015.

Yellin, Robert. *Japanese Pottery Information Center*. 2007. www.e-yakimono.net/, accessed 29 July 2015.

Yellin, Robert. 'Japan's Tea Pots Made by an American Potter', *Japan Times*, 9 August 2004, www.japantimes.co.jp/culture/2004/08/09/arts/japans-tea-pots-made-by-an-american-potter/#.VebyU84Z1us, accessed 2 September 2015.

Yellin, Robert. 'Oribe Overseas: Pottery to Get on a Plane For', *Japan Times*, 26 November 2003. www.japantimes.co.jp/culture/2003/11/26/arts/pottery-to-get-on-a-plane-for/#.Vlrlt2ThB90, accessed 29 July 2015.

Yellin, Robert. 'Redeemers with Feet of Clay', *Japan Times*, 8 January 2003, www.japantimes.co.jp/culture/2003/01/08/arts/redeemers-with-feet-of-clay/#.Vlm9dXuYVus, accessed 29 July 2015.

Index